S·U·M·M·E·R
COTTAGES

SUMMER
COTTAGES

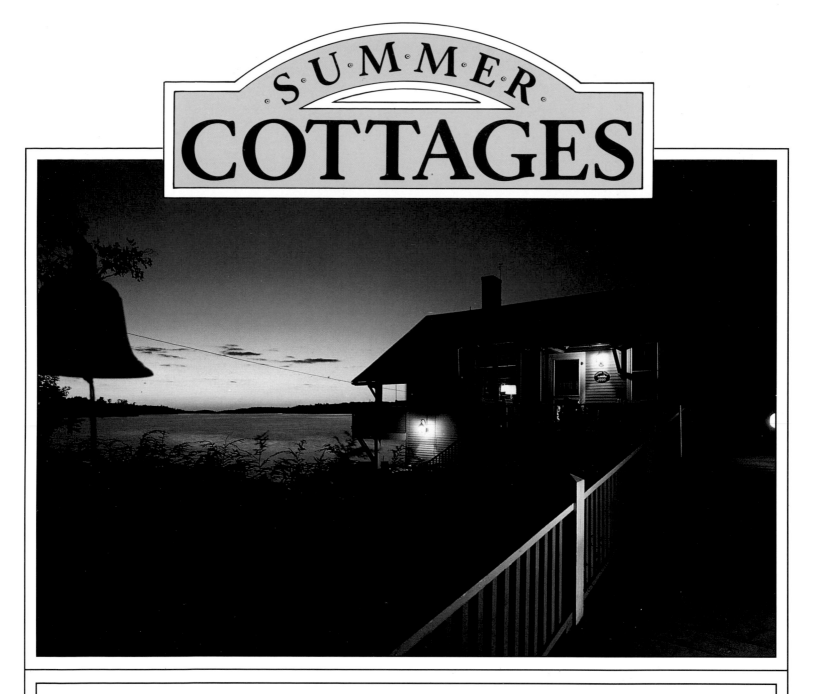

Photographs by John de Visser / Text by Judy Ross

Stoddart

A STODDART / BOSTON MILLS PRESS EDITION

ACKNOWLEDGEMENTS

*We would like to thank all the people that let us into their cottages,
boathouses, bunkies and gardens to take the photographs for this book.*

Canadian Cataloguing in Publication Data

De Visser, John, 1930-
 Summer cottages

"A Boston Mills Press Edition".
ISBN 0-7737-2553-9

1. Vacation homes – Ontario. I. Ross, Judy,
1942- II. Title.

NA7579.C3D4 1991 728.7'2'09713 C91-094203-X

Copyright © 1991 by John de Visser and Judy Ross

Design by Gill Stead
Edited by Noel Hudson
Typography by Justified Type Inc., Guelph, Ontario
Printed by Khai Wah Litho, Singapore

A Boston Mills Press Edition
First published in 1991 by
Stoddart Publishing Co. Limited
34 Lesmill Road
Toronto, Canada
M3B 2T6

American Association
for State and Local History
Award of Merit

Winners of the
Heritage Canada
Communications Award

The publisher wishes to acknowledge the financial assistance and
encouragement of The Canada Council, the Ontario Arts Council and
the Office of the Secretary of State.

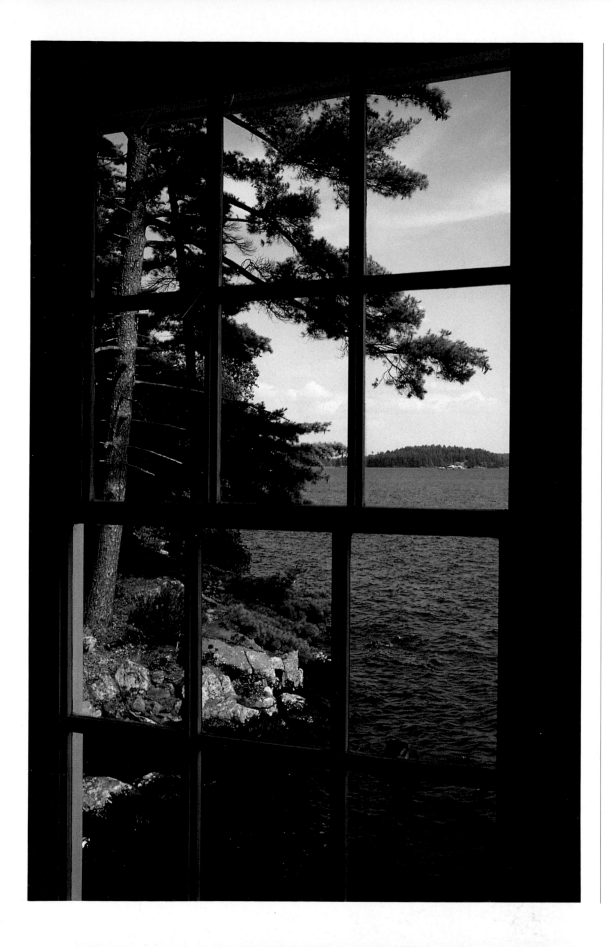

Table of Contents

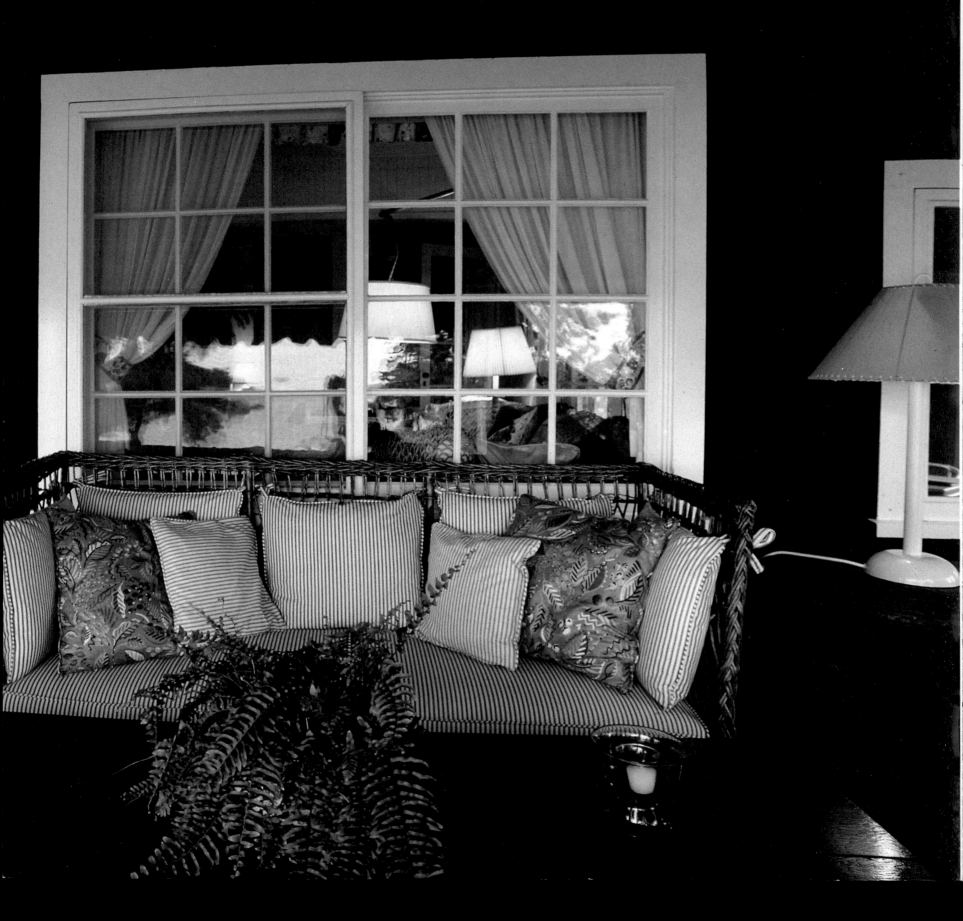

WHERE THE HEART IS

The summer cottage. The mere words evoke images of sun-dappled woods and sparkling waters, breezy screened verandas and the promise of lazy afternoons. Often our most treasured retreat, the cottage has become a metaphor for relaxation, escapism and family kinship. Above all, it's the place where we can cast off our city shoes and worries, sink into an old porch rocker and be ourselves. Perhaps when Henry James said that the most beautiful words in the English language were "summer afternoon," he was envisioning a lazy day at a lakeside cottage.

In many parts of Canada, summers at the cottage are an enduring institution, a part of our natural gravitation to the outdoors. Whether it's to the seashore, the bay, the lake or the river, the common element of this summer migration is the need to be near water. A need that's perpetuated by the children who spend summers jumping off wooden docks, learning to mimic the call of loons, and being lulled to sleep by water lapping on the shore. Stephen Leacock described this need as "mania for the open bush," and it is in Ontario, his native province, that it is perhaps most evident. Scattered across the vast swath of Precambrian rock are sparkling lakes and bays formed when a glacier gouged out deep basins that later filled with water. Here, in this beautiful countryside, cottage communities began to evolve before the turn of the century. The allure of pine-scented woods and crystal-clear lakes was discovered by men of leisure who ventured north to hunt and fish, fell in love with the land, and staked claims to shorefront properties and islands. Before long they built cottages. Some were grand stone mansions with servants' wings and wide staircases. Others were more modest cabins built of wood and shingles. Many of these still exist today, summer homes to the descendants of these adventuresome pioneers.

At the heart of cottage living is the family experience. No matter how widely dispersed or fragmented our families become, the cottage is the homing point to which we all

return. As the enduring family touchstone, it represents the way we wish life could always be. Held within its wooden walls are memories of sunny childhood summers, starry nights, and the kind of companionable gatherings that only happen on lamplit screened porches in the cool of a summer evening. What we hope to capture in this book, as much as the architecture and the interior design of a variety of summer homes, is that essential spirit of cottage life.

With this in mind, we visited summer cottages in Muskoka, Georgian Bay, the Kawarthas, the 1000 Islands and Lake Simcoe. We met cottagers who have poured vast amounts of money into their showcase places, and ones who are proudly hanging on as the fifth generation to summer at the family cottage, determined that nothing will change. Although vastly different in style and dimension, the common elements of these cottages are intriguing. They are all built on water and all have glorious views; they are all treasured as retreats from other lives; and they are all owned by people who say, "My cottage is where my heart is."

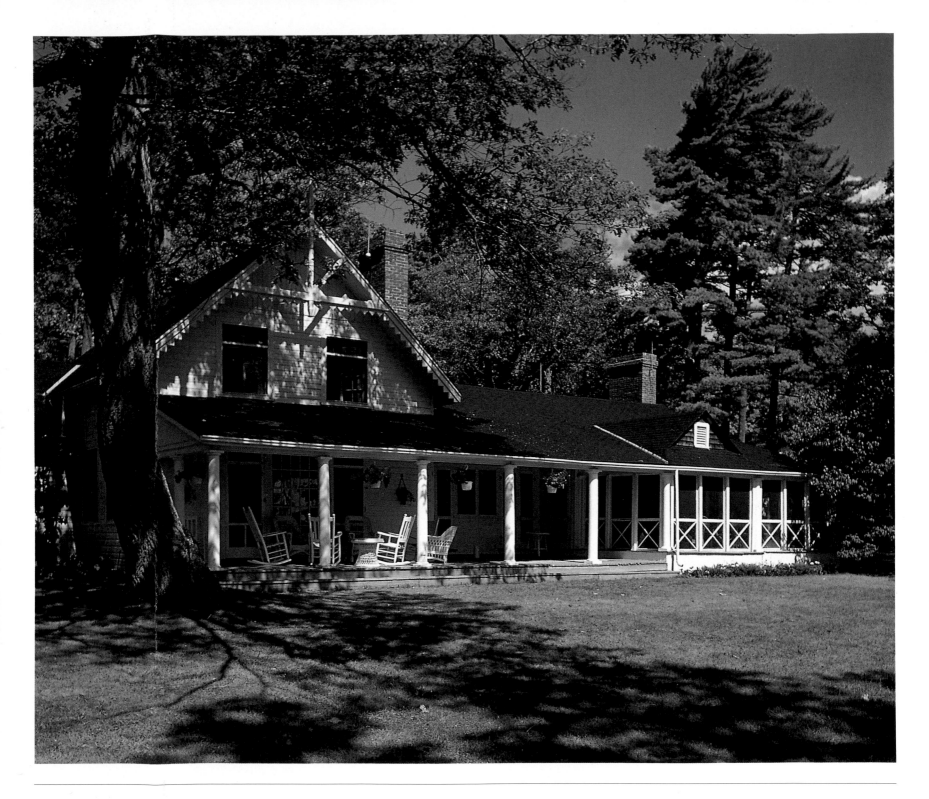

Set on expansive lawns amid towering oak and pine trees, summer homes along the lakefront road at Sturgeon Point were built by wealthy Lindsay industrialists in the 1920s. This summer resort in the Kawartha Lakes is actually a village with twisting lanes, picket fences and all the charm of an English hamlet. The allure is such that one cottager explained, "People with roots here come from all over to spend the summer here, and then later to be buried."

1

HOME AWAY FROM HOME

Whether tucked beneath a canopy of evergreens or jutting off a rocky promontory, these summer homes are focal points for family gatherings, places to languish on hot summer days. Whether grand or humble, new or old, they originated as rural escapes. Many date back to the 19th century, when cities were first perceived as unwholesome places and men of vision took their families to the ''pure, fresh air'' of the countryside for the summer. The concept of cottaging had begun.

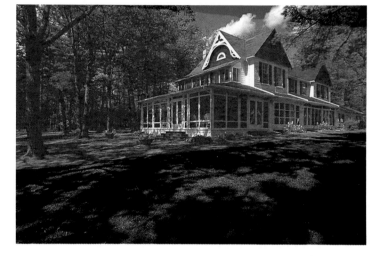

The varied style of these summer places is somewhat dictated by location. In Georgian Bay there's a weather-beaten solidity to the island cabins that withstand gale-force winds and long, shuttered winters. Decorative touches like flower planters and gingerbread trim would seem incongruous with this stark landscape. But in parts of Muskoka where the landscape is gentler, grandly designed cottages and boathouses loom along the lakeshore, their freshly painted facades vying for attention. Along Lakeshore Drive at Sturgeon Point, tourists come to ogle the immense summer homes that were built by wealthy industrialists in the early 1900s. And at Roche's Point on Lake Simcoe, gracious mansions are called cottages even though they have servant wings and separate carriage houses. But for most of us, the cottage is more in keeping with the dictionary definition, a ''small, simple house,'' a cozy nest to which we return summer after summer.

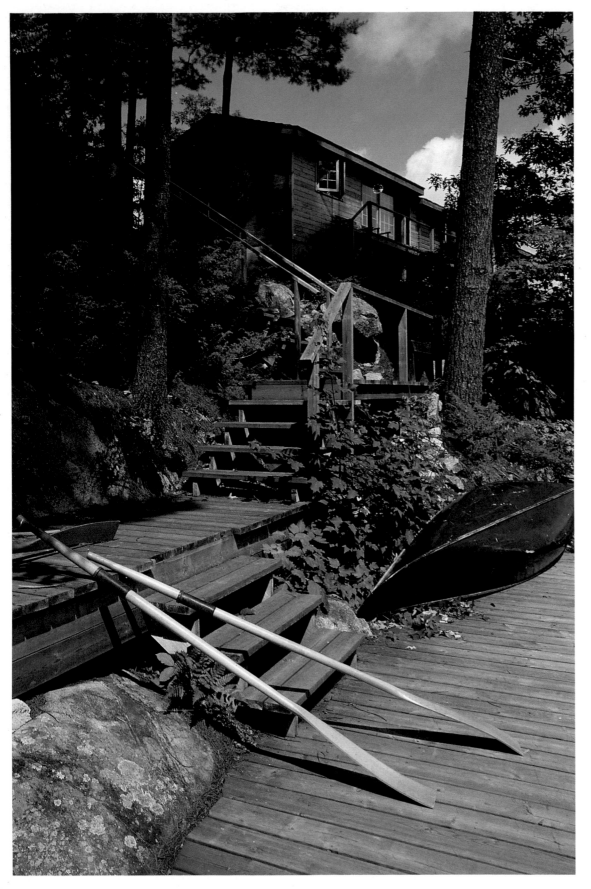

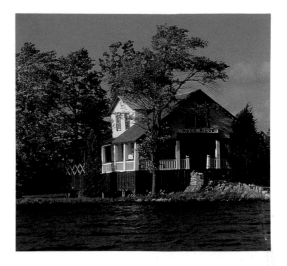

When the Trent Canal system was installed, the water on Stoney Lake rose by about seven feet, leaving islands like this one surrounded by shallow water, the submerged remainder of the land still visible just below the surface.

A cedar Panabode straddles the pink granite shoreline of Stoney Lake in the Kawarthas. Pine trees, sumac and juniper bushes sprout from rocky crevices, and the cottage commands a water view on all sides. "This place is the one material possession I feel strongly about," comments the proud owner.

"When we restored this place we used an old black and white postcard as our only reference," says the owner who restored this imposing Stoney Lake cottage to its original form. "Luckily we found a builder who was willing to go through the laborious process of replacing all the filigree, fretwork and turned posts on the double-decker porch." The widow's peak, with its original glass intact, floods the upstairs hallway with prisms of coloured light. At night, in days past, it was lit by hurricane lamp, a shining beacon for passing boats.

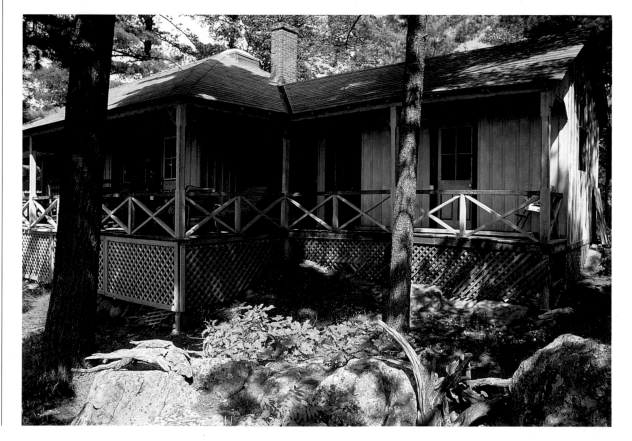

Windhaven, a weather-beaten cottage on a Stoney Lake island, has changed little since it was built in the late 1800s. It sat empty for periods of time, so neighbours dubbed it "the haunted house." Children still paddle by, expecting to see a ghost. Summer life here is elemental, with no plumbing or electricity. "We don't even have screens," laughs the cottage matriarch, "but the bats take care of the insects." The wonderfully symmetrical design includes separate sleeping wings joined by open breezeways under one roof.

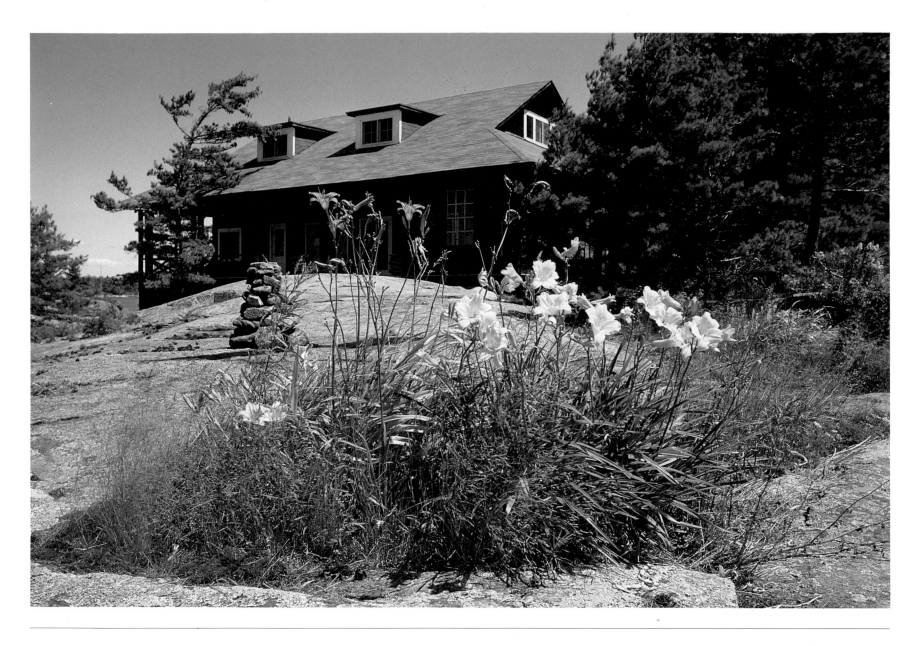

Lilies sprout from the Precambrian rock at Go Home Bay on the eastern edge of Georgian Bay. In this wind-swept region of twisted pines, bald rock and open water, the cottages evince a timeworn simplicity. This one, built in 1912, has been in the same family for three generations.

Proof of durability at another Go Home Bay cottage. These rock foundations haven't budged since the cottage was built in 1900.

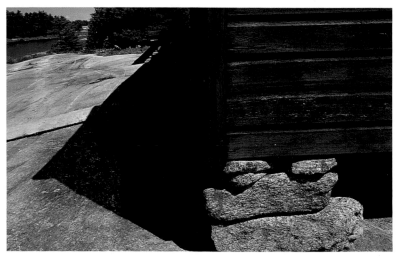

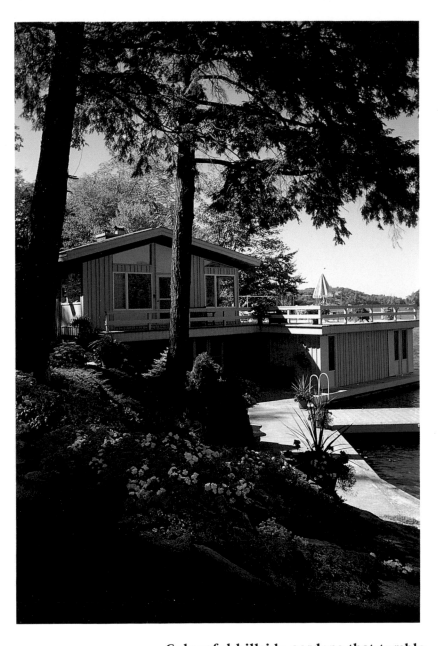

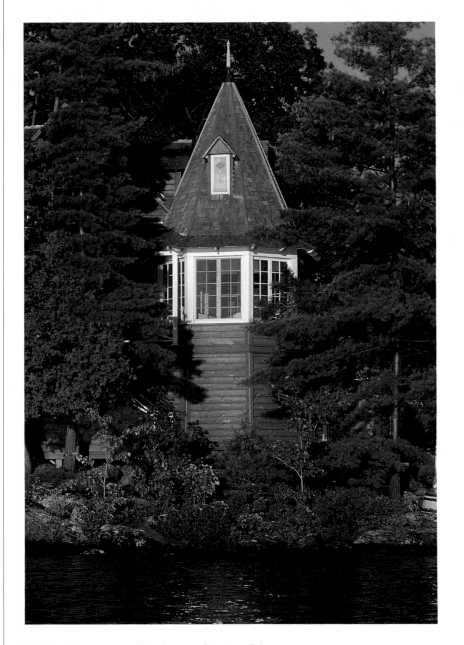

Colourful hillside gardens that tumble down to the lake form the backdrop for this Lake Joseph cottage and boathouse. "After the land was bulldozed to build the place, we had to do something," says the owner, who spent years in the nursery business, "so we began to make rock gardens and never stopped."

Tucked among tall pines, the Gothic tower of this Muskoka island cottage is all that can be seen from the water. Many of these vintage cottages are shrouded in trees, a reminder of their Victorian origin, a time when cottagers preferred a shaded veranda to a sunny deck.

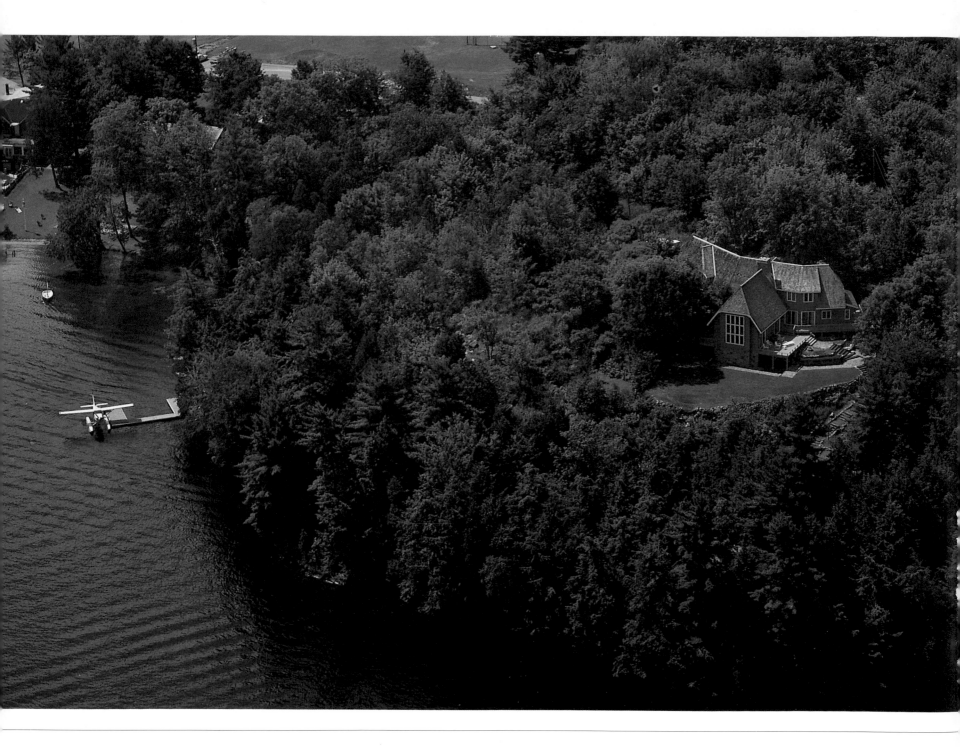

**Bird's-eye glimpses of lavish Muskoka
estates hint at a grand summer lifestyle.**

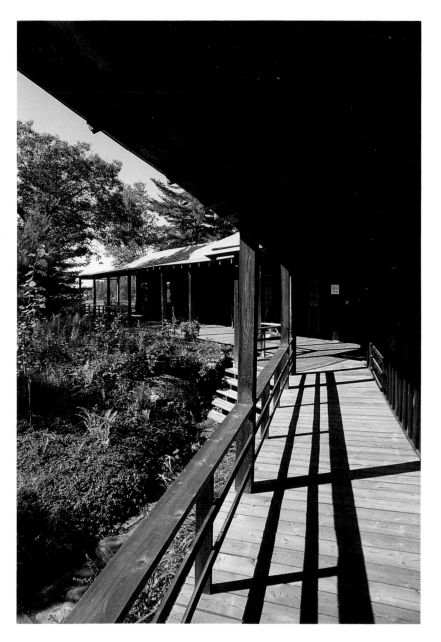 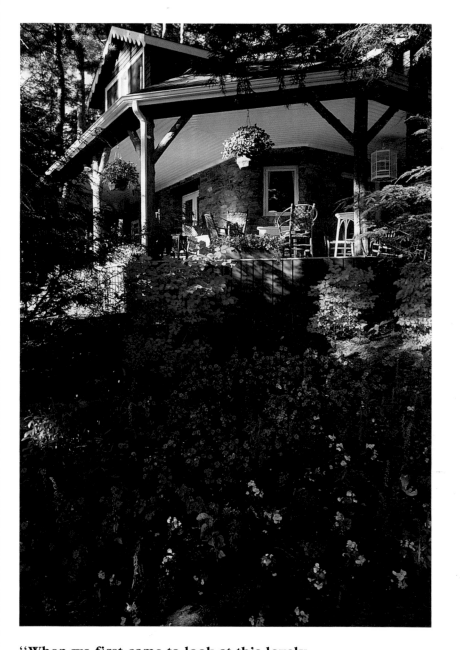

"A visiting architect called this the classic Muskoka cottage," says the owner of this Lake Rosseau family cottage built in 1882, "but what I love is the Oriental simplicity of the design. This is what makes it so private and peaceful." Wraparound verandas and separate sleeping quarters are linked by a common roof.

"When we first came to look at this lovely island with its gingerbread-trimmed cottage, it was a drizzly grey day and everything looked rather forlorn," recalls the owner of this Lake Joseph island. "But there was a Hansel and Gretel quality to the place that appealed to me, and I couldn't help but think that it would be wonderful on a sunny day." The antique hickory chairs on the open veranda enhance its storybook appeal.

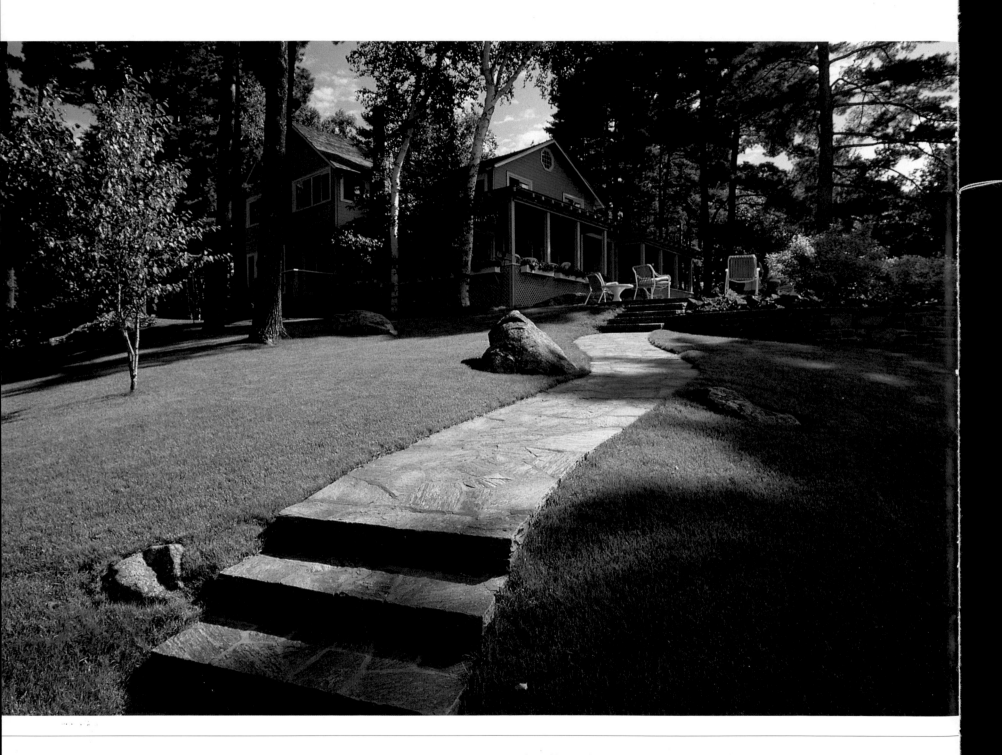

Neatly clipped grass, flagstone paths and luxuriant flower gardens at On The Rocks, one of the island showplaces near Beaumaris on Lake Muskoka.

Two log cabins from the Ottawa Valley were dismantled and brought to this Muskoka lakefront property to be reassembled. Joining the two cabins is a barnwood addition that houses the kitchen, back hallway and second-storey bedrooms. One cabin is now the dining and family room, with a master bedroom tucked under the eaves; the second cabin is a double-height living room with gabled windows in the roof.

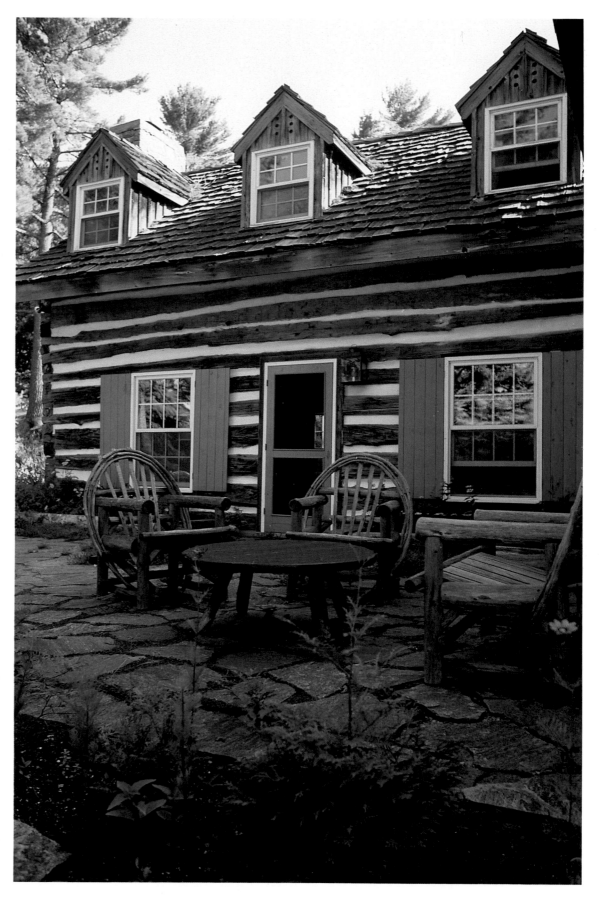

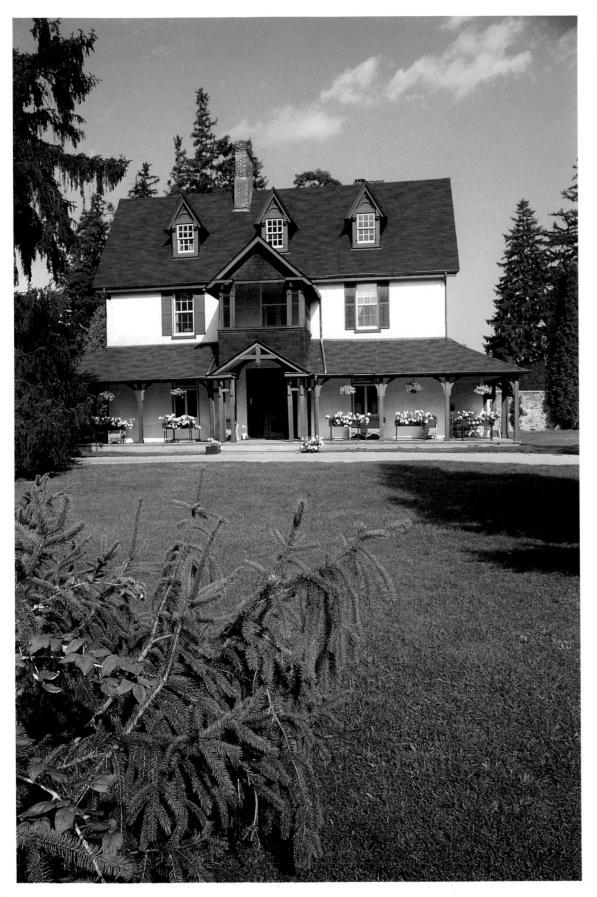

This gracious estate, at Roche's Point on the southern shore of Lake Simcoe, was built in 1860 by A.G.P. Dodge, a New Yorker known as the lumber king of the North. At the time he wrote: "I hope to see the day when the many pretty points jutting your beautiful lake will be occupied by the mansions of the merchant princes of Toronto." Dodge hired Frederick Law Olmsted, the famed landscape architect who designed New York's Central Park, to lay out the gardens. Dodge's stay here was brief, however, and his summer mansion became a hotel and then sold in 1885 to a Toronto industrialist. Today, the fifth generation of this family still summers here. "We are so bound by tradition at this cottage," comments the current owner, "that I don't dare even change the colour of the petunias in the porch planters. They've always been white, and probably always will be."

This Lake Joseph cottage grips the rocky landscape as if grafted to the property. Designed by Toronto architect Keith Wagland, a post-and-beam specialist, the house spreads across an outcropping of sharp-edged rock which rises 20 feet above lake level. "We didn't want it to look like a pea on a pumpkin," says the owner, "so it took a long time to come up with the right architect and the right design."

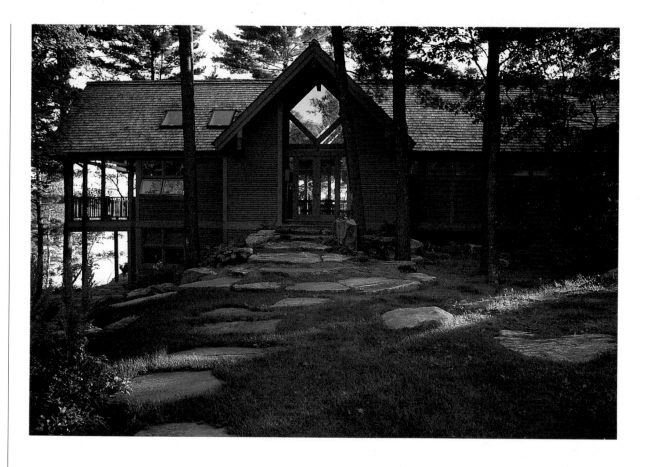

Early morning sunlight casts long shadows at this vintage stone-pillared cottage with its uniquely curving roof lines. Flagstone walks edged with flowers meander down to the boathouse on the rocky shore of Lake Joseph. The 1910 design delights its current owners, who still have the original architect's blueprints showing the bedrooms laid out in curving wings, their windows and sleeping porches facing the lake. "We think it's the perfect plan for a family cottage," say the owners, parents of five sons. "So many of the old architectural features, like built-in wood boxes beside the fireplace which can be accessed from outside, tin-lined rooms for storing linen, and back staircases, are still practical for today's cottage life."

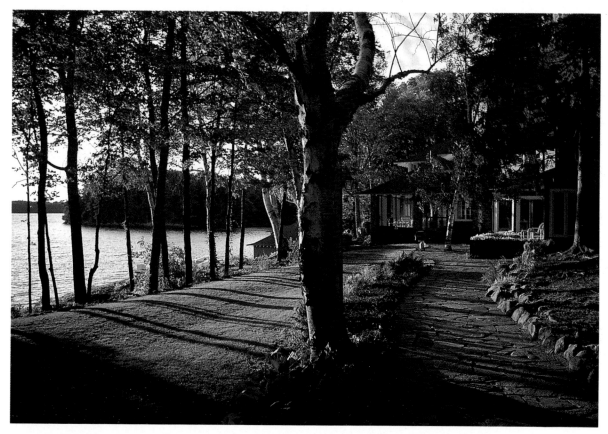

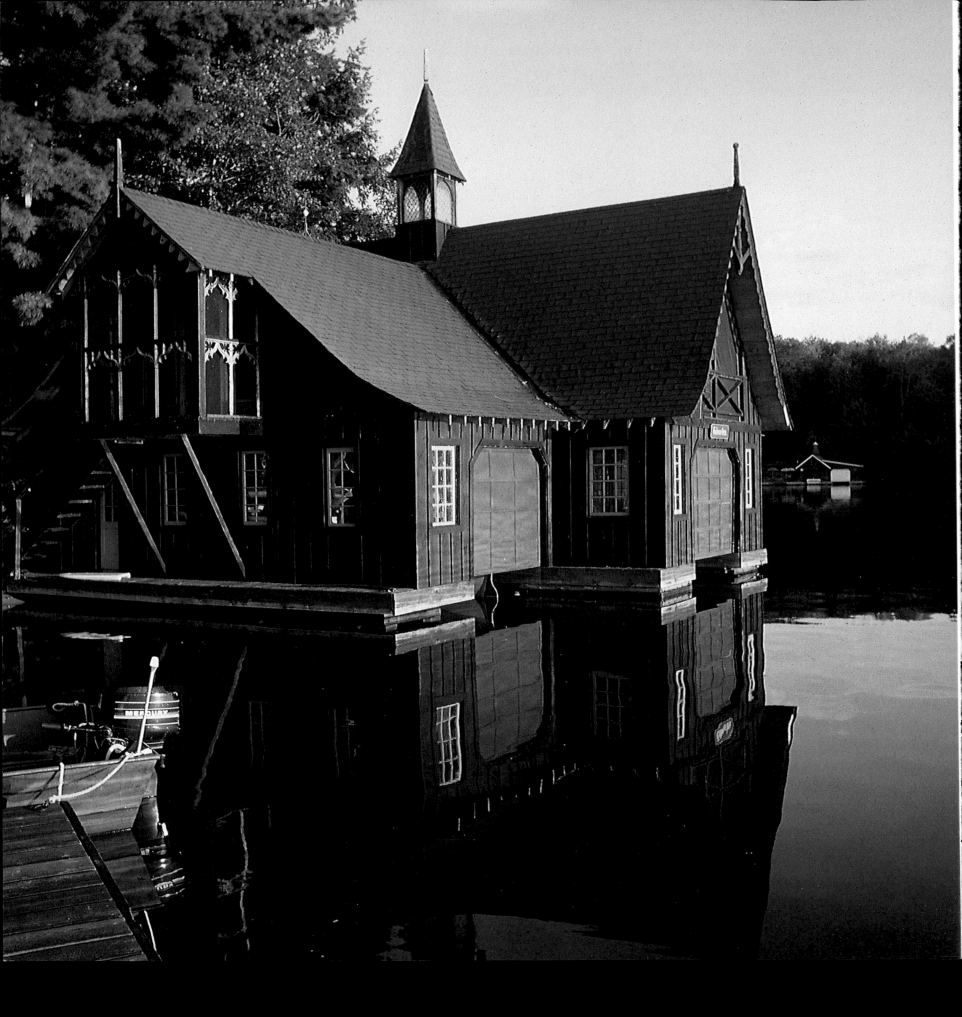

BOATHOUSES IN MUSKOKA

The shorelines of lakes Muskoka, Rosseau and Joseph offer beguiling glimpses of a variety of boathouse styles. Some of these grand old buildings date back to the late 1800s, when wealthy families needed such structures to shelter their private steam yachts. Later, with the advent of gas engines and the mahogany launch, boathouses grew to include as many as eight slips, with

expansive living quarters above. Sprouting around the lakes today are such remarkable reproductions of these buildings that it's sometimes difficult to distinguish the old from the new.

Inside, bobbing majestically in their slips, are beautiful watercraft, the legacies of Muskoka's fine boatbuilders. Back in the 1930s Muskoka was known as the custom boat-building capital of North America, and builders like Duke, Greavette, Minett and Ditchburn handcrafted dazzling launches using the finest mahogany, leather and chrome. Many such boats still ply the lakes, ideal occupants of these elegant shoreline boathouses. Boathouse exteriors range in architectural influence from Victorian lavishness, with gables, turrets and balustrades, to Shaker simplicity, with clean lines and board-and-batten siding, and nearly all have window boxes spilling over with summer blossoms. While the maintenance of these old treasures has become an increasing challenge, their survival is testament to the skill of their original builders.

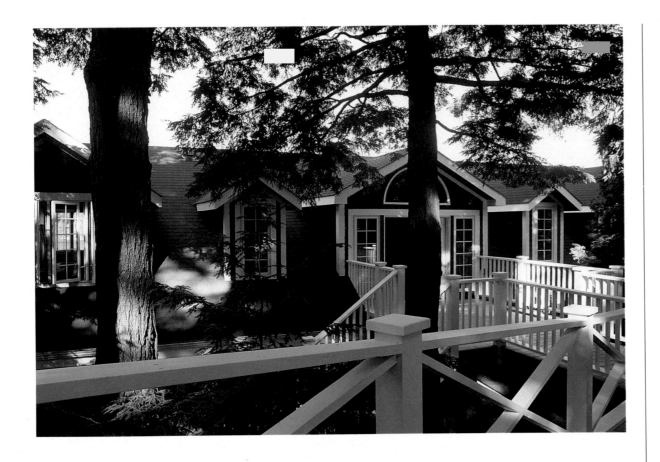

This multi-slip boathouse, a replica of the old Muskoka style, spreads across the shore of Lake Joseph. With this addition the sleeping capacity on this family island increases to 21 beds. ''We call it our summer hotel,'' laughs the owner, who lives in Switzerland and uses this summer home to entertain friends and family from around the world.

A steeply pitched cedar-shake roof and board-and-batten siding in soft taupe blend naturally into the Lake Joseph shoreline. Spectacular flower boxes add splashes of colour. The cottage and boathouse are nestled in a secluded bay that's peaceful and ''so private,'' says the owner, ''that we never wear bathing suits.''

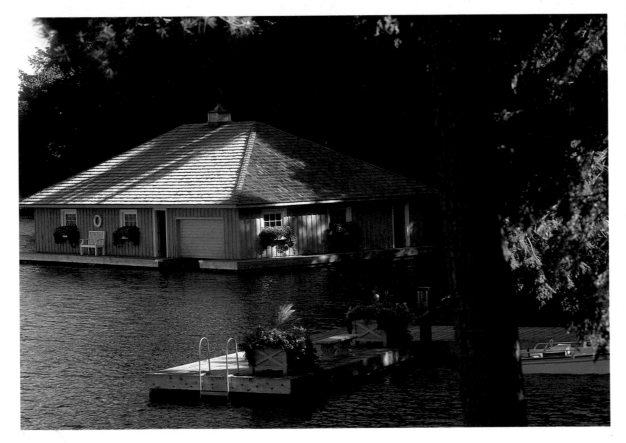

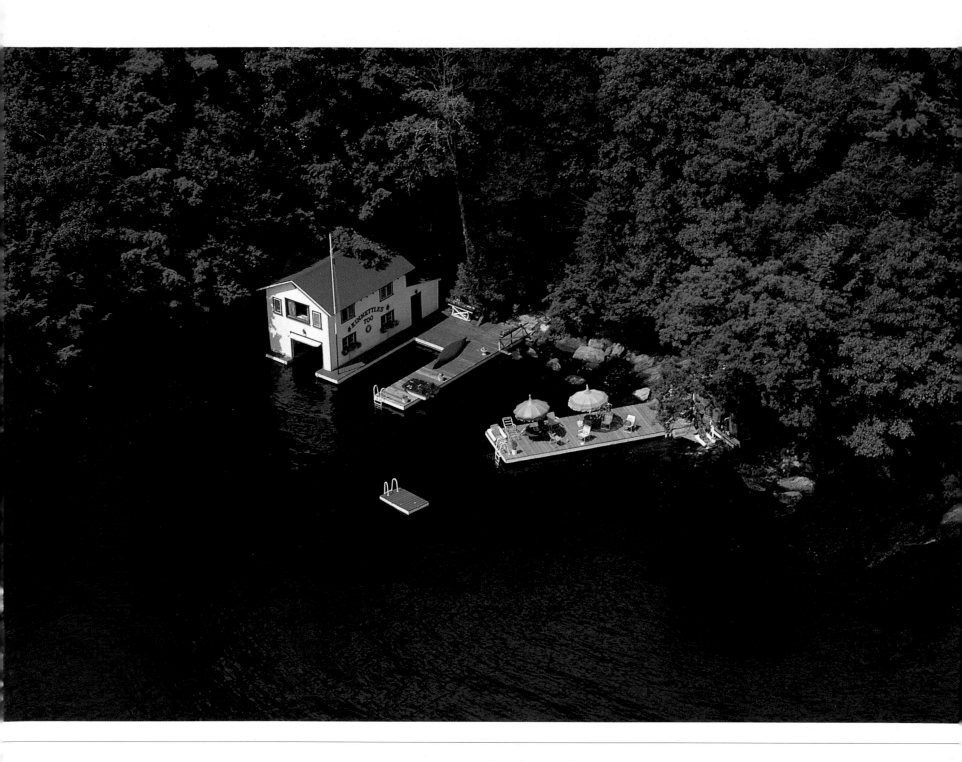

Daytime activity centres around the boathouse on hot summer days.

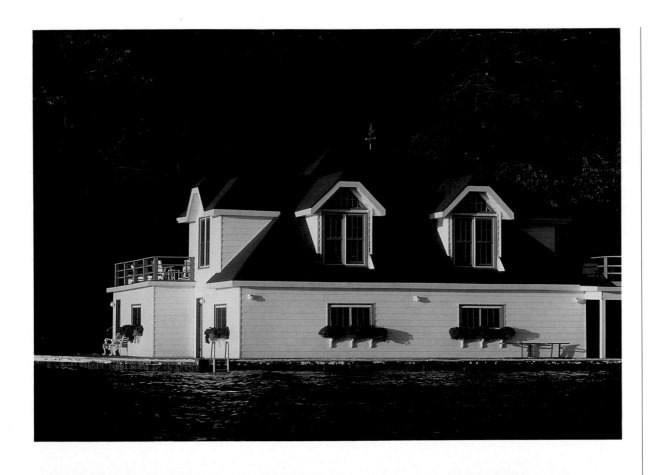

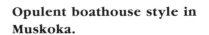

Opulent boathouse style in Muskoka.

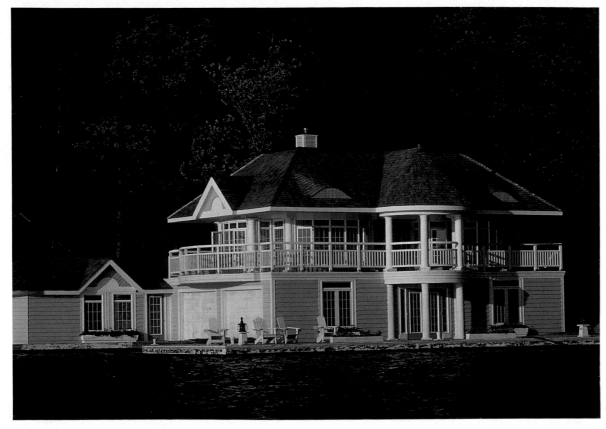

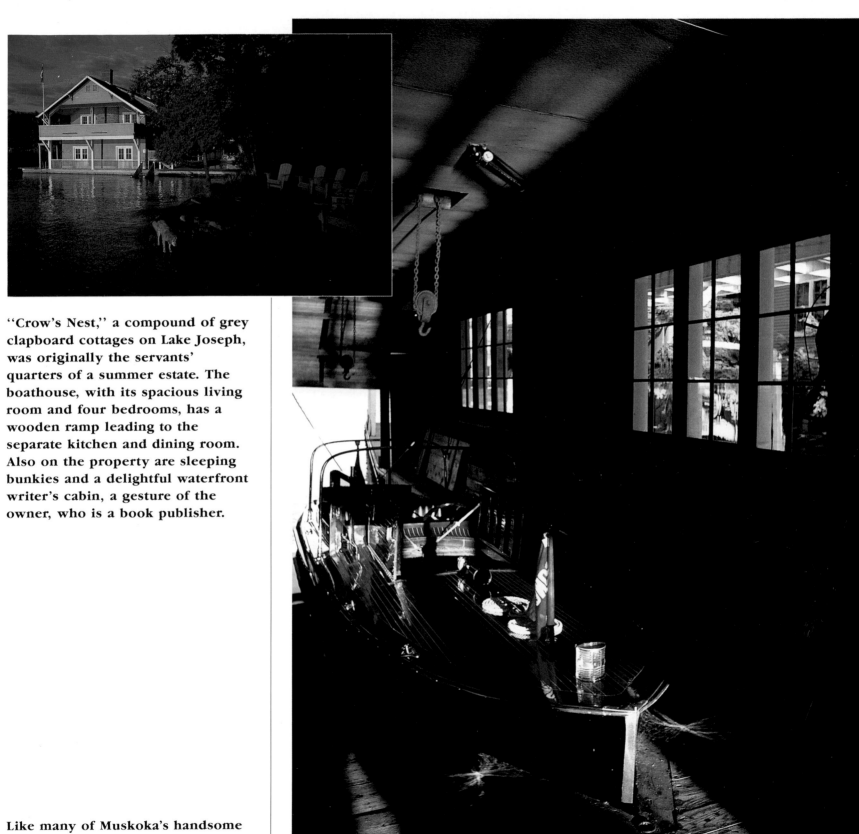

"Crow's Nest," a compound of grey clapboard cottages on Lake Joseph, was originally the servants' quarters of a summer estate. The boathouse, with its spacious living room and four bedrooms, has a wooden ramp leading to the separate kitchen and dining room. Also on the property are sleeping bunkies and a delightful waterfront writer's cabin, a gesture of the owner, who is a book publisher.

Like many of Muskoka's handsome boathouses, "Crow's Nest" shelters an equally handsome antique mahogany launch.

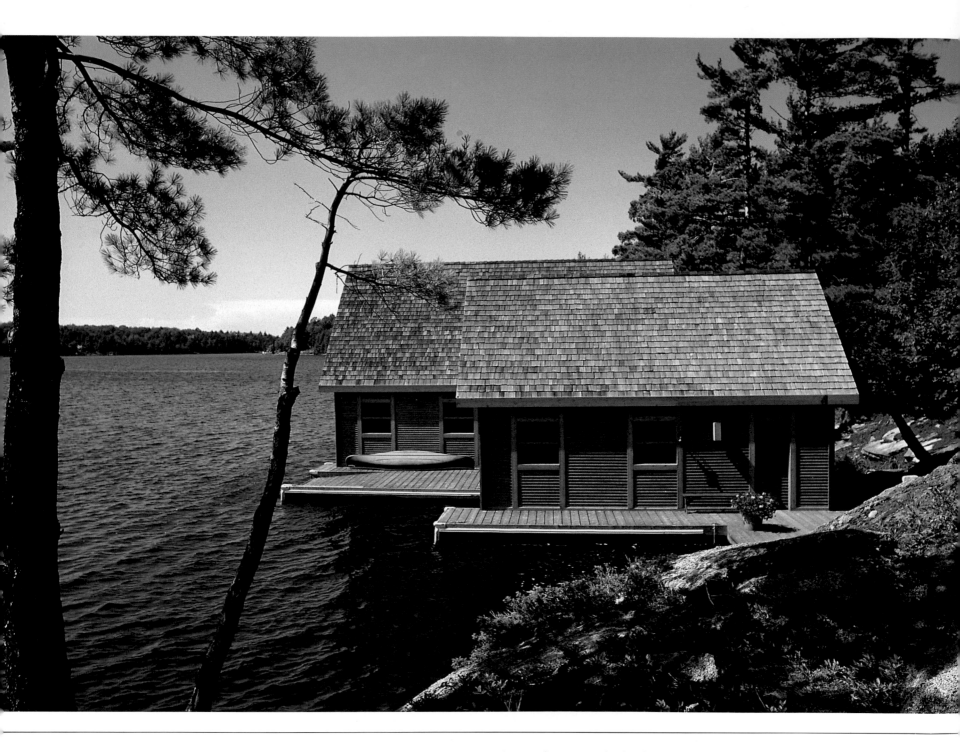

A spacious Muskoka boathouse looks less massive because it was designed to look like two smaller ones, one set back from the other.

3

LIVING ABOVE THE BOATS

Despite romantic notions about living upstairs in a boathouse, the second floors of most old Muskoka boathouses were originally spartan staff quarters intended for the family servants. If the staff was housed elsewhere, then the space served a more exotic function, such as a ballroom in the big-band heyday of the twenties, or a ball-hockey floor when dancing went out of fashion. But, like

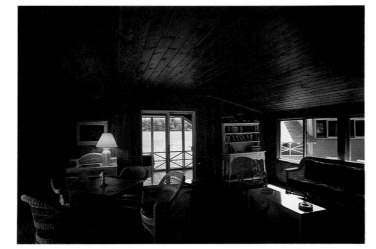

forgotten attics in city homes, these quarters are now being reborn, swept clean of cobwebs, and restored to their cozy gabled origins.

In some of the more grand boathouses, the upper storey has more square footage than an average cottage. Woodmere, a sprawling grey clapboard boathouse on Lake Rosseau, was built in 1897. In the upper level is a sitting room with stone fireplace, a bathroom, four ample bedrooms and a delightful south-facing screened porch. And at Sunset Island, on Lake Joseph, the massive new boathouse needed 15 under-water cribs for support and took four years to build. "We built our boathouse to use the upstairs as guest quarters," claimed one Muskoka cottager, "but when it was finished, we loved it so much we moved into it ourselves." Others plan the boathouse for the older children, but when the time comes, they retreat there themselves. Boat-house dwellers speak wistfully of the lulling quality of life above the water, the shiplike sensation and the wonderful sunset views.

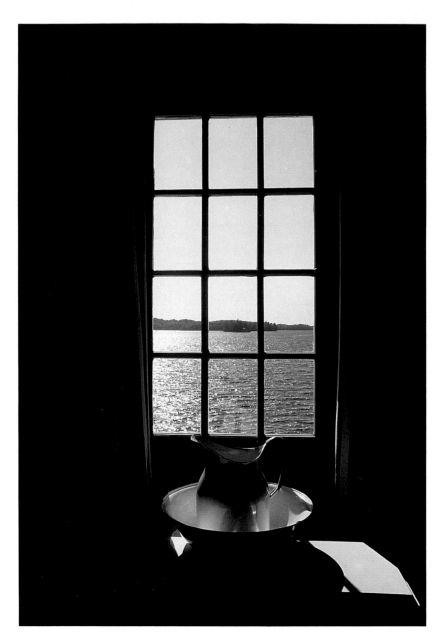

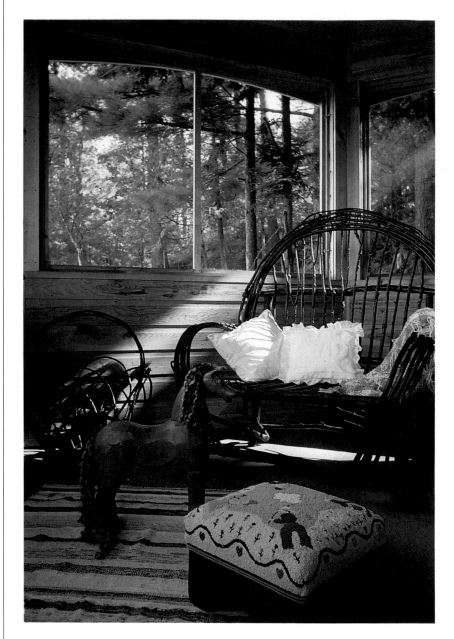

A vast stretch of Lake Joseph sparkles outside the bedroom window of this boathouse.

Pine-scented breezes waft through the screens of this porch tucked under the turret roof of a newly built canoe house. Some of the twig furniture was made by the owner, and the colourful hooked footstool was a country auction find. An adjoining bedroom is a favourite hideaway overlooking Lake Muskoka.

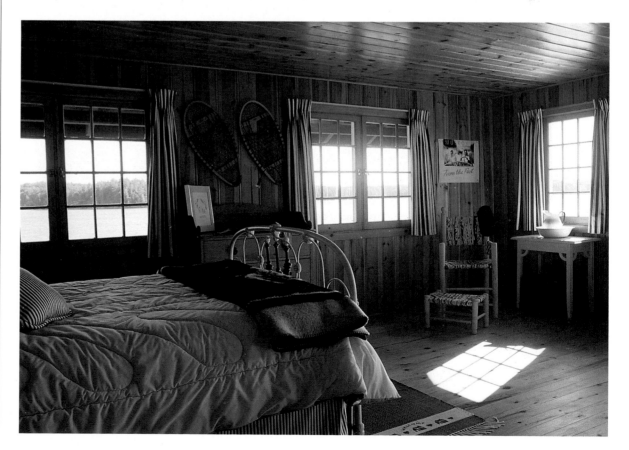

Several coats of glossy white paint are all that's required in this vintage boathouse bedroom with its interesting gables and sloping ceilings. A serene setting for a lazy summer afternoon.

Sun pours into this boathouse bedroom, the perfect private retreat for a college student. An antique iron bed and red, white and blue colours complete the nautical scheme in this warm pine-panelled room.

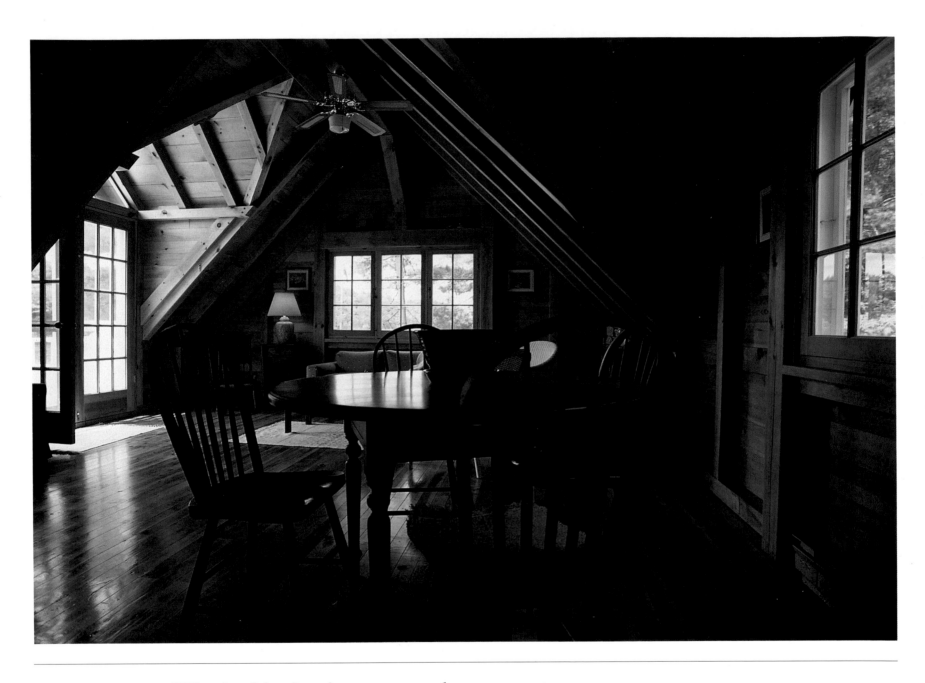

Milk-painted furniture in sage green and
warm pine floors create a mellow mood
in this boathouse near Milford Bay. Built
in the traditional post-and-beam style, it
blends perfectly with the vintage
cottage up the hill.

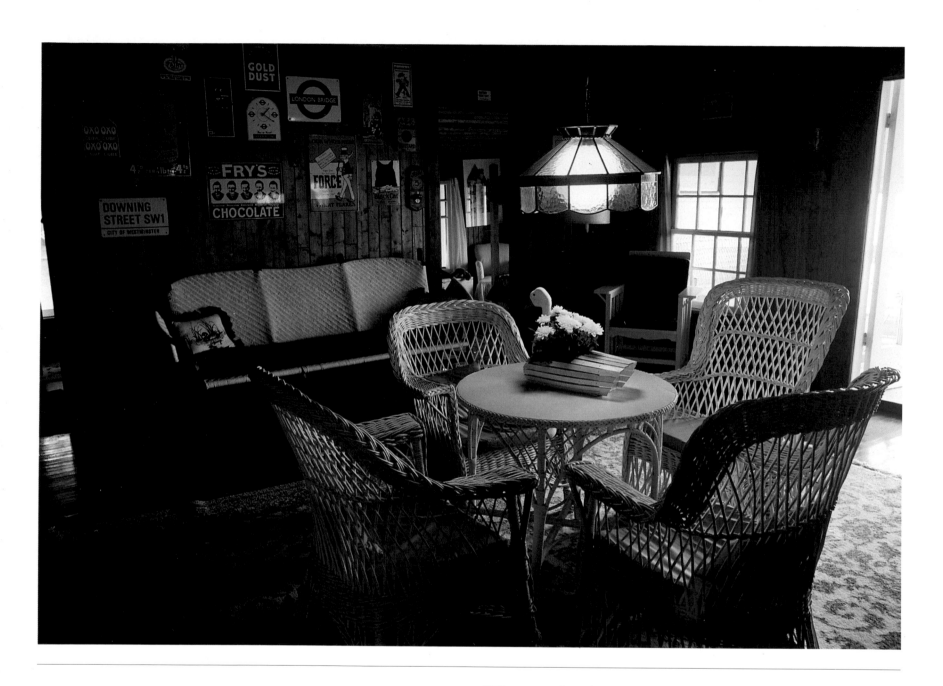

"We wanted a place where our kids and their kids would want to gather in the summer," says the man who recently bought this sprawling island in Lake Rosseau. Of the 14 buildings in the compound, this boathouse, built in 1897, is the oldest. Its three bedrooms, bathroom, sitting room and screened porch provide a tranquil haven for weekend guests.

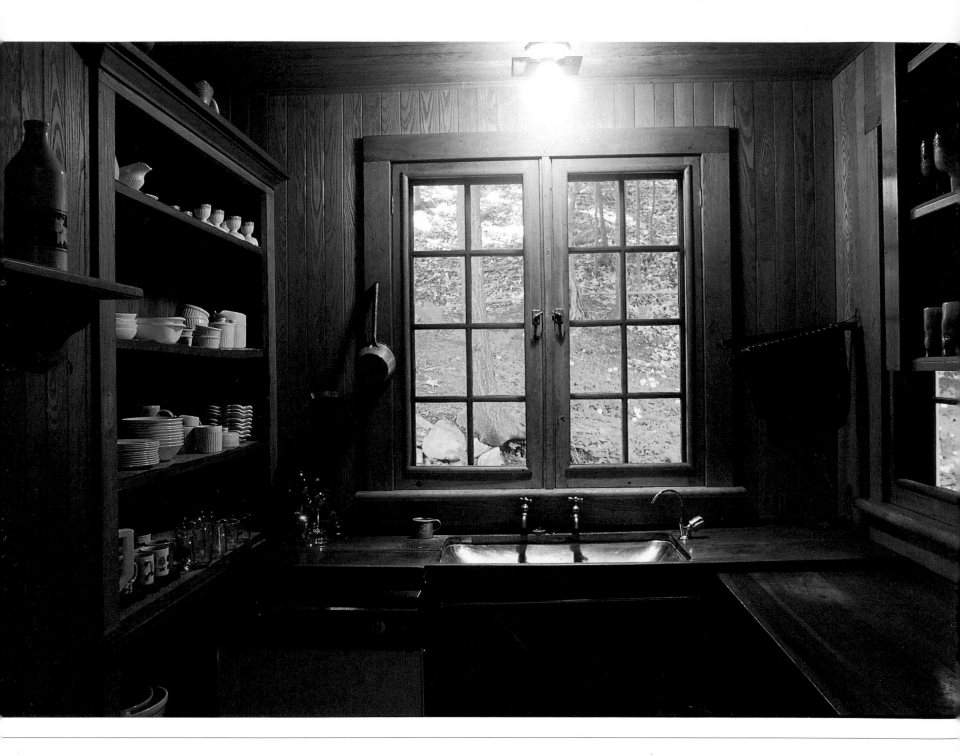

What every country house needs is a
walk-in pantry with loads of shelves for
tableware and crockery. Here, the old
kitchen blends the charm of the old with
the convenience of the new. The cupboards
and wooden counters are turn-of-the-
century, the dishwasher is new.

THE COOK'S DOMAIN

If the cook in charge considers summertime an opportunity to create imaginative meals, the kitchen will likely be a cheerful room with everything in its place — homemade jams and pickles on pantry shelves, freshly picked vegetables in quart baskets, herb pots on a window sill, and the warm odour of coffee cake baking in the oven. On the other hand, if the cook prefers to spend

time down at the dock, the kitchen may operate as a kind of haphazard take-out restaurant where the only rule is "close the refrigerator door."

Either way, in most cottages the kitchen tends to be the hub. Keeping outdoor appetites satisfied and the larder filled are ongoing tasks. In contemporary open-plan kitchens, the cook can stir the stew and still take part in family games. But in old back-of-the-house kitchens, where propane powers the appliances and a hand pump draws water from the lake, keeping things the way they always were is more important. As one cook explained while removing hot loaves of oatmeal bread from her wood-stove, "I don't want to hear the whir of a food processor or the dinging of a microwave oven at my cottage. I like the quiet of an old-fashioned kitchen."

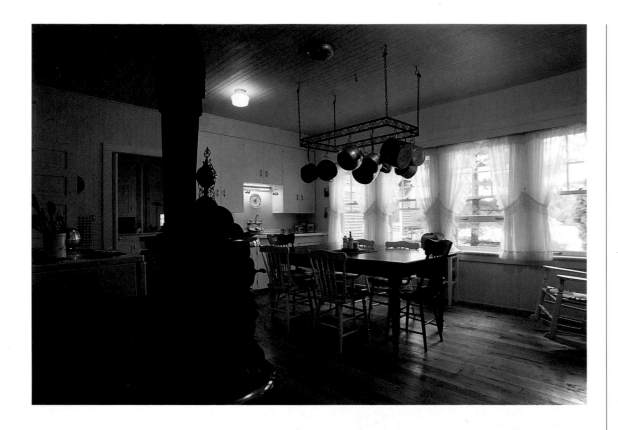

Typical of the extravagant cottages built at Beaumaris in the early 1900s, this one has 13 bedrooms, 5 fireplaces and a ballroom in the boathouse. The cavernous kitchen was designed for the bevy of servants employed by the original American owners. It still evokes an aura of early cottage life with gauze curtains blowing in the breeze, a blackened wood stove and the pine-plank floor swept clean as a whistle.

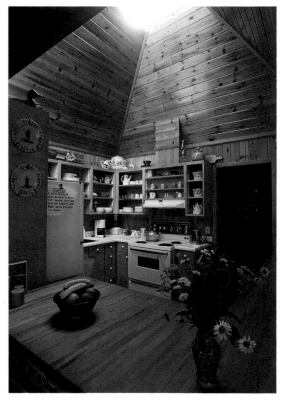

"My husband and I both noticed this house plan in the newspaper by coincidence," says the owner of this compact Muskoka cottage. "We liked the simplicity and the central location of the kitchen. A skylight in the peak of the domed roof bathes the pine kitchen in sunshine and wooden counters open to the living and dining areas."

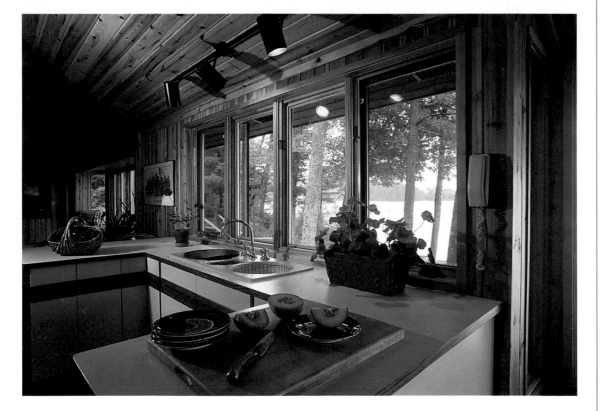

A sparkling water view keeps the cook happy in this cheery pine kitchen overlooking Lake Muskoka. "I never mind being in the kitchen," she says, "because I feel as if I'm outdoors."

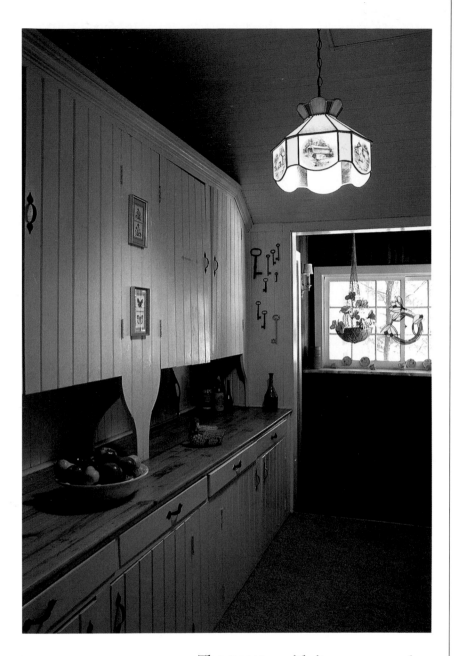

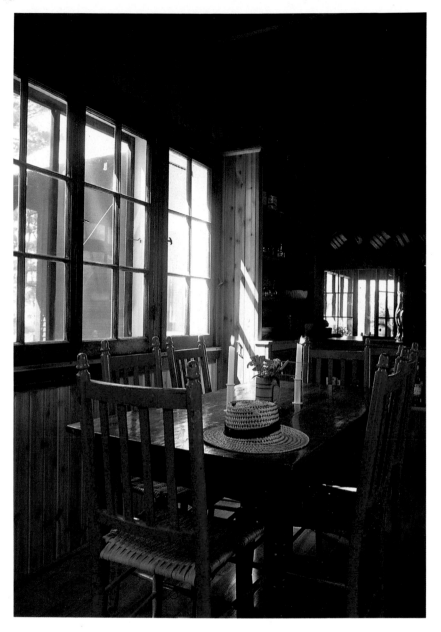

The pantry, with its worn wooden counters, used to be the servants' domain, but now it's a place where teenagers rummage for something to eat. The children are the fifth generation to summer in this rambling home, one of the oldest in Sturgeon Point.

"We never wanted to change anything here," explains the woman who summers in this Georgian Bay cottage, "but the kitchen was so dark we added a skylight and new door to the back porch to bring in needed light." The third generation of this family now gather around the worn pine table for simple island meals.

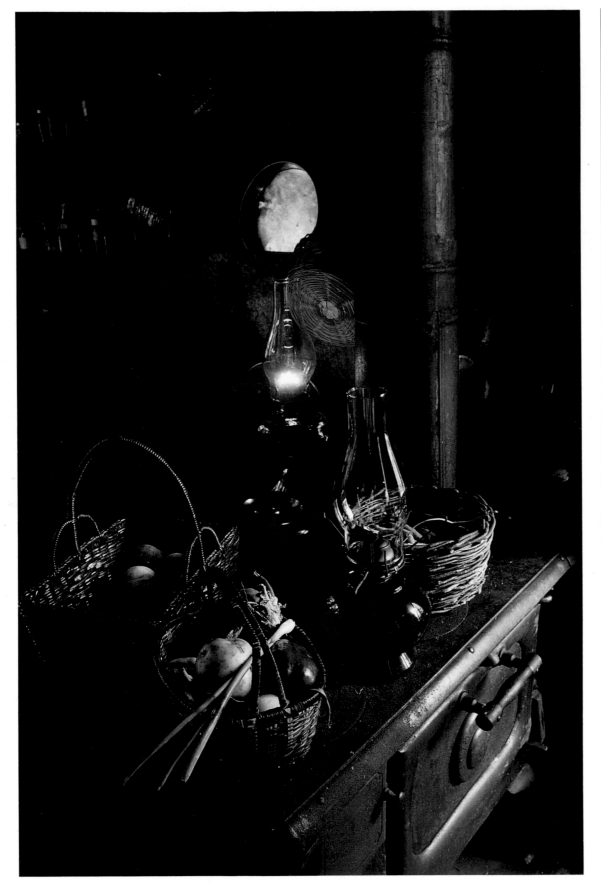

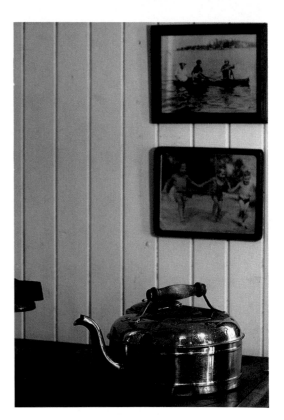

Time stands still in age-old cottage kitchens.

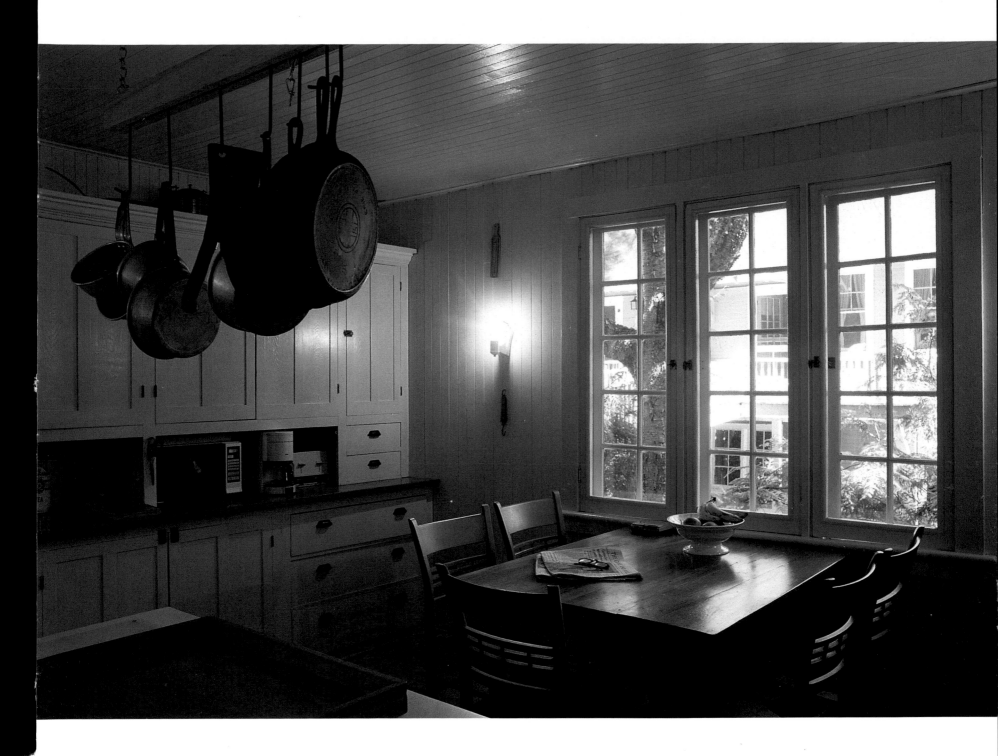

In this old cottage, the kitchen, pantry, summer porch and dining room are housed in one building. A ramp links them with the boathouse (seen through the window), which has a living room and bedrooms in the upper storey.

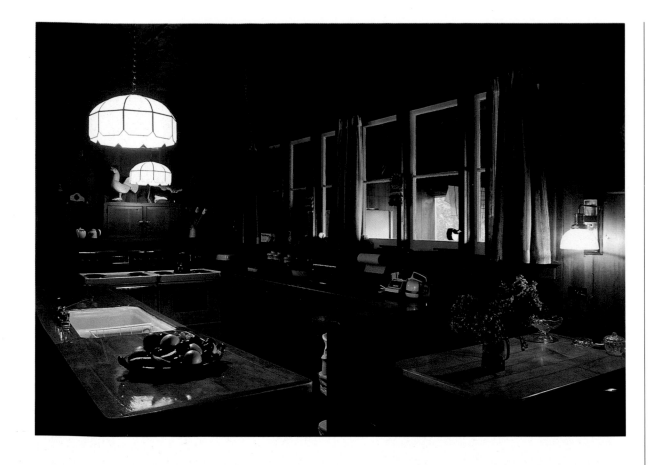

Called "the lodge," this immense log building is part of an island compound of cottages. In addition to this kitchen, the lodge houses an eating area with two 10-foot-long tables and a sitting room with a stone fireplace. Rivalling a hotel kitchen in size, there's a walk-in freezer, a cold room, separate pantries and an eating porch, formerly the staff dining area. A large extended family gather here on weekends for breakfast and dinner — "but never for lunch," adds the mother of the clan.

A vintage 1000 Island cottage kitchen where, in the past, servants stoked the wood-stove and baked the bread. Today everyone pitches in for easy summer entertaining.

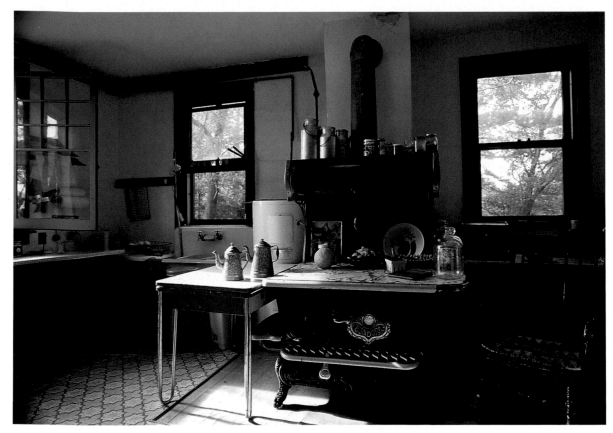

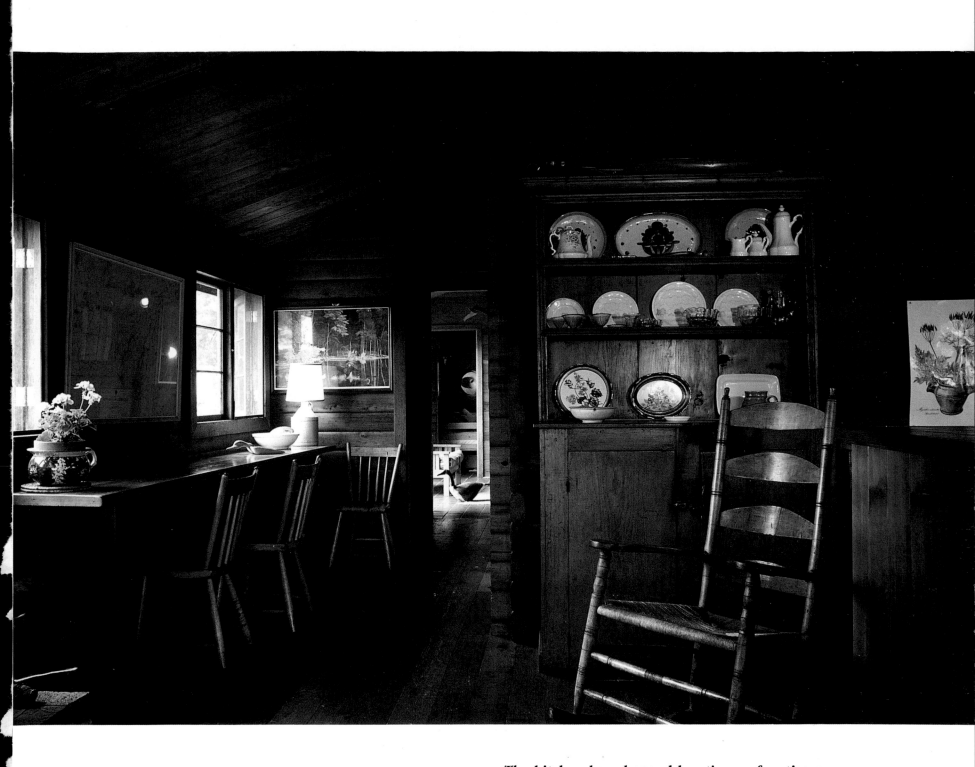

The kitchen has changed locations a few times in this cedar cottage on Stoney Lake. "We keep adding and shifting rooms around," says the handyman owner who putters about with tools in hand. "I'm always looking for things to do around here, but I've almost run out of rational additions."

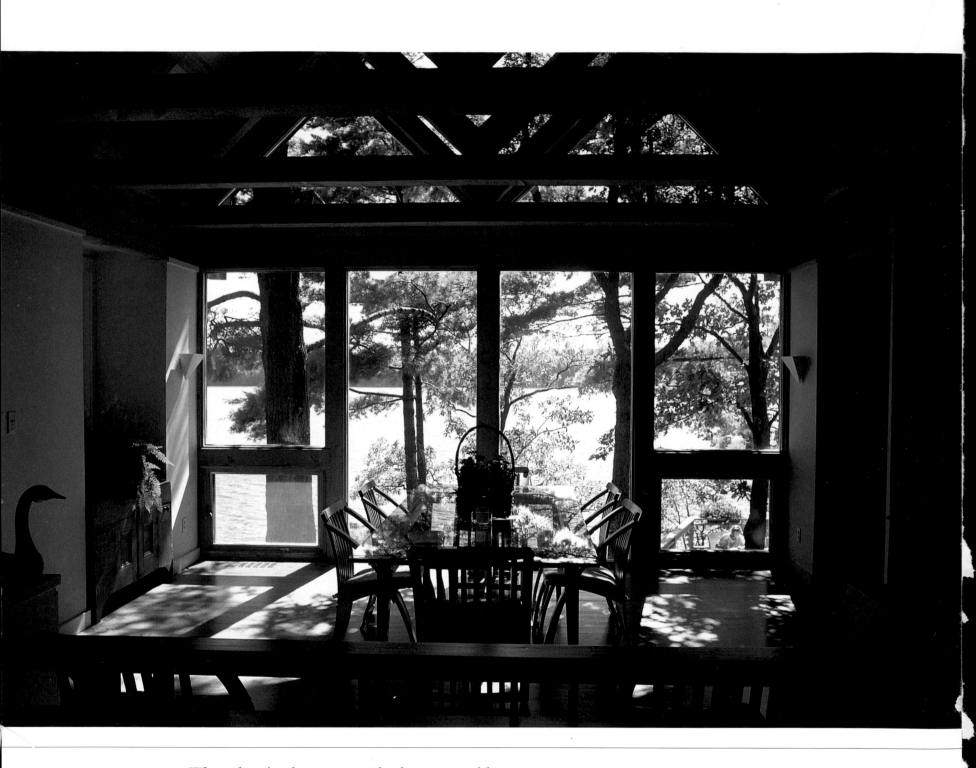

When there's plenty to startle the eye outside,
simplicity is welcomed inside. "I wanted something
serene and uncomplicated," says the owner of this
architect-designed cottage on Lake Joseph. In this
airy dining room, walls of glass open to the lake view.
"I love it here in the late afternoon," she adds,
"when sunlight dapples the floor."

TABLES FOR TWELVE OR MORE

A cottage dining table can never be too large. No matter how small the cottage, a great big table is needed when feeding hordes of weekend guests or playing board games on rainy days. It's the boisterous gatherings at these large tables that breed some of our best cottage memories. At one Georgian Bay cottage, the oversized dining table converts to a ping-pong table when the meal is finished. "It's sort of an all-purpose piece of furniture," quips the cottage owner.

A common element in vintage cottage dining rooms is the huge stone fireplace, one of several that warmed the high-ceilinged rooms of unheated summer mansions. In the early days the adults would be served meals at the fireside main dining table, while the children sat at a separate nursery table.

In Muskoka, most dining-room furniture was sturdy mission oak that boatbuilders churned out in the off-season. It proved so durable that most of it is still in use. At more formal cottages on Lake Simcoe and in the 1000 Islands, English mahogany tables and silver tea services grace the dining halls. While at Georgian Bay tables, there's the scent of sweet grass from the Indian-made placemats and napkin rings. At one Pointe au Baril cottage the owners hired an artist to paint their old wooden dining-room chairs, using primary colours in a different (and significant) design for each member of the family.

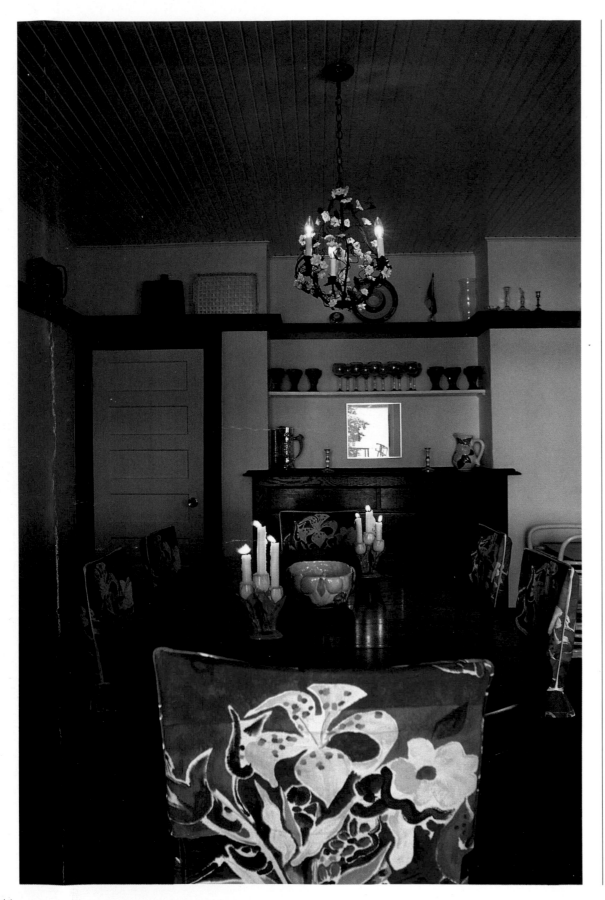

The oak table which seats 12 came with this 1906 cottage, as did most of the furniture. To brighten the room, the owner chose to paint the dark wood panelling white and cover the chairs with a cheerful cotton print. The chandelier, candelabras and pottery are all from Italy.

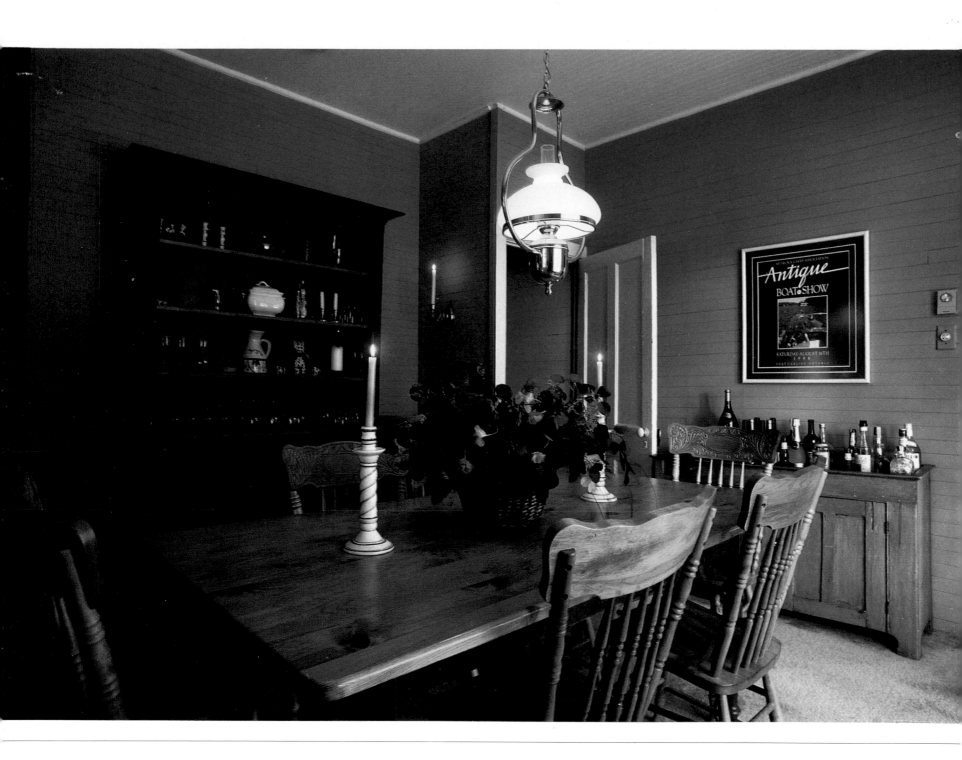

A well-stocked bar in the pine dry sink,
comfortable press-back chairs, candlelight,
wine, good food and a heart-melting view
of Lake Muskoka. Can summer dining
get any better?

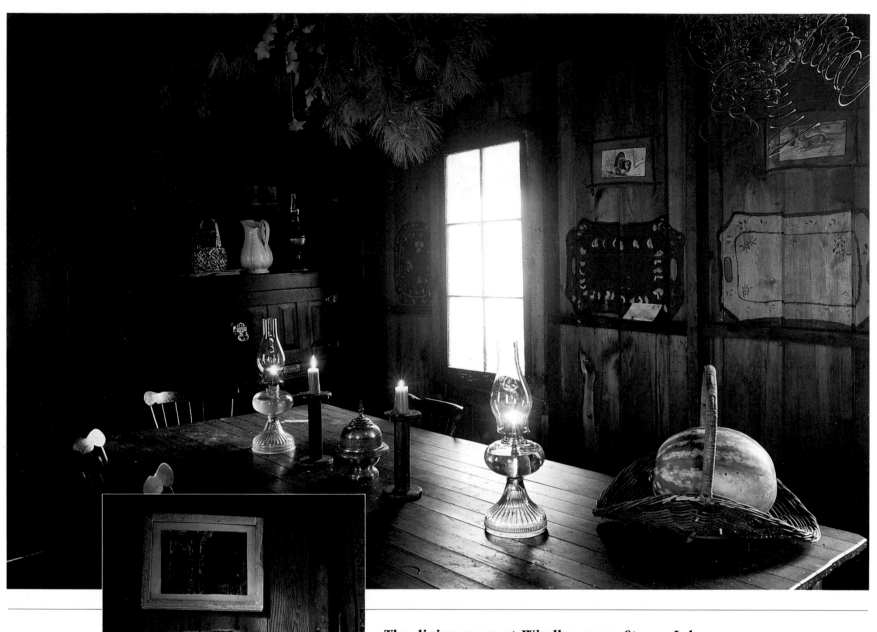

The dining room at Windhaven on Stoney Lake, awash in the golden light of candles and coal oil. Eccentric touches abound. Hanging over the table (made from floorboards) is a cluster of rusty bedsprings, and all around the room above the wall ledge is a collection of handpainted trays. Both have been there for decades. "I like the idea of living here just as it was," says the owner. "I don't believe in changing things."

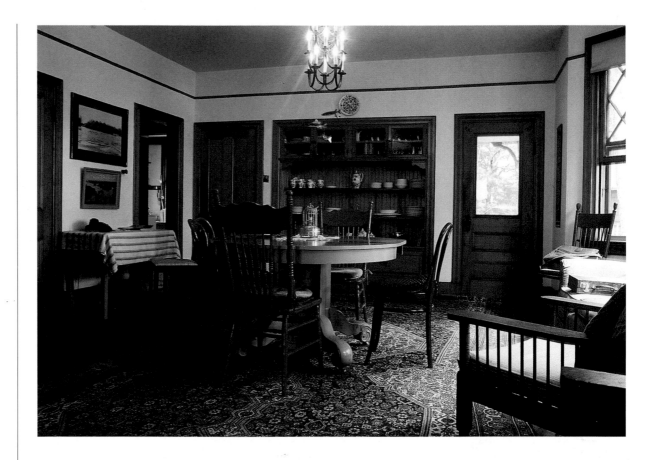

Doors and windows open to the refreshing breezes of the St. Lawrence River in this colourful dining room. Perched high above the river, this 1000 Islands cottage dates back to 1896.

The original windows in this Muskoka cottage dining room were all small and high, like the one at the end of the room. "You couldn't see out the windows when you sat at the dining-room table," explains the owner, "so we replaced them with French doors that face the lake."

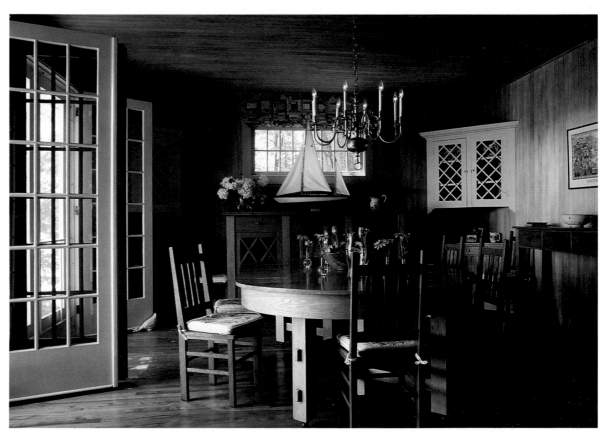

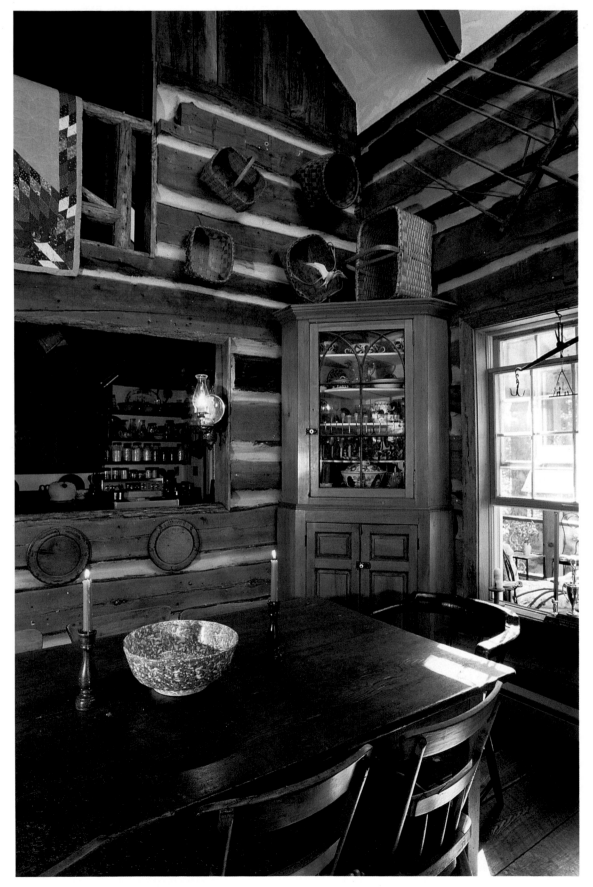

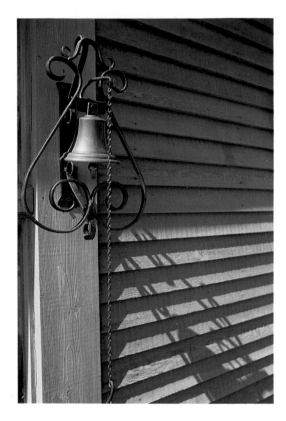

A dinner bell on the boathouse calls one and all to meals.

A passing window to the kitchen was carved through the original outside wall of the log cabin which became this Muskoka cottage. Hanging from the second-storey balustrade is a handmade quilt. Farm tools, Indian baskets and country china fill other nooks and crannies in this antique collector's summer home. "I constantly move things around," admits the owner, an inveterate collector, "and I often buy something without the faintest idea of what I'm going to do with it."

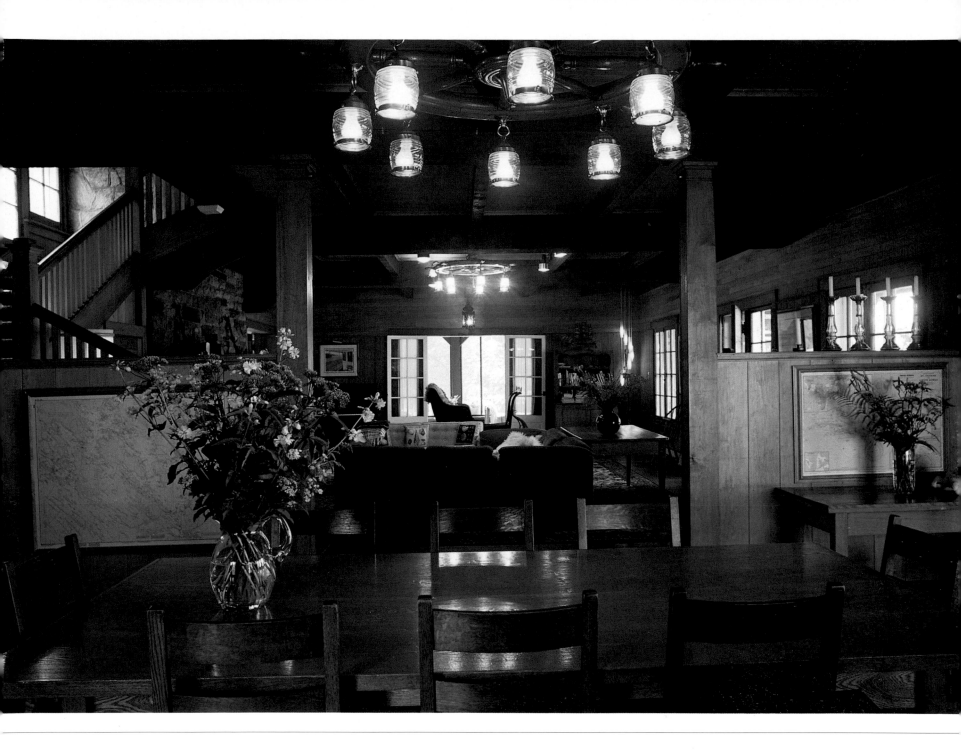

Grey Rock, a classic Lake Rosseau cottage built by a Pittsburgh banker in 1904, has been so well maintained by successive owners that little has changed. Basswood walls, massive stone fireplaces and spartan oak furnishings are in pristine condition throughout the sprawling two-storey home. "Keeping the old place going is extremely expensive," confesses the current owner, "but we feel we're helping to maintain a part of Muskoka heritage, and that means something."

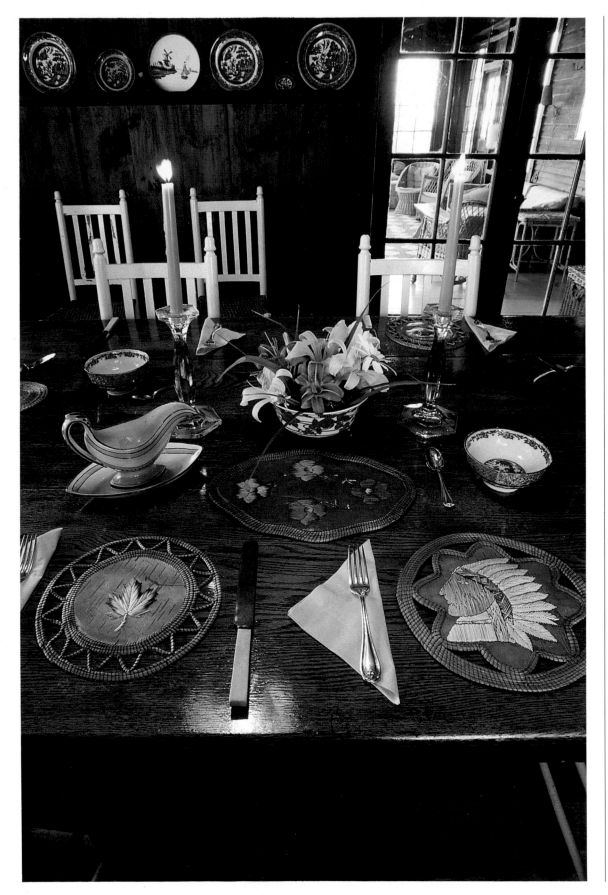

The homespun look of barnwood, pine and a vintage quilt on the veranda at Lake Joseph.

"The Ojibwa women used to row 18 miles from Christian Island to our dock to sell these handicrafts," remembers the owner of Keewaydin, a cottage at Go Home Bay in Georgian Bay, "and as I recall nobody really wanted to buy these things, but you felt you had to." Today, however, the family treasures these placemats made of birchbark, sweet grass and porcupine quills. The sturdy oak dining table and early Canadian chairs have been here for generations.

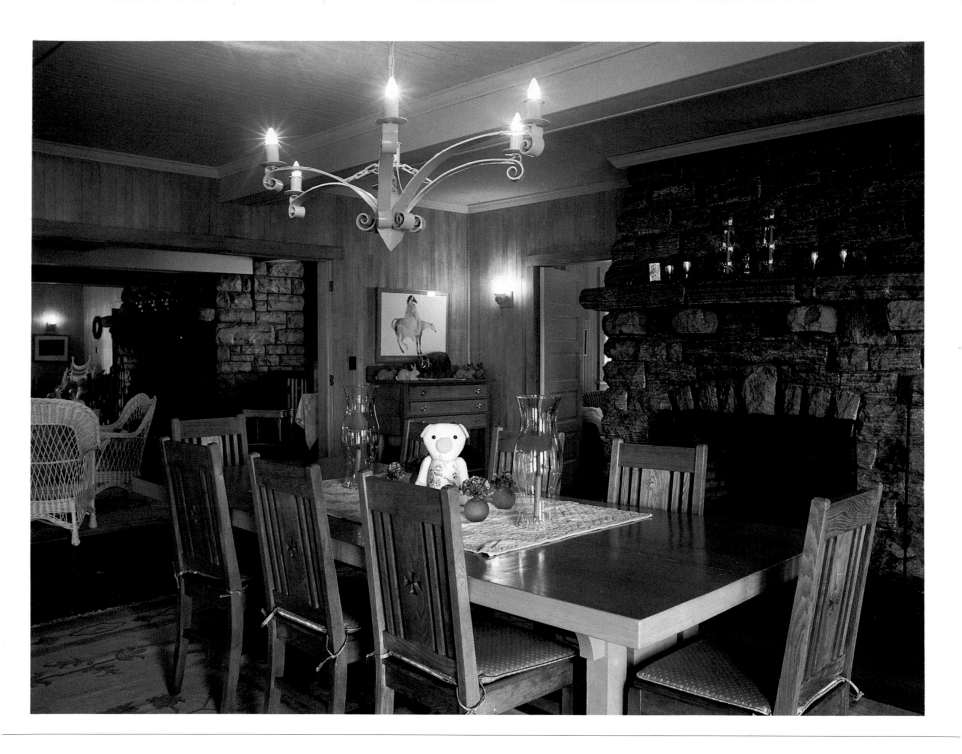

Old beams, freshly painted in seafoam green, and crisp white wicker chairs brighten Cinderwood, a classic island cottage at Beaumaris in Lake Muskoka. Pastel colours in the dhurrie carpets are repeated in chair pads and quilts. And a favourite teddy bear is given centre stage on the oak dining-room table.

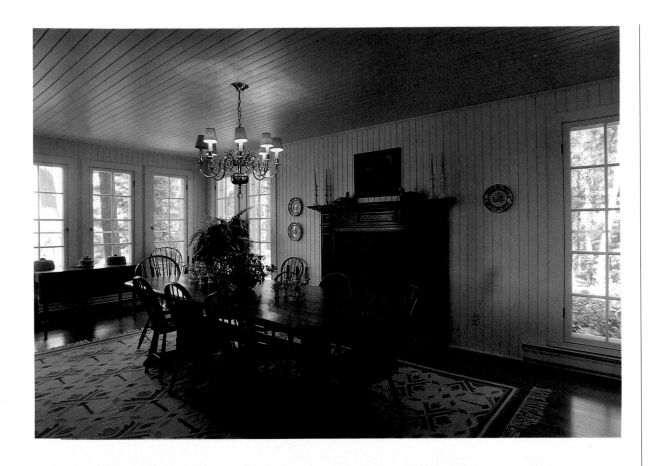

In vintage Muskoka dining rooms there's always a table large enough for entertaining hordes of weekend guests and a fireplace to warm the room when the nights turn chilly.

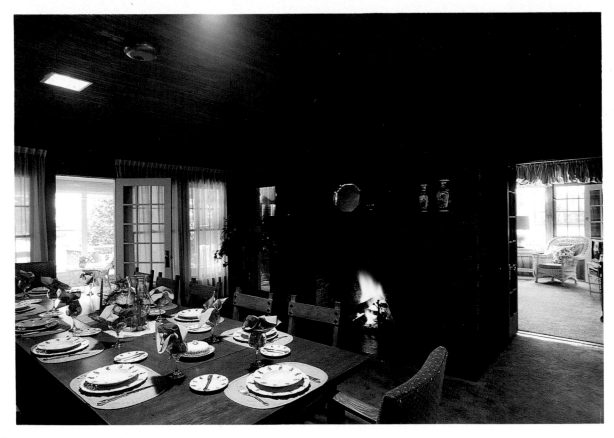

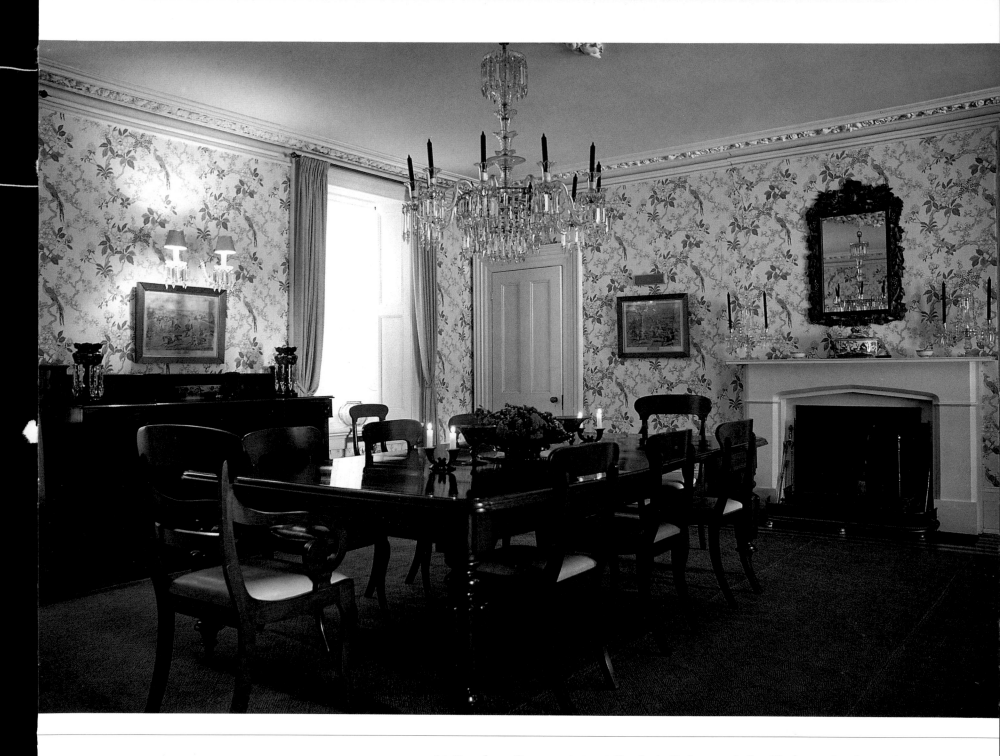

At Beechcroft, an estate at Roche's Point on Lake Simcoe, the formal dining room hasn't changed since the days when women dressed in full-length gowns and the men wore starched collars. "I think it's important that things don't change at a cottage," comments the owner, who lived in England for a few years. "When I came back here I'd always spend the first while checking to see that everything was the same. There's something very reassuring about it."

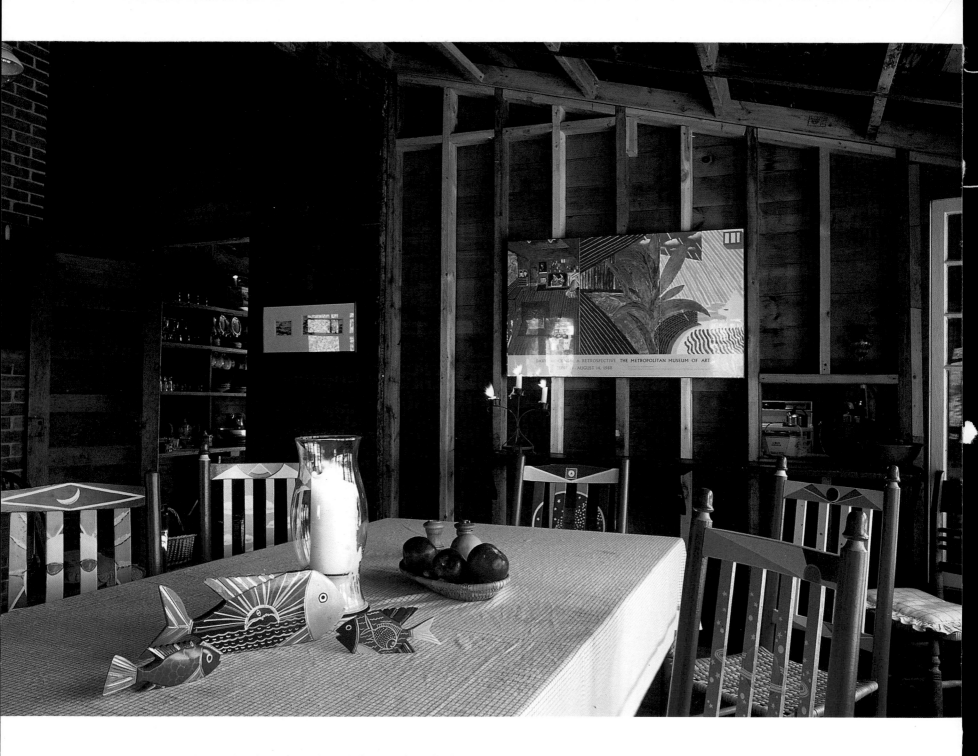

This refreshingly colourful, woodsy dining
room is located at Pointe au Baril in
Georgian Bay. A David Hockney print,
Mexican wooden fish, and chairs
handpainted (by artist Sara Nadeau) for
each member of the family add brilliant
dashes of primary colours.

The cold storage cellar, once used for storing meat and dairy products, now has a tasteful new function at this Lake Joseph cottage.

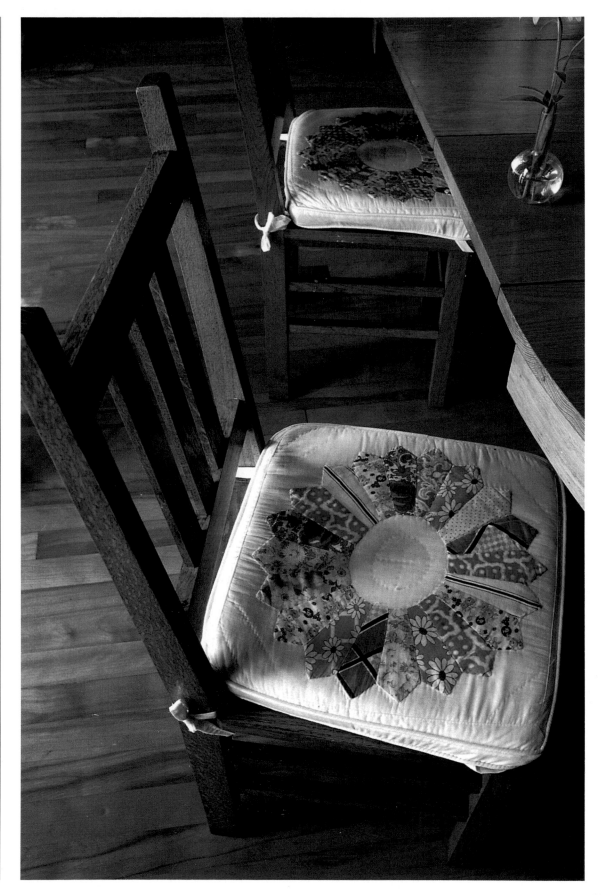

An old quilt was cut up to make covers for 12 chairs in this Muskoka dining room.

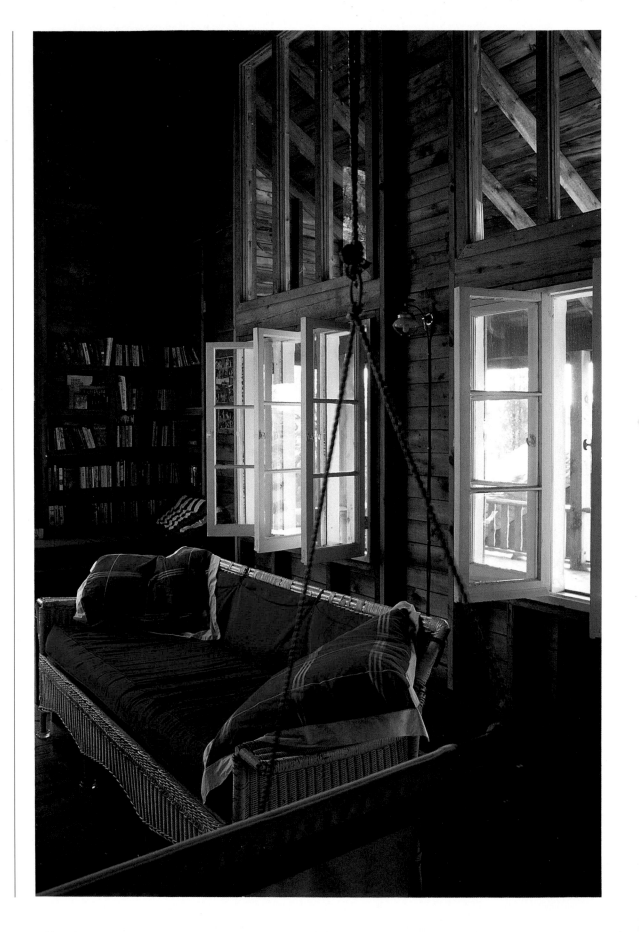

Windows open to the bay breezes in this Pointe au Baril island home where summer days are spent in a bathing suit. To bring more light into the dark wood-panelled living room, the ceiling was raised to the rafters and a second set of windows was mounted above the original ones.

6

CURL-UP INDOOR COMFORT

Summer is meant to be lived outdoors, picnicking on rocky points and lazing in hammocks. But on days when the rains come and the north winds blow, all we want is a deep, squashy sofa, a cozy afghan, and a good reading light. This feet-up comfort is usually the first consideration for cottage sitting rooms. For some, the ideal is an easy-care kind of place where barefoot children can run

through with dripping pails and everything sweeps clean in minutes. Others see the country house as a place to indulge their sense of style, and every nook is designer decorated. But comfort is paramount, whether the seat of choice is a creaky rocker with faded chintz cushions or an elegant loveseat.

In century-old sitting rooms certain things are sure to appear: a large fireplace, usually built from stones collected on the property, small windows intended to keep out the summer sun, wood-panelled walls (often lined with regatta ribbons), well-thumbed photo albums, field guides and guest books, and invariably a piano. In those early days music was so important that piano companies advertised in cottage directories. In the 1902 Muskoka Lakes Association yearbook, the firm of Gourlay, Winter and Leeming ran an ad for piano rentals claiming: "The summer outing is robbed of half its charm if music is made impossible by want of a piano."

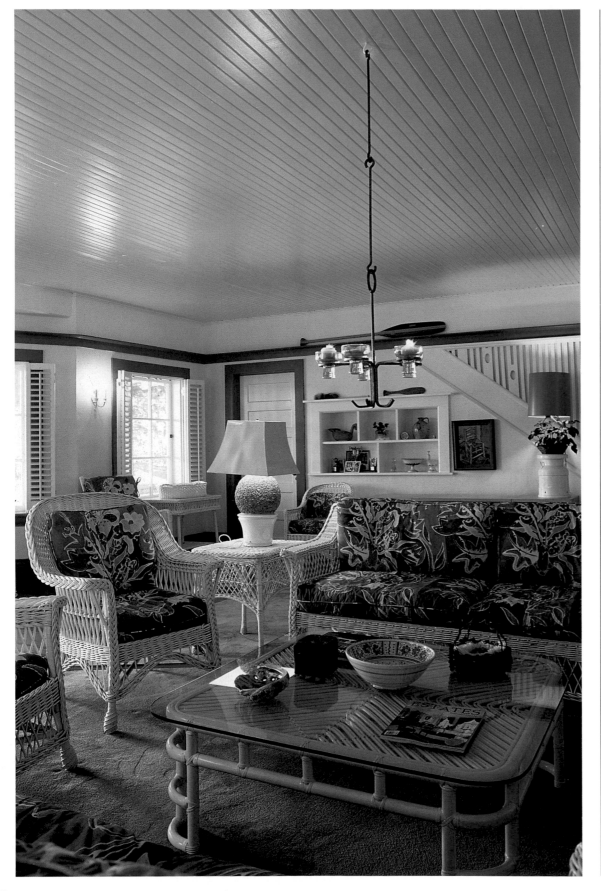

Bearing little resemblance to the original dark and somber living room, this Lake Joseph cottage is now all-white and cheerful. Glossy paint coats the basswood walls, green trim outlines the architectural details, and white wooden shutters replace old-fashioned drapes on all the windows. "I believe in bringing the outdoors in," says the owner, an interior designer, "and I tend to use the colours of nature throughout."

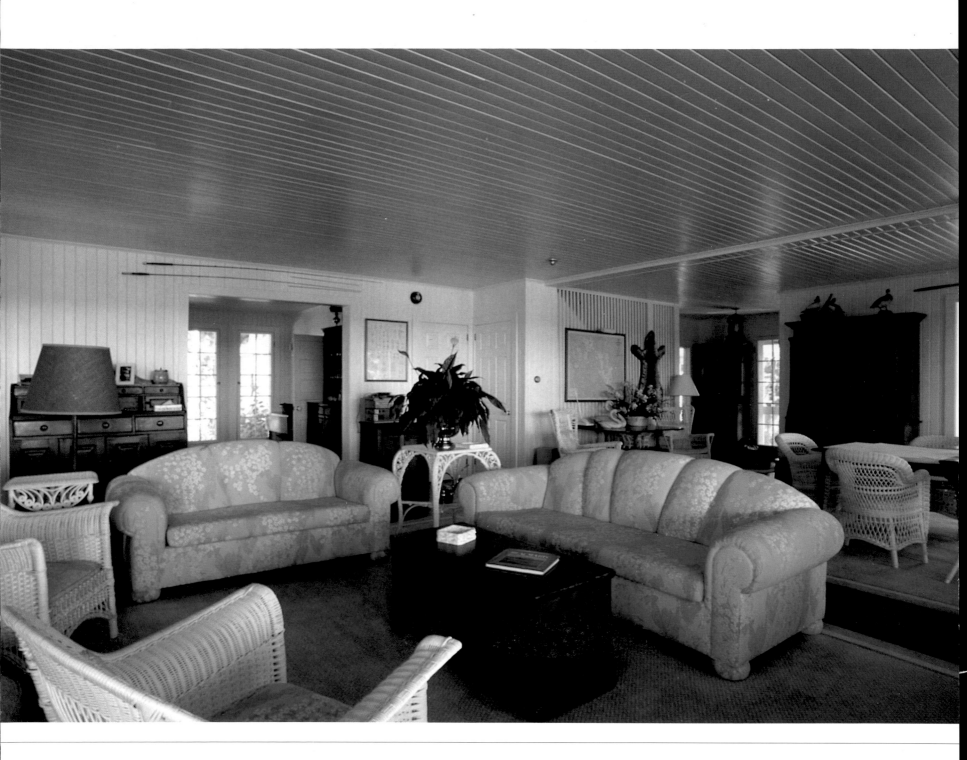

Crisp white walls and sofas the colour of lime sherbet give this Muskoka cottage a feeling of perpetual summer.

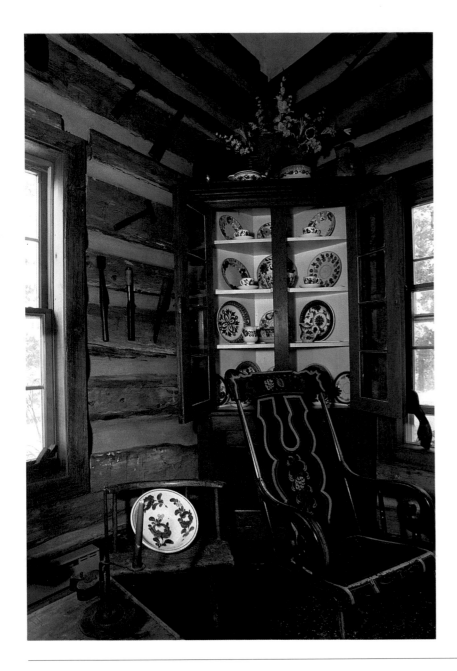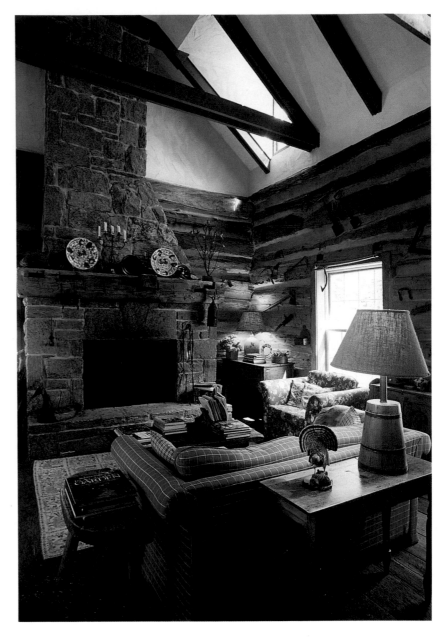

A turn-of-the-century log cabin is given new life as the living room of a Muskoka cottage. The handrailing on the stairway was made from the cabin's original joists, and the fireplace mantel was an old barn beam bought at a country auction. A pine corner cabinet houses a collection of primitive cottage ware. To provide height and airiness, four logs were added to the walls and gabled windows installed in the roof. "The proportion of the gables is often wrong on log houses," explains the owner. "We wanted to make sure that they looked right from the outside as well as the inside."

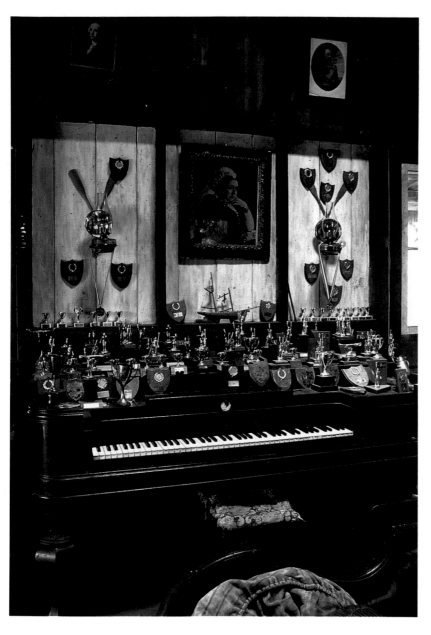

A vintage piano and a cluttered assortment of wall hangings and regatta trophies join Queen Victoria in this Stoney Lake sitting room. "When I moved here, the only things I threw out were the straw-and-horsehair mattresses," states the owner of this weather-beaten cottage that has been her summer home for several decades. "I don't dust or clean either. Although sometimes I throw things away that the red squirrels and mice have destroyed."

Rainy day fun at the player piano. Songs include: "The Light of the Silvery Moon" "Some Day My Prince Will Come" and "When It's Springtime in the Rockies." At this Roche's Point cottage the grandchildren know all the words.

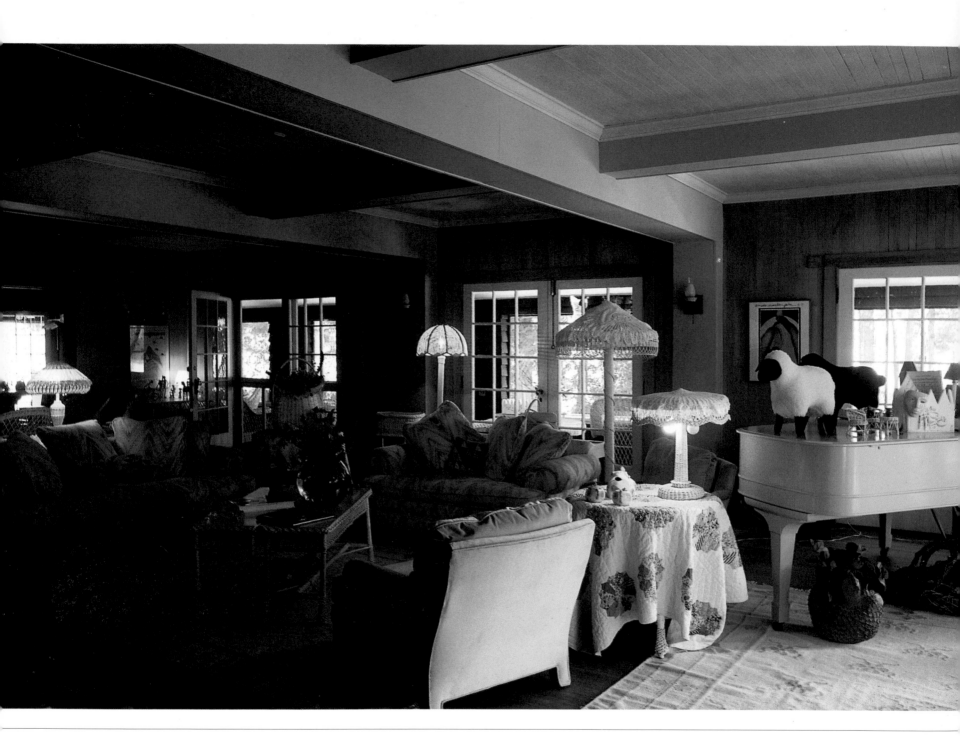

Whimsical country touches enliven this
spacious Muskoka cottage. The grand piano
bears a coat of soft green paint, the wicker
lamp shades are draped with lace hankies,
and antique quilts make interesting table
covers. The gently rounded sofas are designed
for convivial evenings in front of the fire.

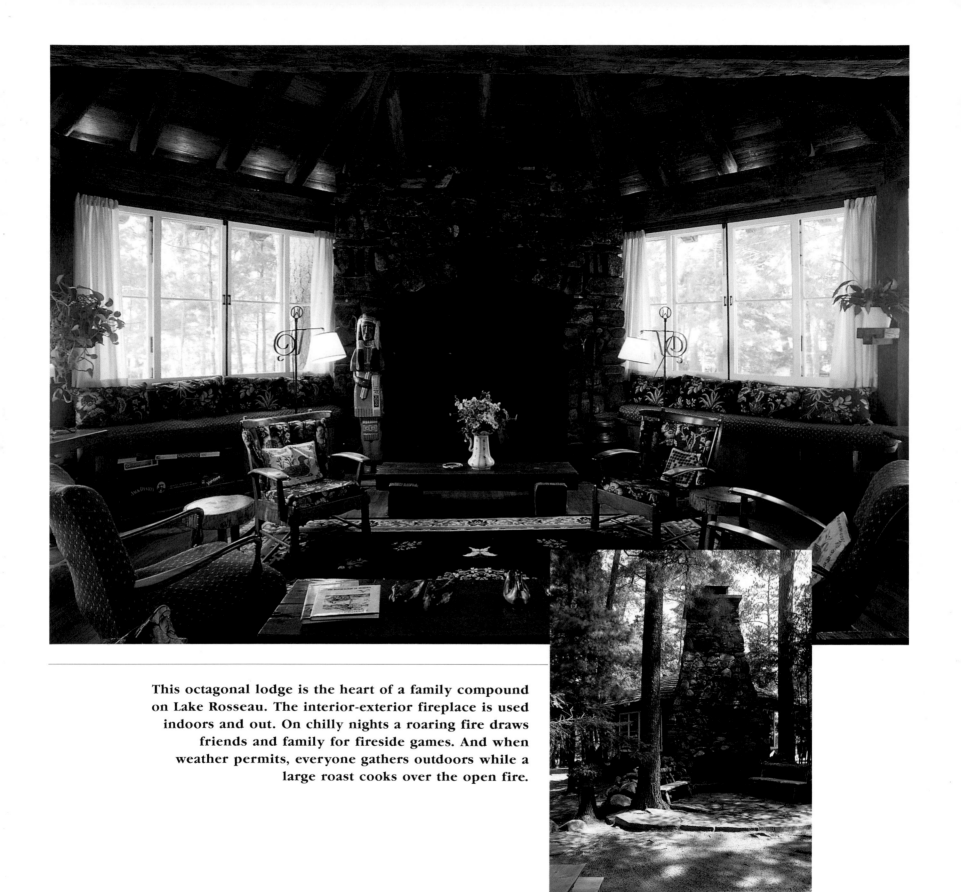

This octagonal lodge is the heart of a family compound on Lake Rosseau. The interior-exterior fireplace is used indoors and out. On chilly nights a roaring fire draws friends and family for fireside games. And when weather permits, everyone gathers outdoors while a large roast cooks over the open fire.

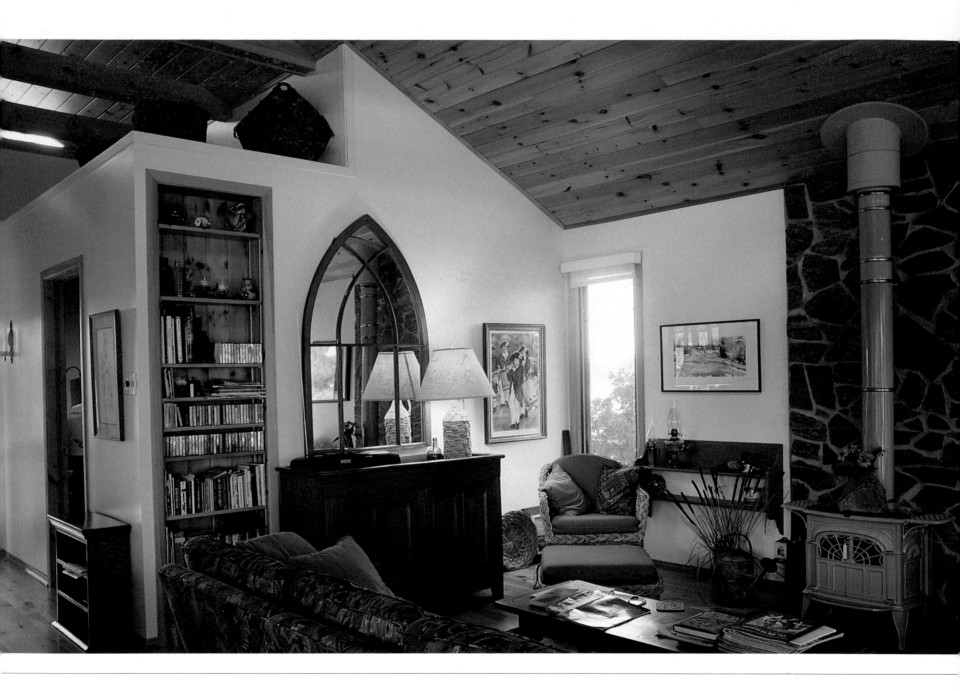

Perched on a tiny Stoney Lake island, this compact cottage is exactly what the owner wanted. "I did my own plans to scale," she explains, "and I wanted a happy place that is light, bright and airy." Surrounded by deck and full of light, the cottage is the result of two years of planning. "I love it," she adds. "I sometimes come up just for a day in the off-season, to sniff the fresh air."

An applique wall-hanging of the island in Go Home Bay, where this family have summered for generations, also depicts events in the owner's life. Hanging proudly in the woodsy living room, it was the handmade gift of a neighbour.

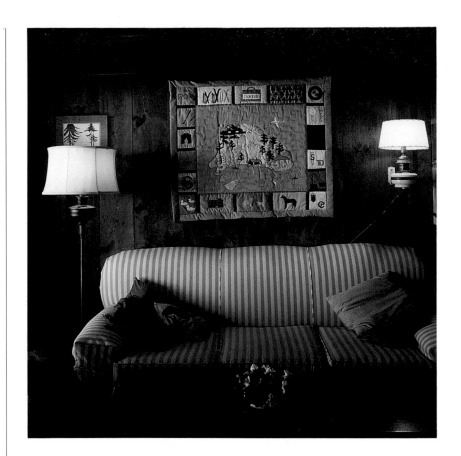

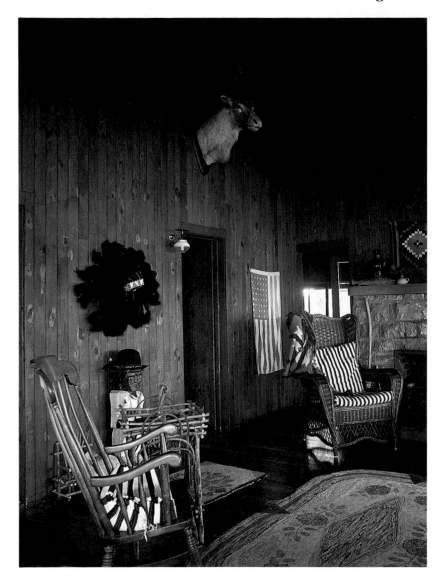

At Pointe au Baril in Georgian Bay the cottages are usually sold with the contents intact. "It's just too difficult to move things from these remote islands," explained one cottager. Here, the new owners have added wicker armchairs (that look old) and some American folk art to the original twig furniture and hooked rugs.

A handpainted milk-can lamp casts light on a quilted table cover.

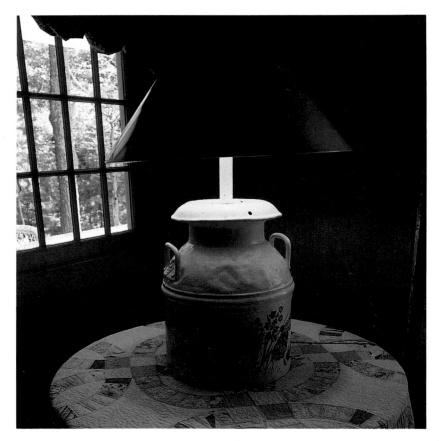

THE FIREPLACE

At the heart of the cottage is the fireplace. It smoulders away the dampness in the daytime, filling the air with the pungent scent of woodsmoke. At night it becomes a crackling presence to which we are drawn, like moths to a lamp.

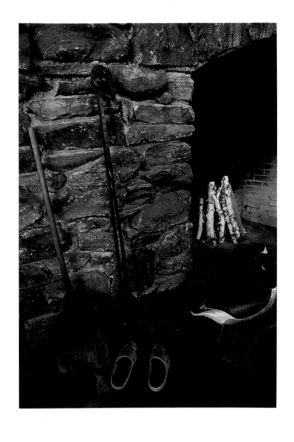

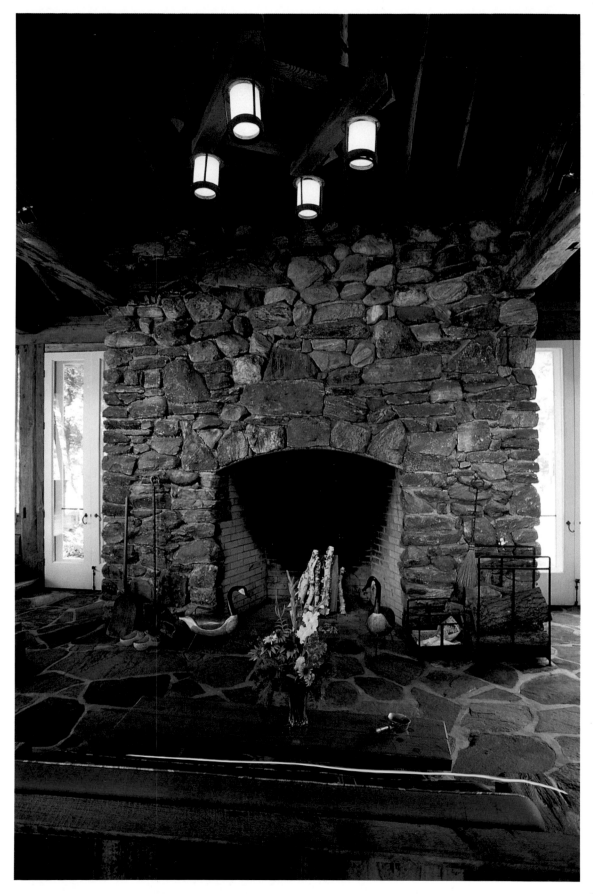

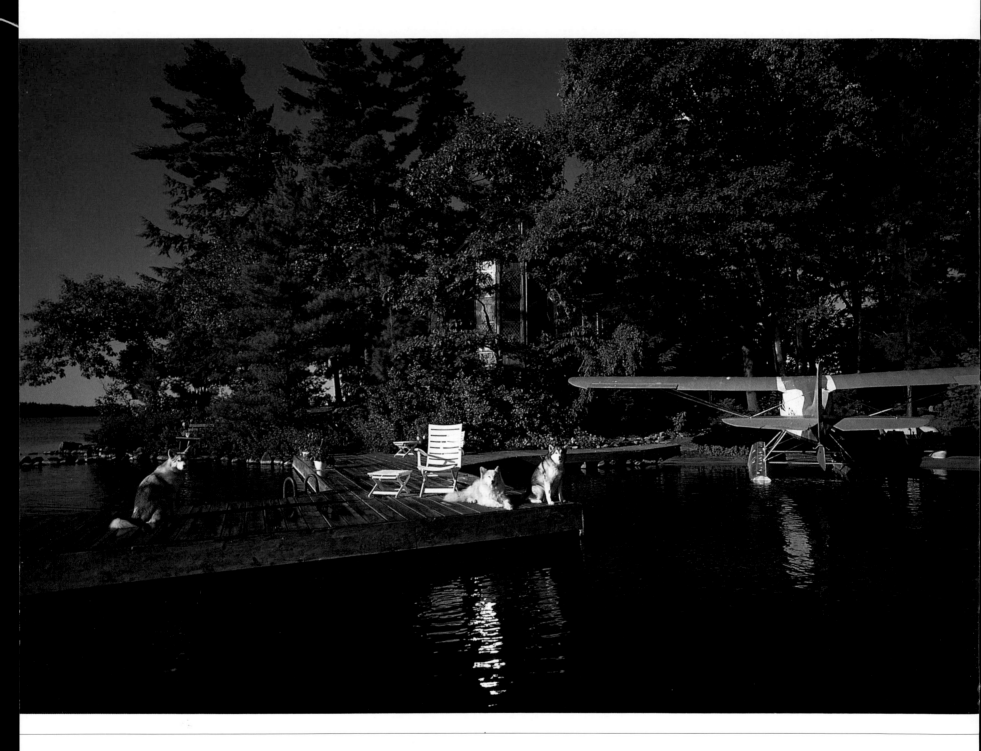

A summer afternoon going to the dogs.

THE GREAT OUTDOORS

In the depths of winter I think back to the cottage and how the green grass feels beneath my bare feet.
A Lake Simcoe cottager

Canadian summer, although the briefest of seasons, seems to bestow our fondest and most lasting memories. Long after summer is over, we remember mornings when the sunrise painted the sky crimson; days when the air was heady with the fragrance of pine; twilight moments when the lake was still except for the sound of a paddle slapping the water; and nights when the northern lights shimmered across the horizon.

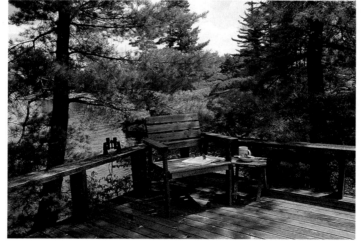

For cottage dwellers, the outdoor spaces where we spend these golden summer days and star-filled nights might be a wooden dock full of carved initials, a wraparound deck built above a boathouse, a patch of sandy beach where we can dig our toes into the warm sand, or a gazebo built as a place of meditation on a quiet point.

Unlike shady summer porches, our decks today are angled to capture every vestige of sunlight. For shade, a leafy tree grows through the floor. And most important, our breezy outdoor rooms have private places where we can settle into a deep lawn chair with a tall drink and a thick book and lose ourselves on a summer afternoon.

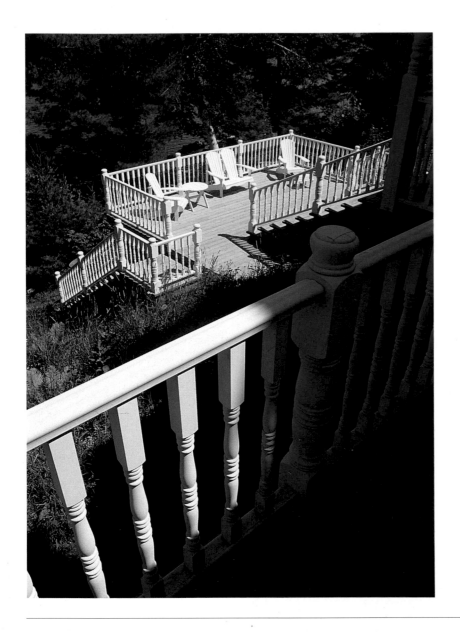

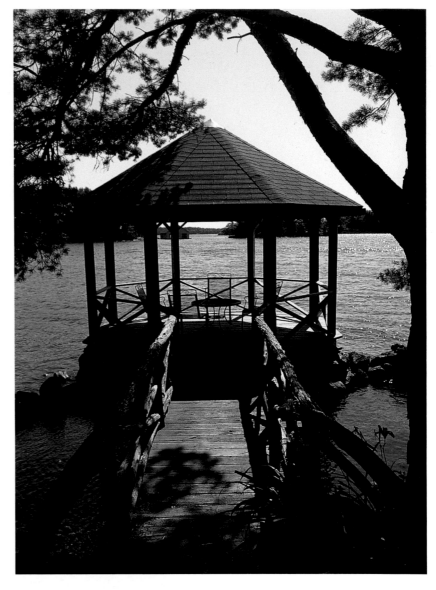

Freshly painted white railings and Muskoka chairs add old Ontario flavour to this lakefront retreat.

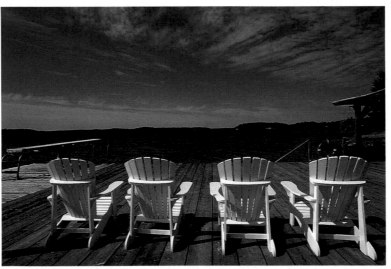

A gazebo built on a stone platform — the perfect vantage point for admiring the setting sun.

Viewing for four. Wooden deck chairs overlook the sparkling water of Lake Muskoka.

A sun-drenched patio sits on a half-acre
island in Stoney Lake. Wooden chairs
stained grey-green blend with the natural
flora. "It's like a nature retreat here,"
says the owner. "I'm surrounded by
loons, herons and ducks."

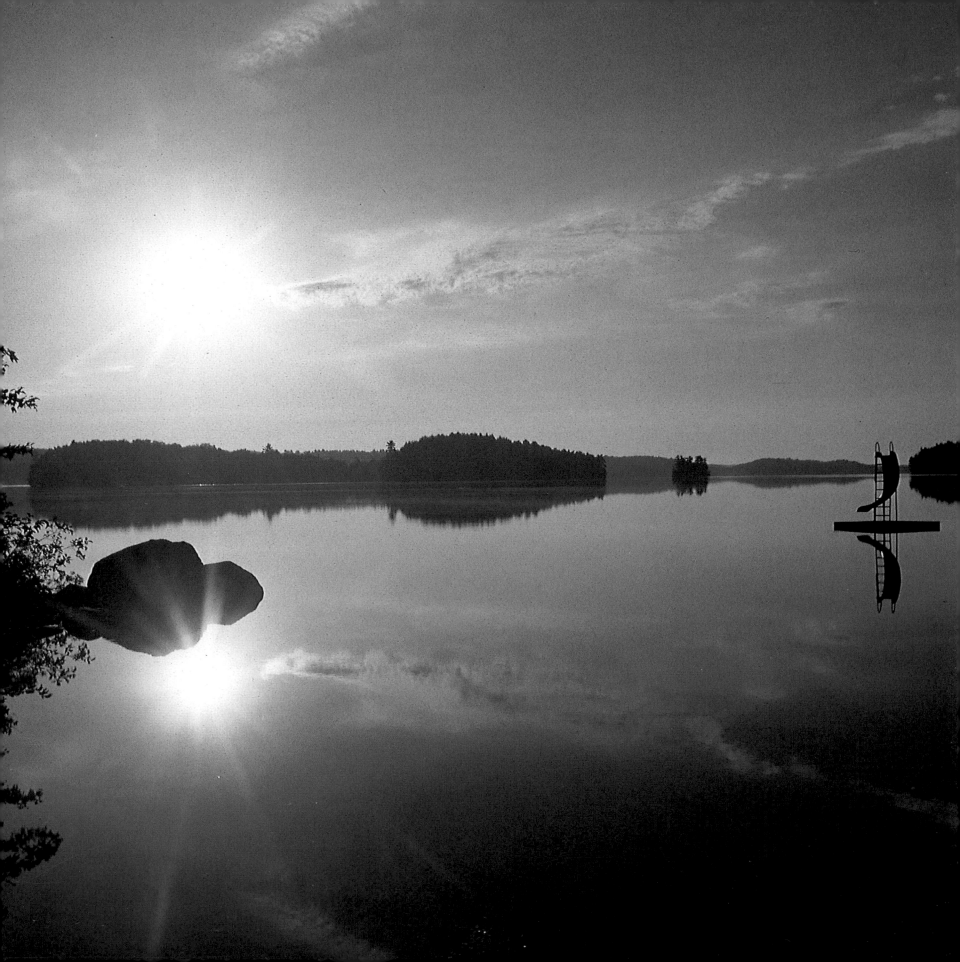

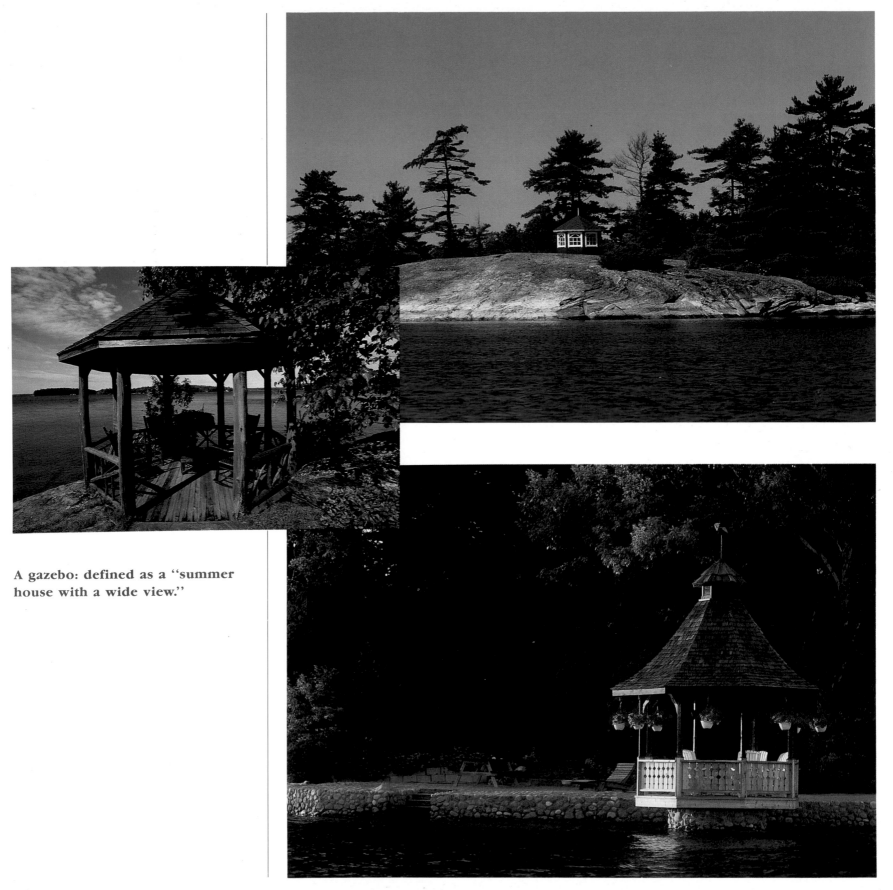

A gazebo: defined as a "summer house with a wide view."

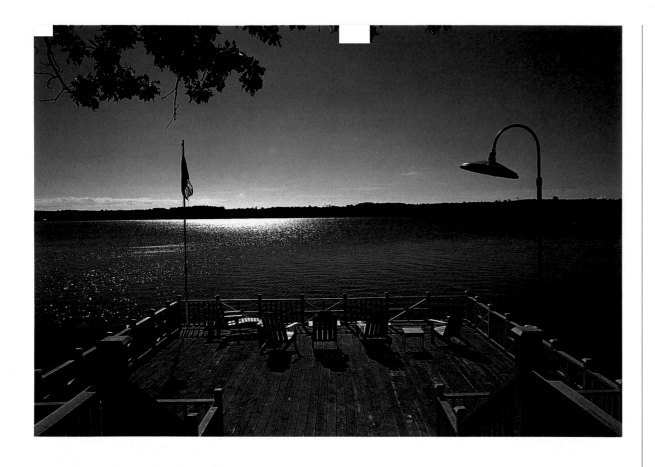

The boathouse deck offers a fine view of passing boats on Sturgeon Lake.

Cantilevered off a rocky ledge, a perfect deck for watching the sun go down on Lake Joseph.

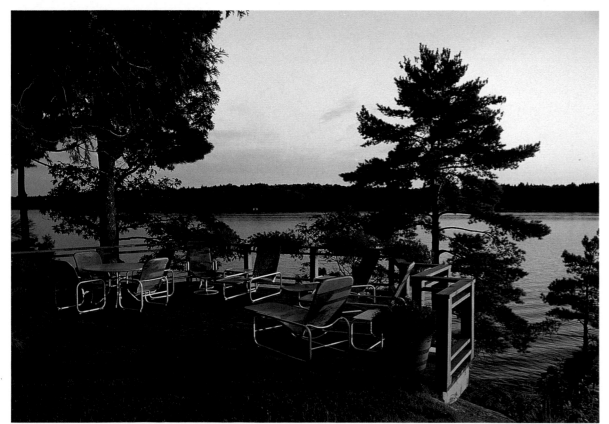

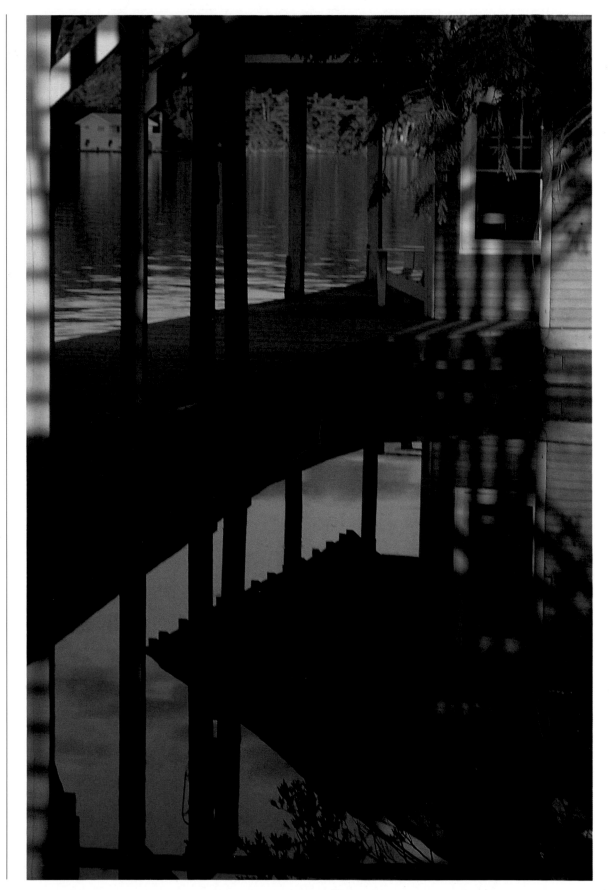

The end of a golden summer day.
Sunset shadows on Lake Joseph.

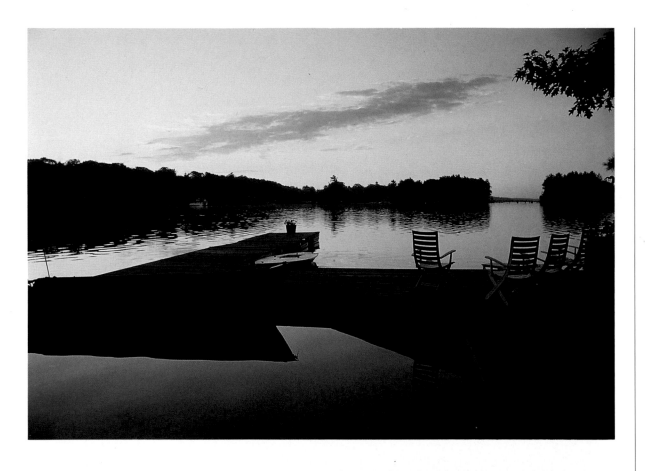

All's quiet on the dockfront in Muskoka . . .

. . . and in Georgian Bay.

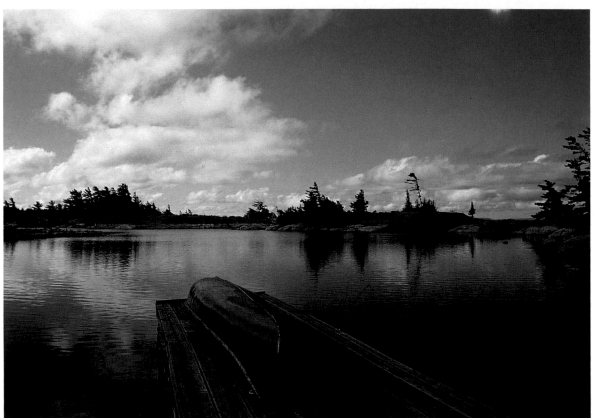

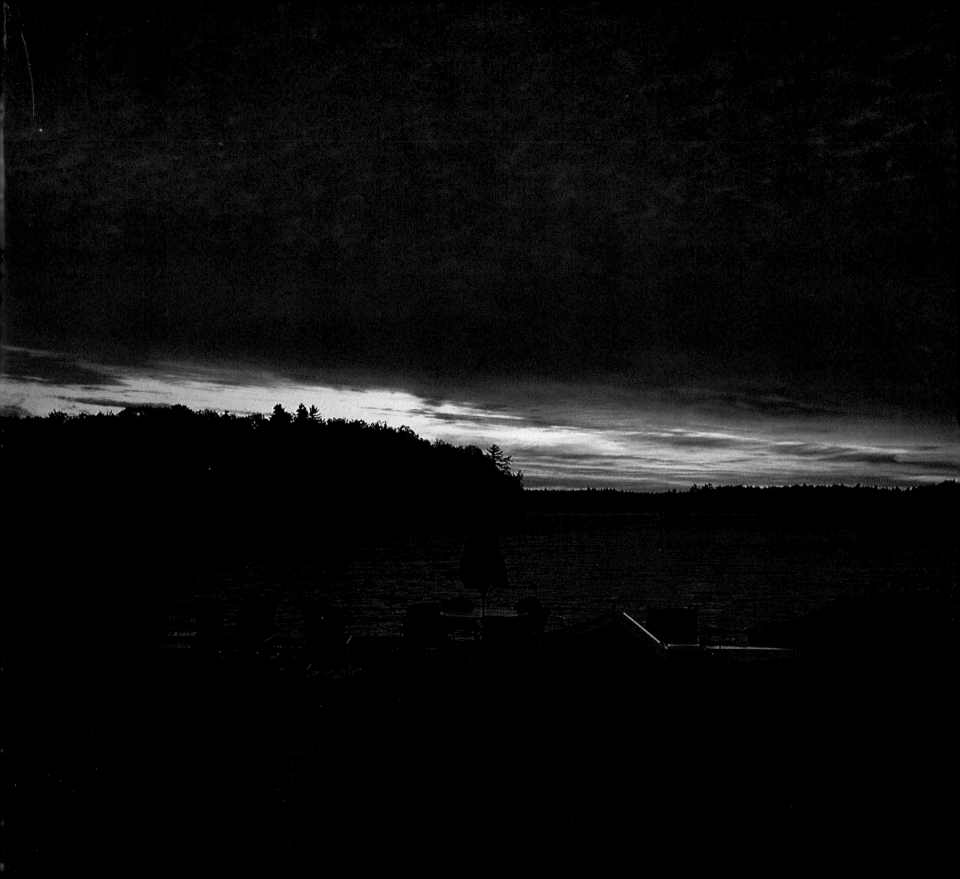

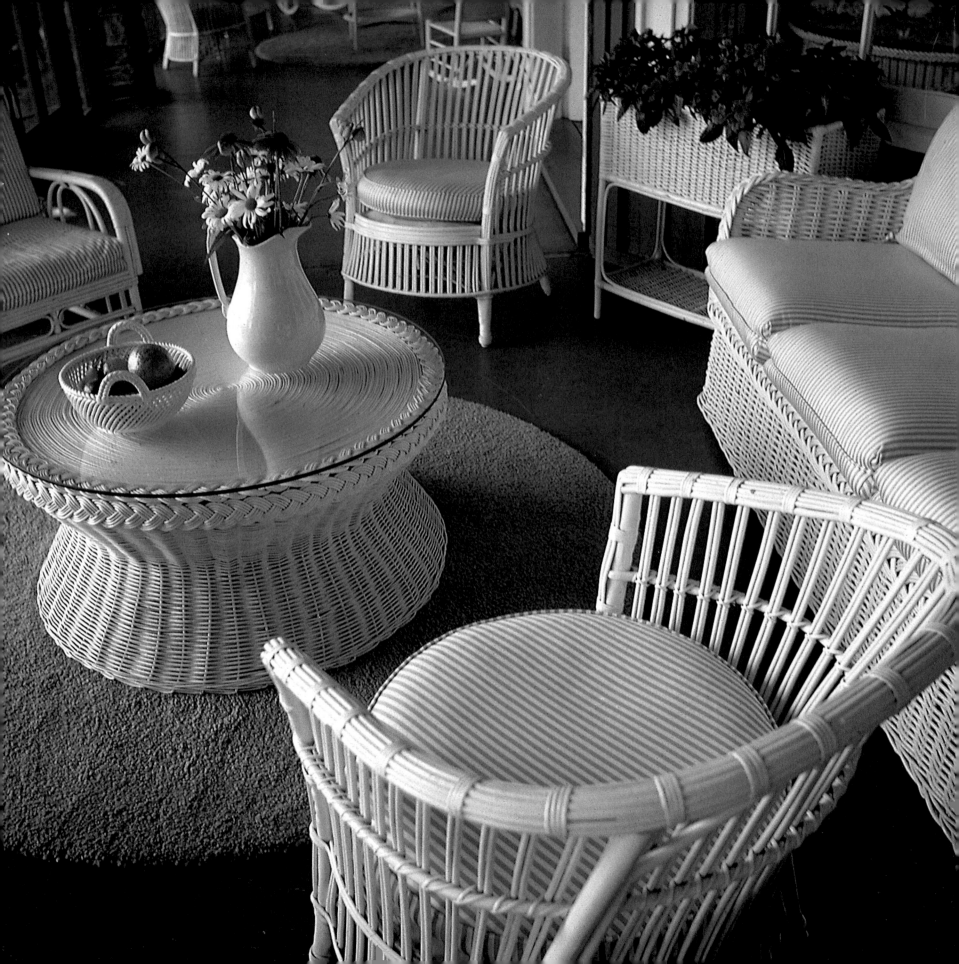

SUMMER PORCHES

In cottage country, summer homes tend to be tucked at the end of long country lanes or shrouded in trees along the shoreline. Situated for privacy, they can barely be seen. Many of the older places were built when sunshine was something to avoid, when the heat of the day gave young ladies ''the vapours.''

Back then, wide covered verandas with split cedar railings meandered along the sides of the cottage. These verandas were much used, especially by the long-skirted women who sat fanning themselves in wicker rocking chairs (called ''digestive chairs'' by doctors in those days). Sepia-toned photographs show them gathered in circles, sipping tea or doing needlework. The men always seem to be standing and viewing the camera impatiently, as if they would have preferred to be out fishing.

The love affair with wicker that began in Victorian times seems undiminished. In its original state or freshly spray-painted, this woven rattan furniture is still a common sight on cottage verandas. Other porch furniture, made of bent willow and hickory, and porch swings which hung by chains from the rafters, were handcrafted by cottage caretakers during the winter months. Clustered in cozy groupings on shady verandas, this century-old furniture still looks right today.

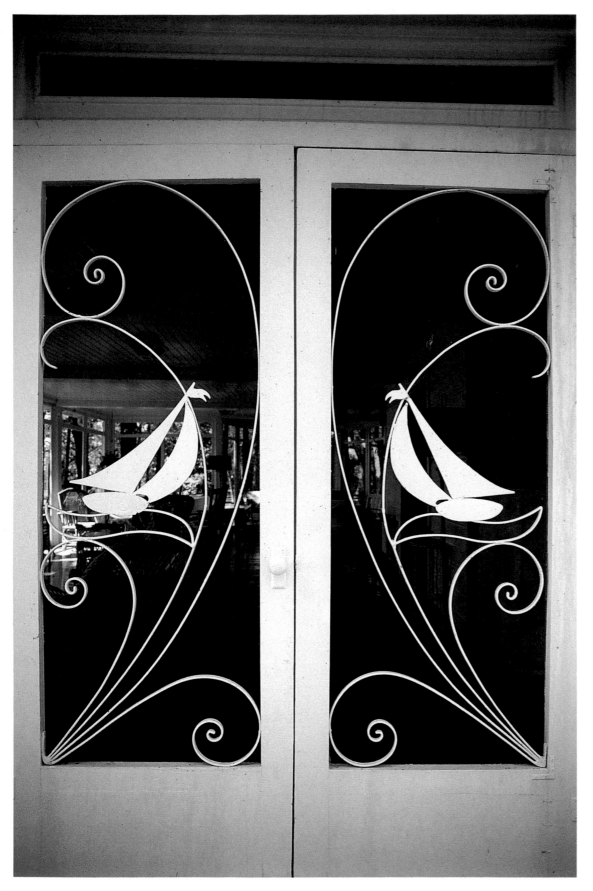

White wrought-iron sailboats adorn the screen-porch doors in this Sturgeon Point cottage. Sailing regattas have been part of summer life here since 1838.

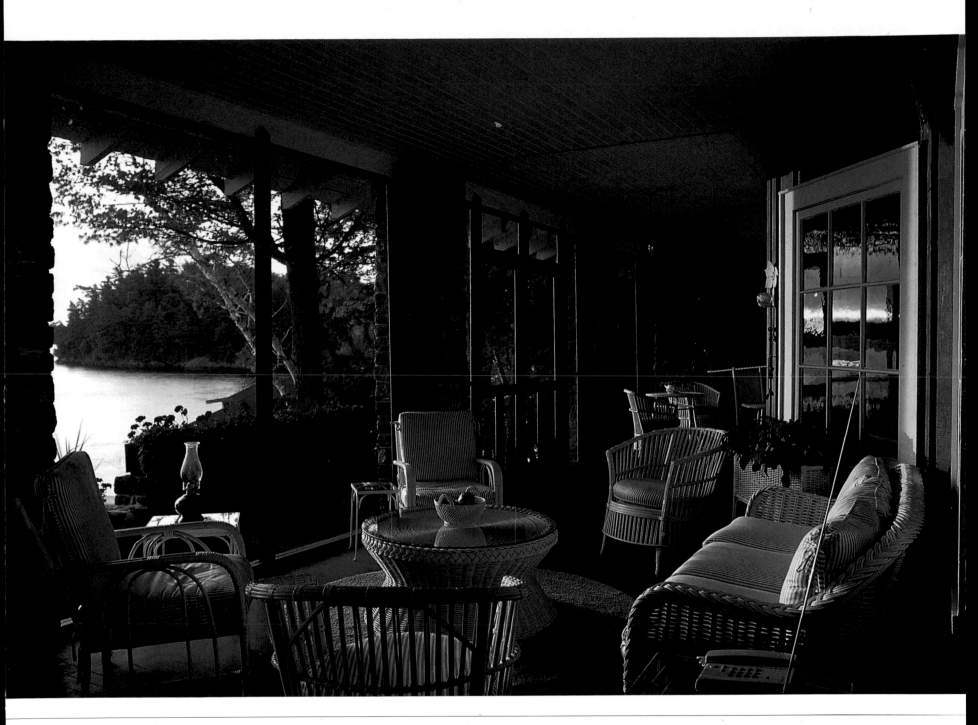

Verandas on old cottages served as
outdoor sitting rooms where families
gathered at different times of the day to
enjoy the fresh air and cooling breezes.
At this Lake Joseph cottage the wraparound
porch has been screened with extra-wide
ceiling-high screening which is
almost invisible.

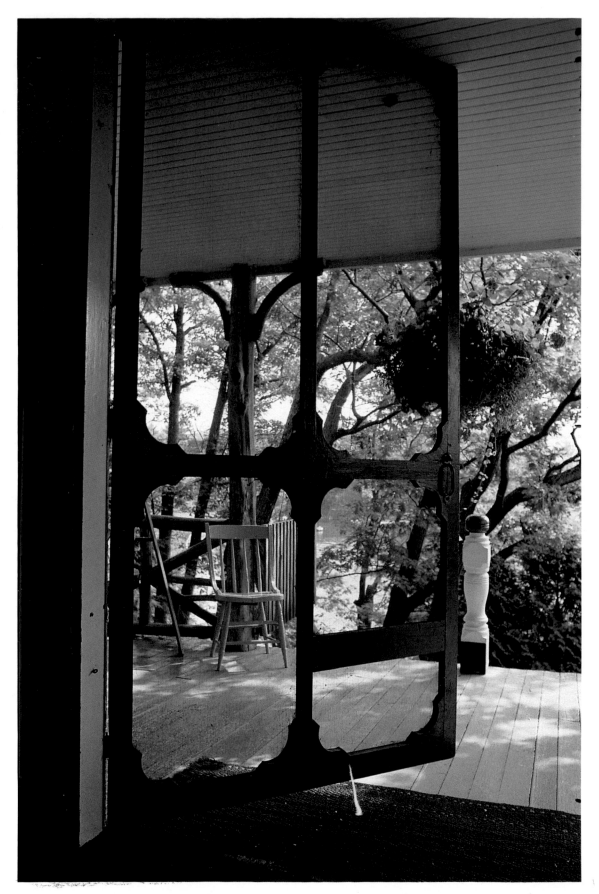

A glimpse of cool water through leafy trees on a veranda in the 1000 Islands. Perfect for cat naps.

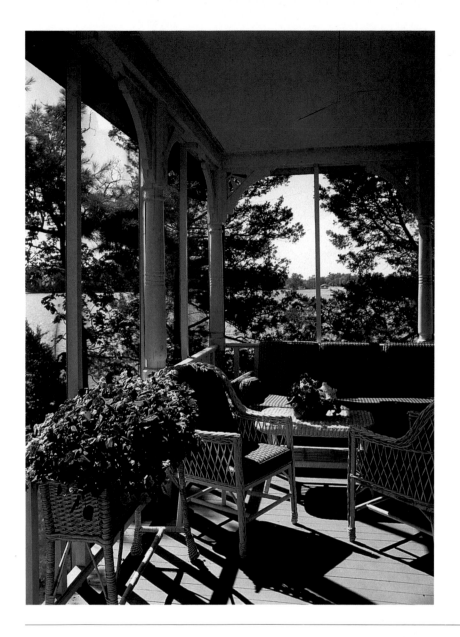

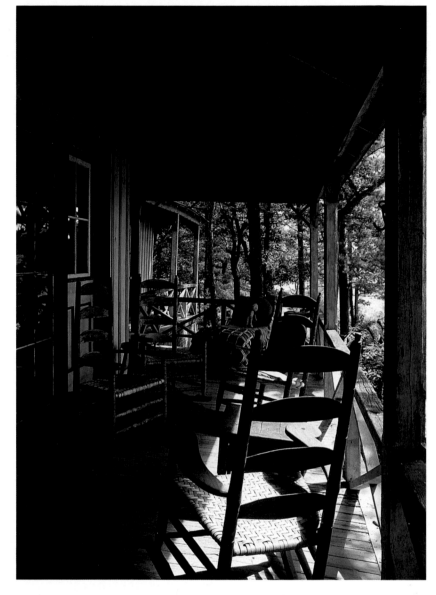

"Summertime and the living is easy" on a screened porch at Stoney Lake.

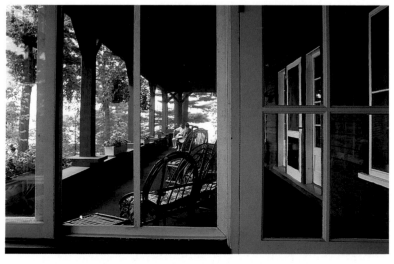

Originally built as a haven from the sun, this Stoney Lake porch, which wraps around three sides of the cottage, has remained true to its origins.

Tucked beneath deep eaves, this Lake Rosseau veranda runs the length of the cottage. Rustic bent-twig chairs are perfect for porch sitting.

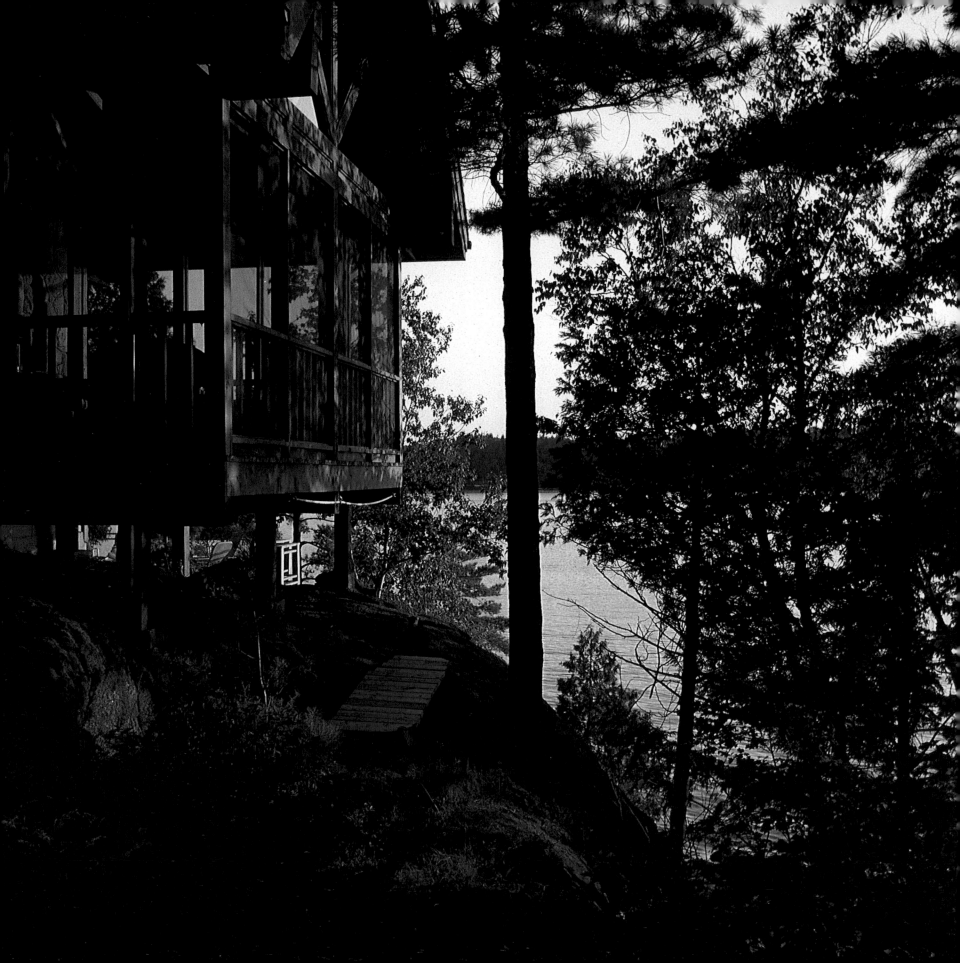

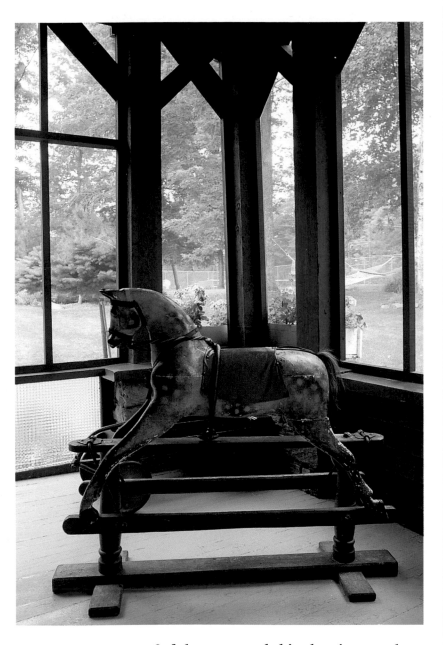

Soft breezes cool this sleeping porch on Lake Rosseau. Beyond the rocking horse is a view of twin hammocks and a tennis court.

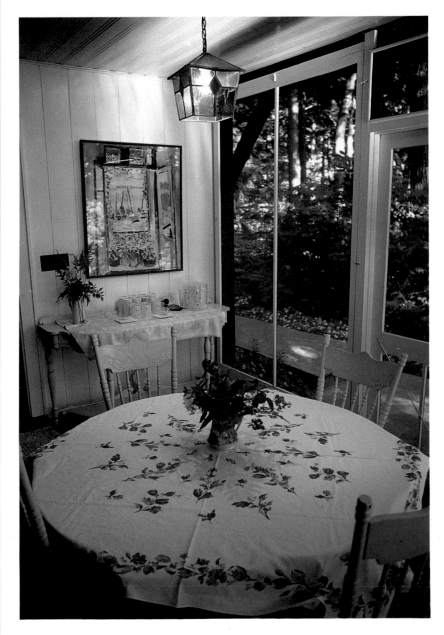

A screened breakfast nook leads to the kitchen in this old Lake Joseph cottage. The tablecloth is one of a collection stowed in an antique pine hutch in the dining room.

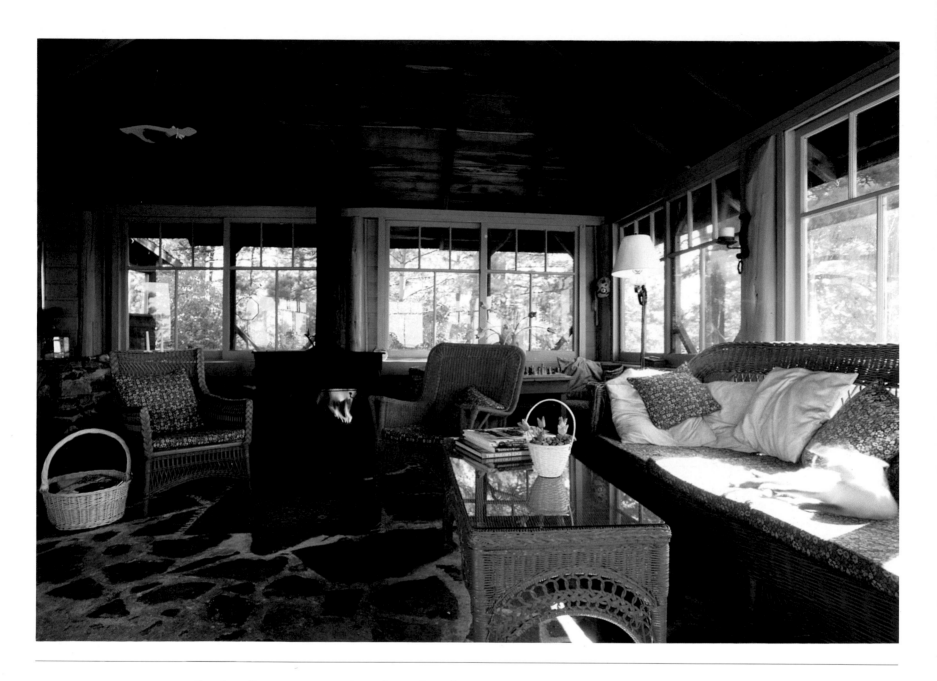

Gordon Pearson, an artist who painted
with members of the Group of Seven,
designed this turret-shaped room with its
stone floor and sliding windows. Today
it's a favourite room in this family
cottage, a place to gather for games, curl
up in front of the fire, or simply savour
the wraparound view of Go Home Bay.

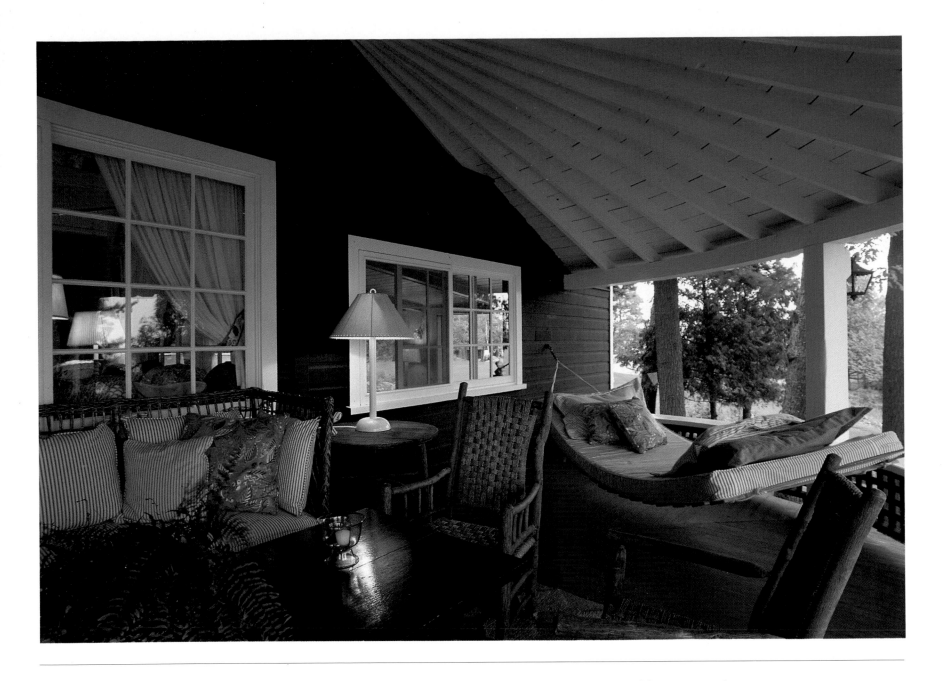

At Beaumaris, new cushion covers in crisp cotton enliven the old porch furniture. Little else has changed at this cottage where the fifth generation of Americans now summer. "That's why we return every year," comments the patriarch of this summer place, "we like it just the way it is."

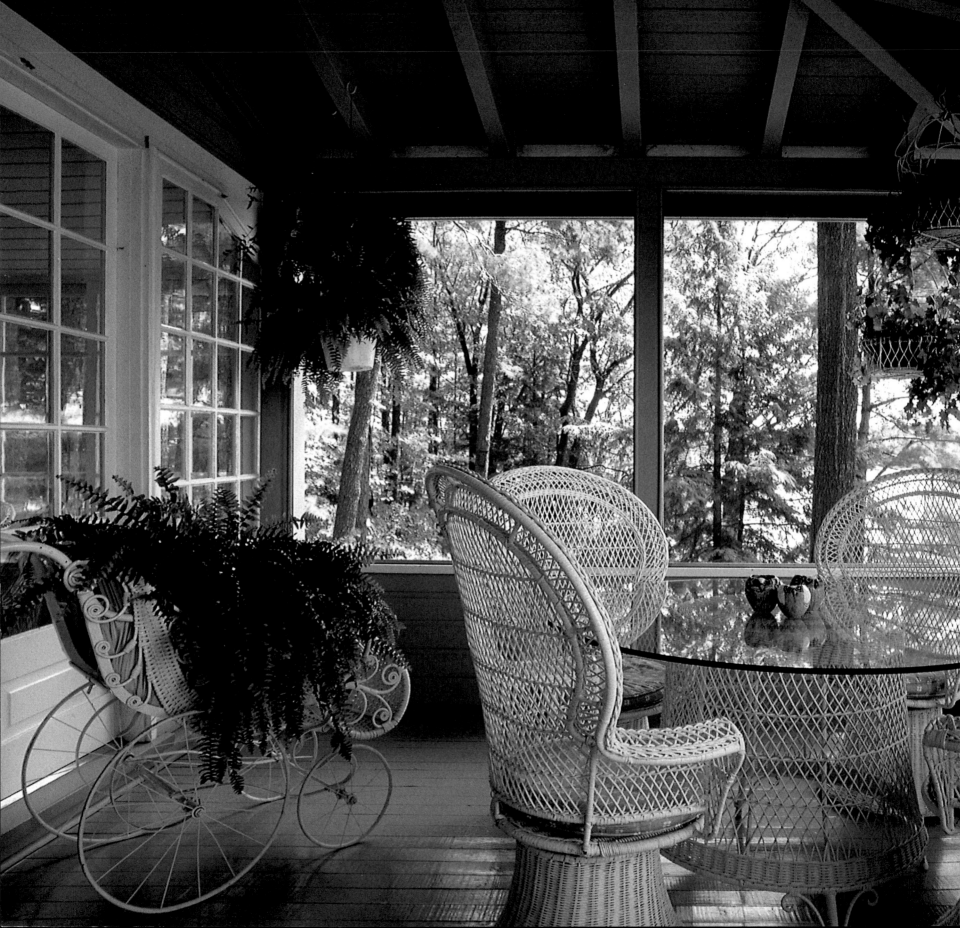

The children of the family hate to see anything change, so the porch furniture at this Go Home Bay cottage has been the same for generations.

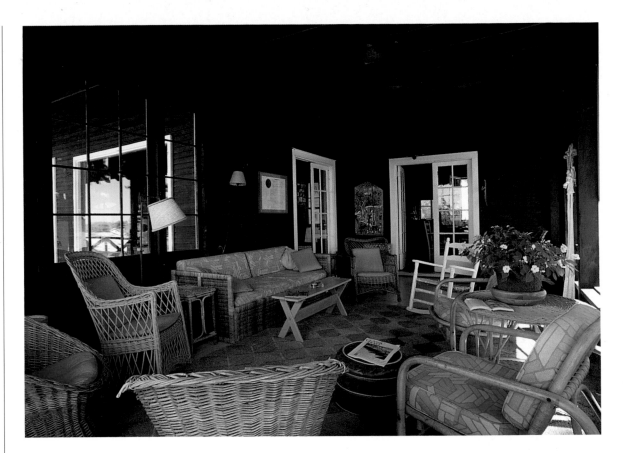

Sun and shadow interplay in the screened dining area of a Lake Joseph cottage. The twig table and chairs made by Nannyberry Woods are of alder and willow. The tabletop is made of pine boards from an old granary.

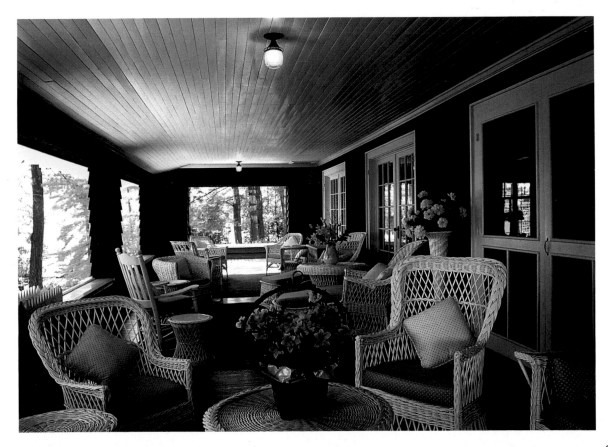

Verandas large enough for several seating groups, plenty of wicker, and porch swings hanging from rafters are common at vintage Muskoka cottages.

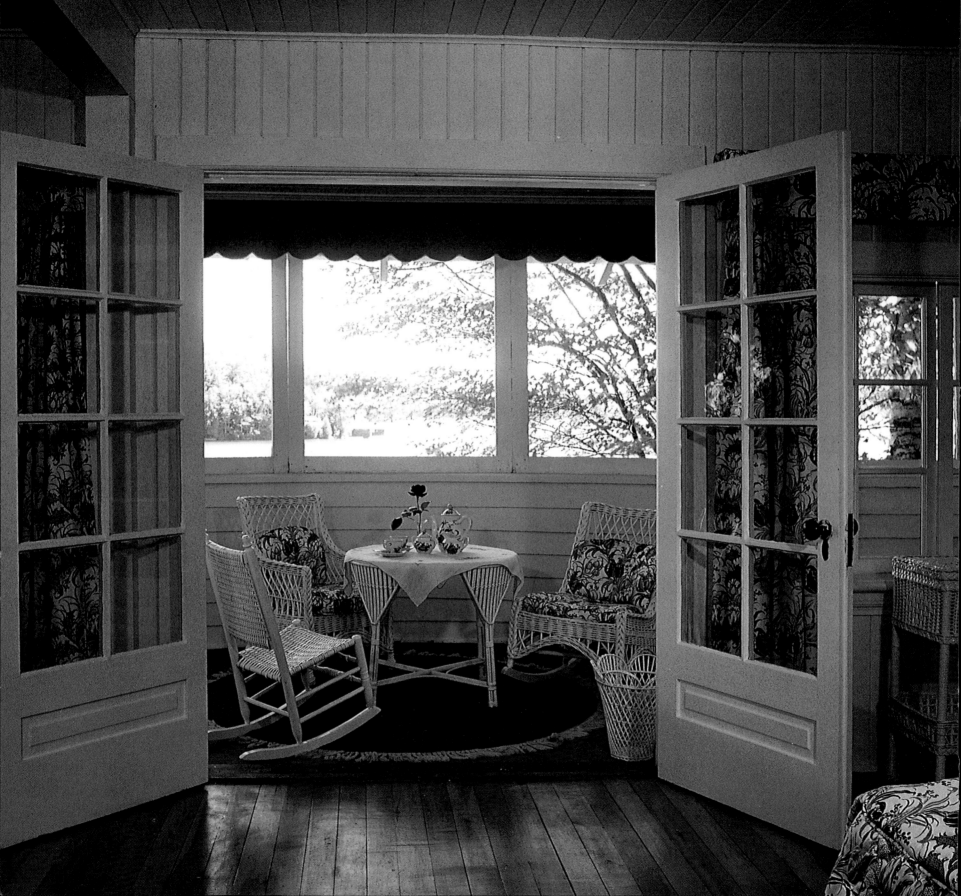

9

BEDDING DOWN

Few things are more memorable than the woodsy scent of an old cottage bedroom, the kind with creaky wooden floors, old iron beds, a washbasin in the corner, and windows with thin curtains moving in the breeze. Here, in these mellow, woody rooms where as children we read with flashlights under the covers and fell asleep to the sound of waves, our fondest cottage memories were born. In many old cottages, little has changed in these spartan, camplike bedrooms.

Back in the days before plumbing and electricity, the well-appointed cottage bedroom had a complete china set for washing (including a chamber pot and a slop bucket), a dresser with built-in candle stands, and a screened sleeping porch to retire to on steamy summer nights. Even now, in vintage cottages, carefully preserved porches are favourite places to sleep. "Our sleeping porch is often the only place to hide when all the kids are here," laughs the mother of a lively clan. Their master bedroom opens onto a screened porch spanning the front of the cottage and overlooking the lake. *(opposite page).*

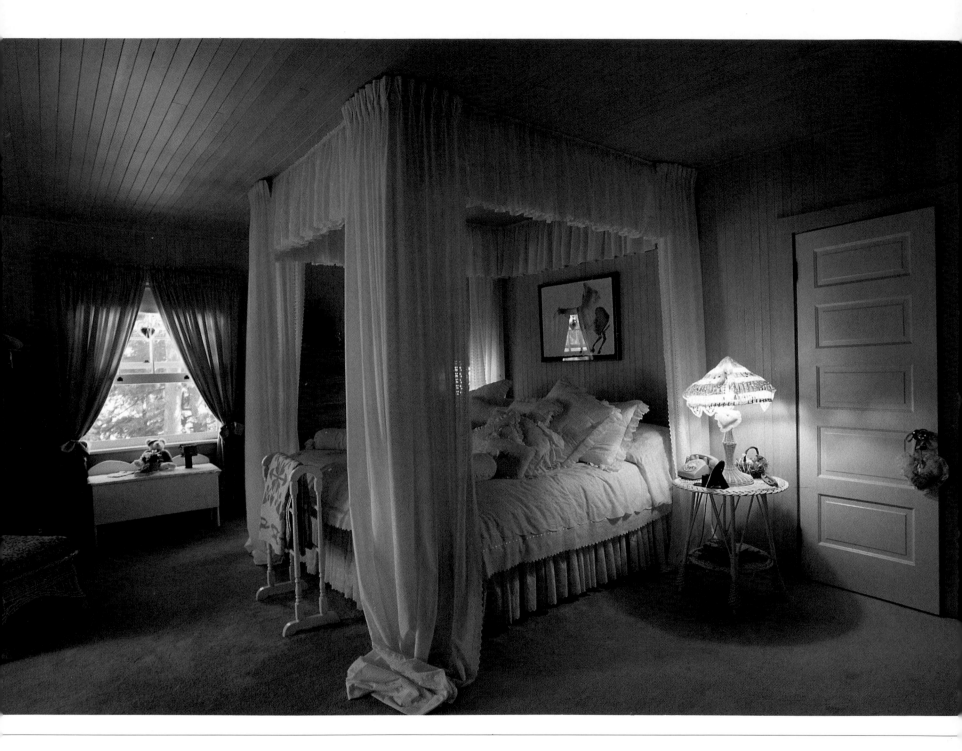

A romantic country look is achieved in
this Muskoka cottage bedroom. The four-
poster bed is clothed in layers of fresh
cotton and lace, potpourri hangs in lacy
envelopes from doorknobs, and thick
pink carpet cushions the floor.

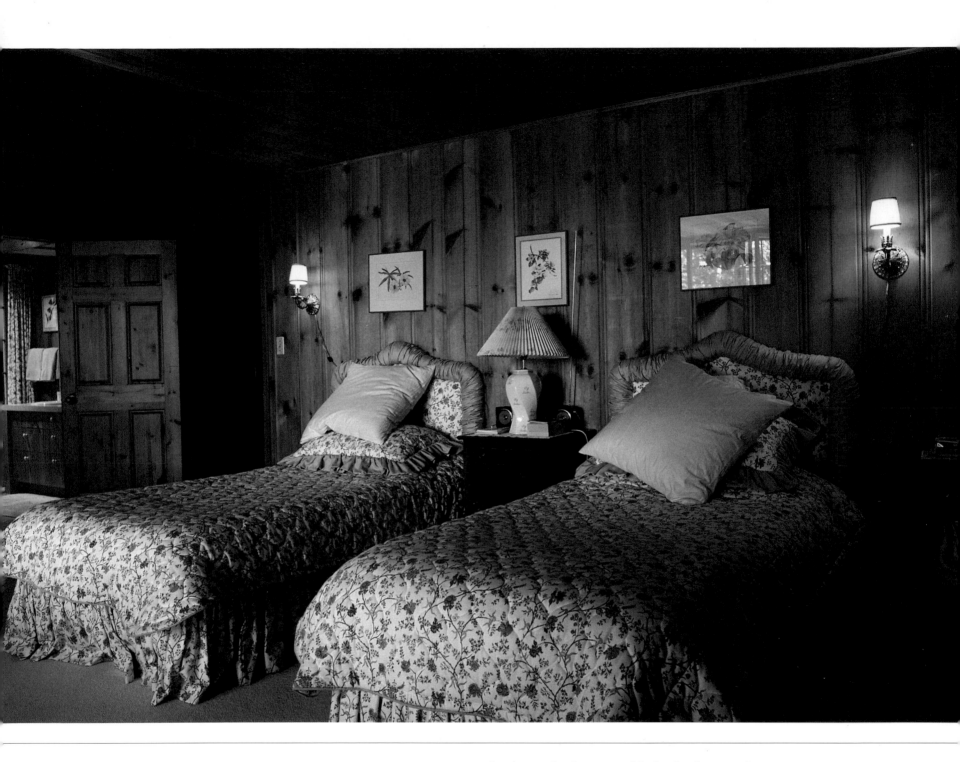

A master bedroom with its bathroom is a recent update to this 100-year-old cottage on Lake Joseph. "We're more interested in comfort than rustic," comments the owner, who spends the entire summer here.

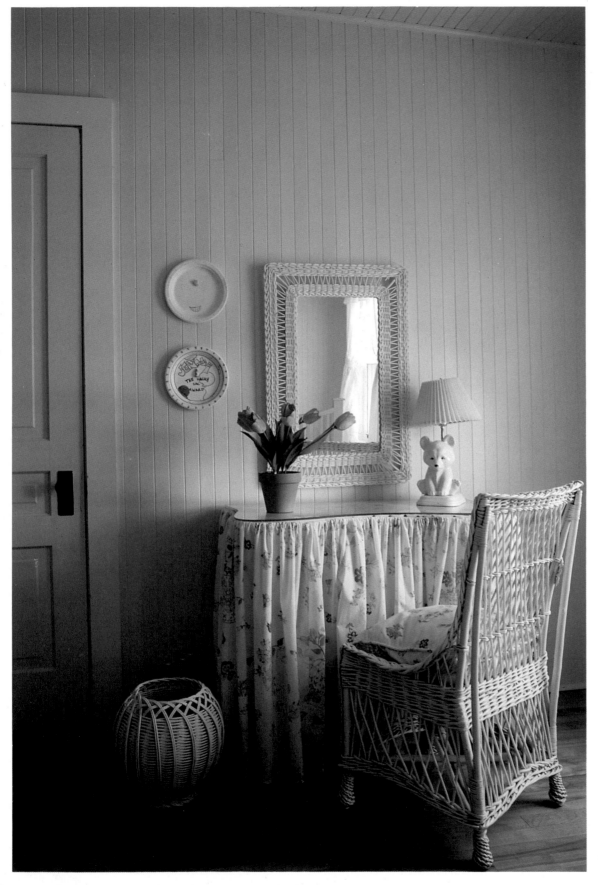

Summer serenity captured in a vintage Muskoka bedroom. "What I love about this place," says the owner of this rambling old cottage, "is it's architecturally so uncomplicated. There are no little dark rooms and all the bedrooms face the lake."

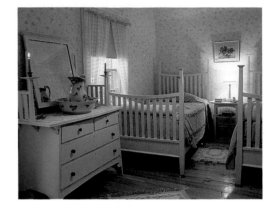

All the bedrooms in this 1895 Roche's Point cottage originally had dressers with candle stands, lace curtains and a complete china set for washing; most of these are still in good condition. Even the old wallpaper still hangs on some of the walls. "Preserving the old here is a constant chore," says the current owner, who lives in Texas but spends the summer season here, "every year I carefully wash the ancient lace curtains and lay them out on the grass to dry."

At right:
"The sunset view from this bedroom is the best in all of Georgian Bay," enthuses the owner, who grew up spending idyllic summers at this Go Home Bay cottage. "The rocks turn pink and the water becomes an incredible mix of violet and red. It's a breathtaking spectacle."

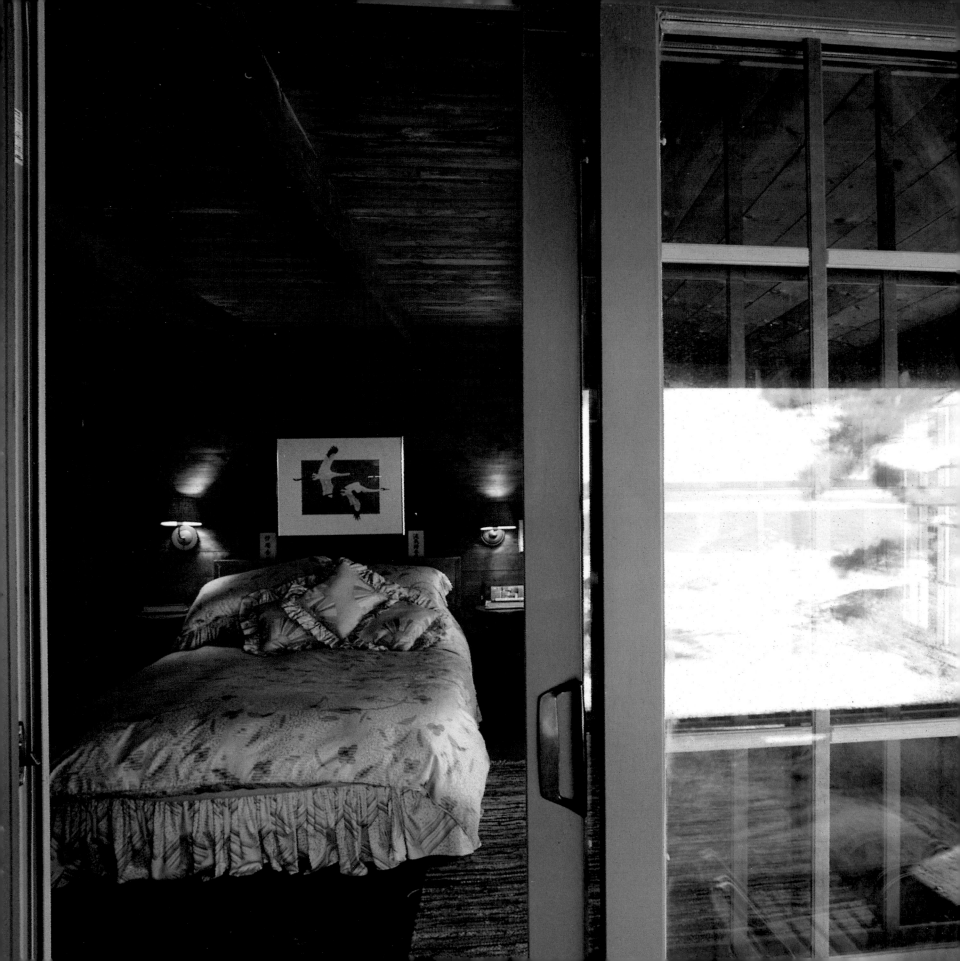

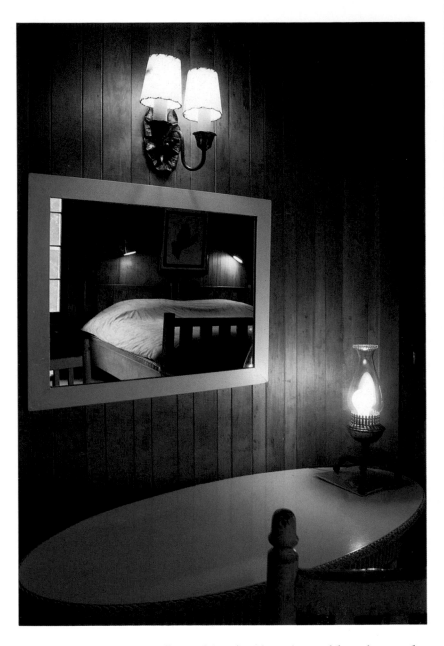

Reflected in the dressing-table mirror, the simplicity of an old-fashioned bedroom in a cottage on Lake Rosseau.

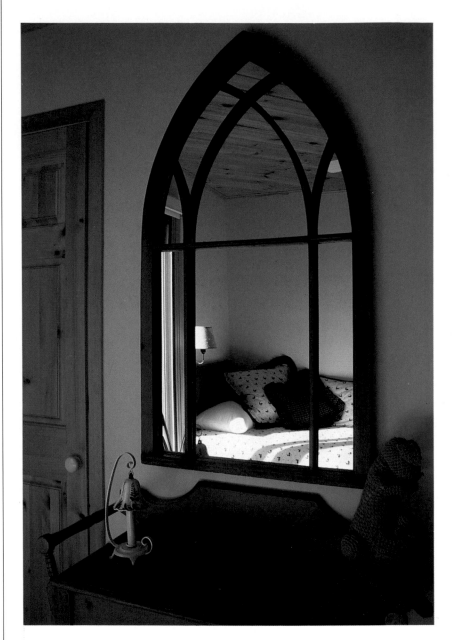

The bedroom of a Stoney Island cottage reflected in a Gothic mirror. "This cottage is so bright and airy," notes the owner, "that even on the dullest day I don't have lights on."

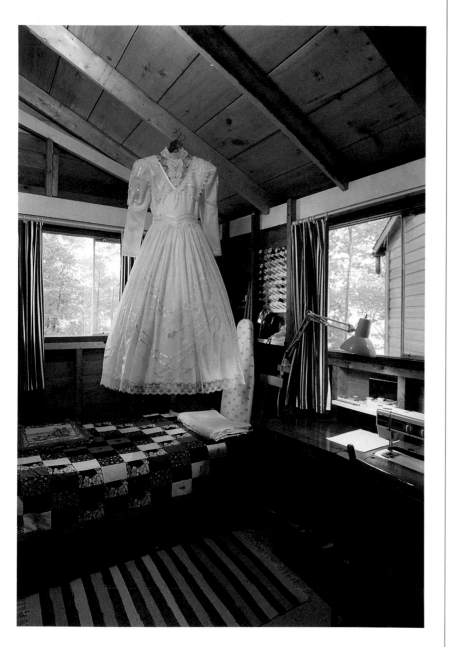

In small cottages like this one on Stoney Lake, the guest bedroom is an all-purpose space which can be easily converted to a sewing room when weddings take place.

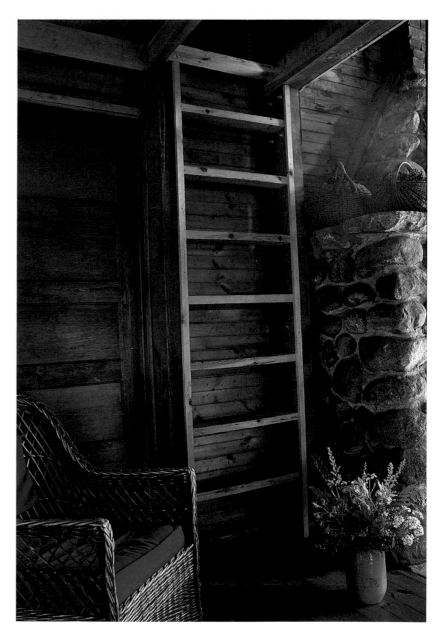

A ladder beside the stone fireplace leads to the sleeping loft in this Pointe au Baril cottage.

When this turn-of-the-century cottage was built on an island near Beaumaris, Lake Muskoka, the carpenter carved heart-shaped cutouts in the banister and furnishings. To perpetuate the theme, the current owners have filled the rambling cottage with hearts and teddy bears. In this guest bedroom, the heart pillows are made from old quilts.

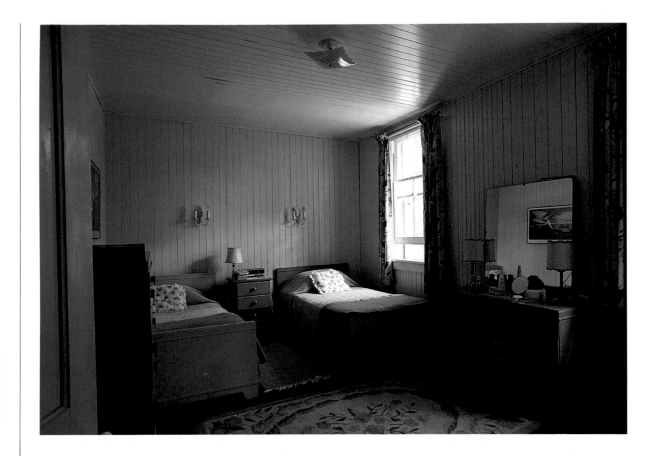

"I like pastels in bedrooms," states the owner of this Sturgeon Point summer home, "so the old tongue-and-groove cedar has been painted a different pastel colour in every bedroom."

Sailing is this Sturgeon Point family's summer obsession. Outside the boys' bedroom, the hallway is lined with regatta ribbons won over many years by family members.

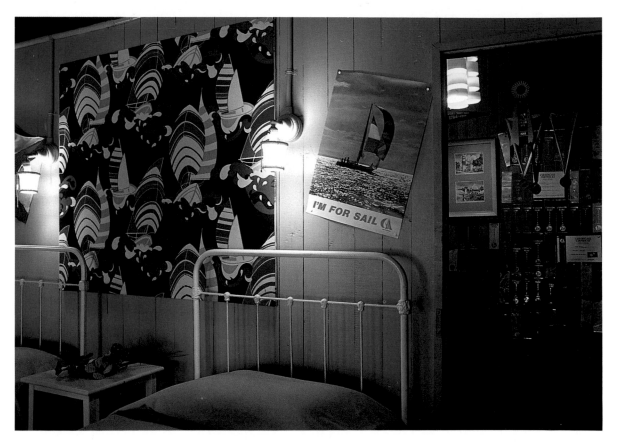

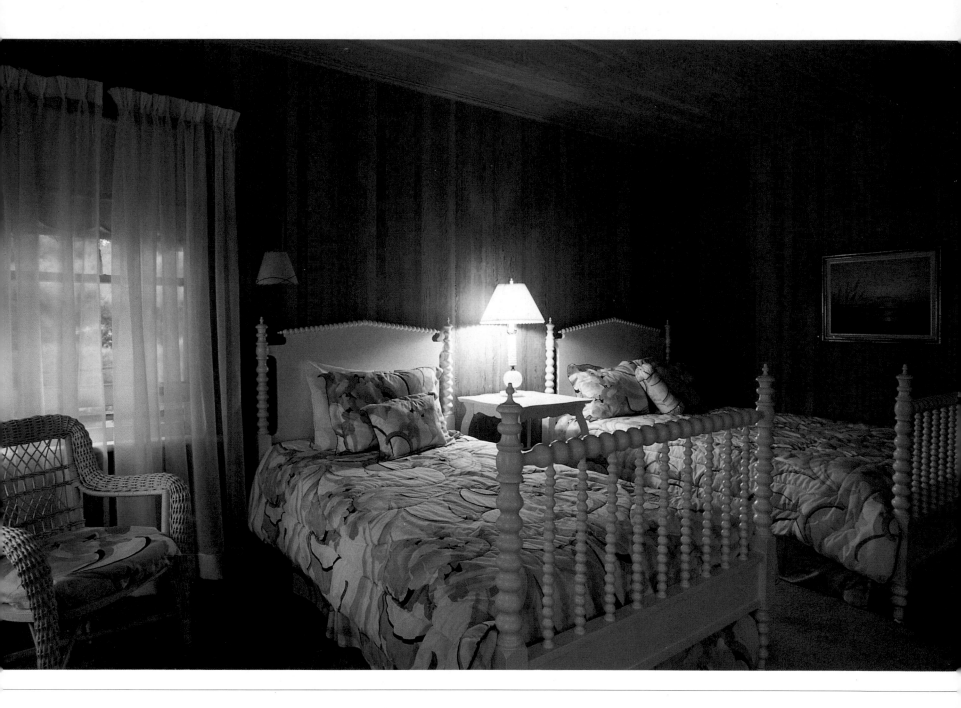

Lake breezes blow through filmy curtains
in the bedroom (1 of 13) of this enormous
Marco Island cottage. The boathouse and
cottage were built in 1900 by Peter Curtis,
one of Muskoka's master builders. The
owner, who bought it in 1981, says,
"When I first came into this old place
there was enough furniture up in the
attic to fill two more cottages."

A young girl's bedroom in a Muskoka cottage filled with lace, quilts and needlepoint cushions. White fans in all the bedrooms have stencilled designs on the blades and every window has a lake view.

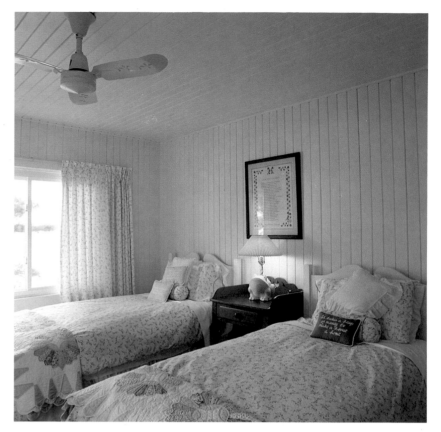

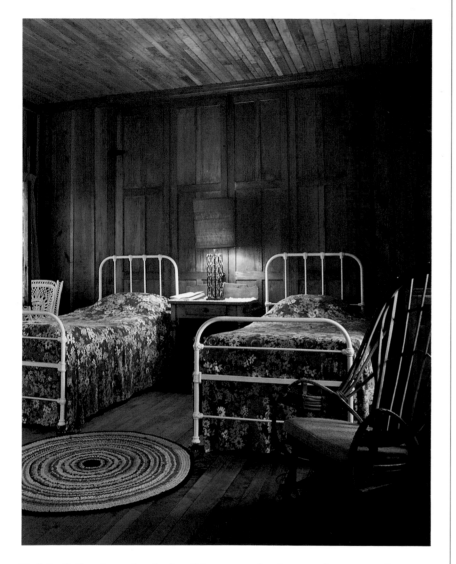

Behind the iron beds in this guest bedroom is a set of doors. "In the old days the doors would open to the adjoining room," explains the owner of this classic old Muskoka cottage, "then there would be one large room which was often used as a ballroom."

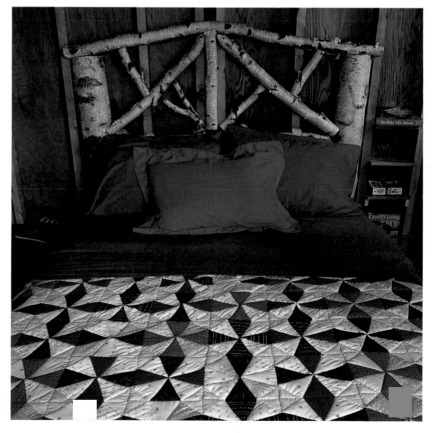

Rustic idyll. Sleeping cabins are more common than second-storey bedrooms on Georgian Bay islands. In this Pointe au Baril cabin, the birch headboard was made by the current owner.

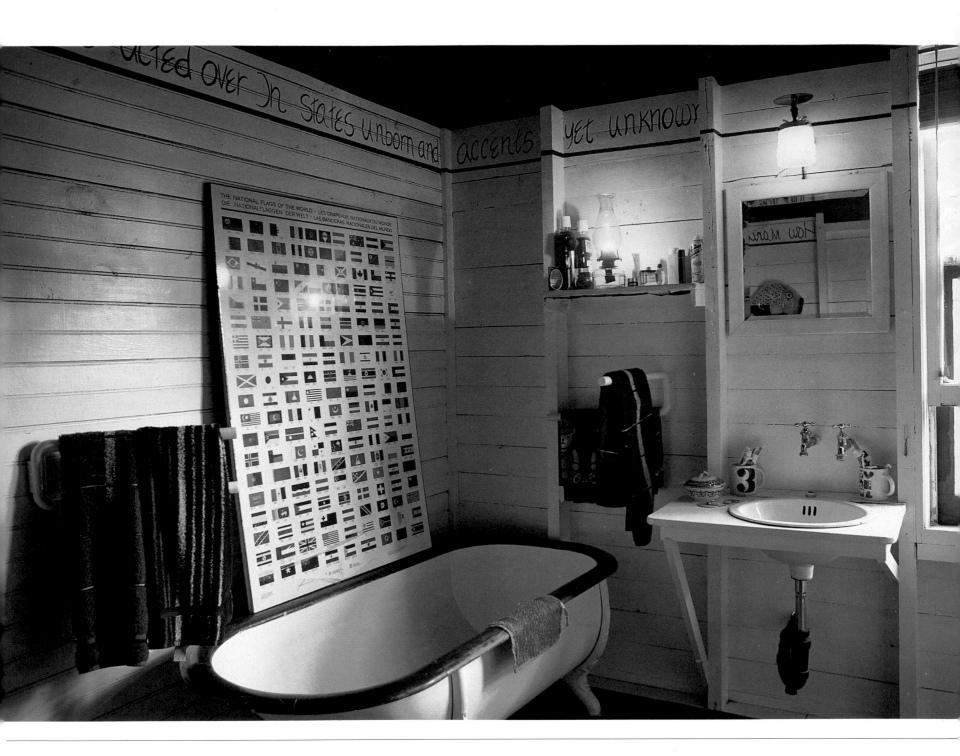

Scripted on the bathroom walls in this
Pointe au Baril cottage is a quote from
Julius Caesar: "How many ages hence
shall this our lofty scene be acted over in
states unborn and accents yet unknown."

PRIZE PRIVIES

No room in these summer cottages has been through more changes than the washroom. As plumbing improved we moved from the old wooden outhouse tucked discreetly in the woods to the indoor bathroom with clawfoot tubs and running water. "Something is missing since plumbing moved indoors," lamented one Georgian Bay cottager with fond memories of outdoor privies. And indeed, at many old places, much of the cottage lore has to do with outhouse adventures in the good old days, hilarious tales of nighttime encounters with wildlife and spiders emerging from the depths. But now we have septic systems and holding tanks — and quaint reminders of their fragility tacked to bathroom walls.

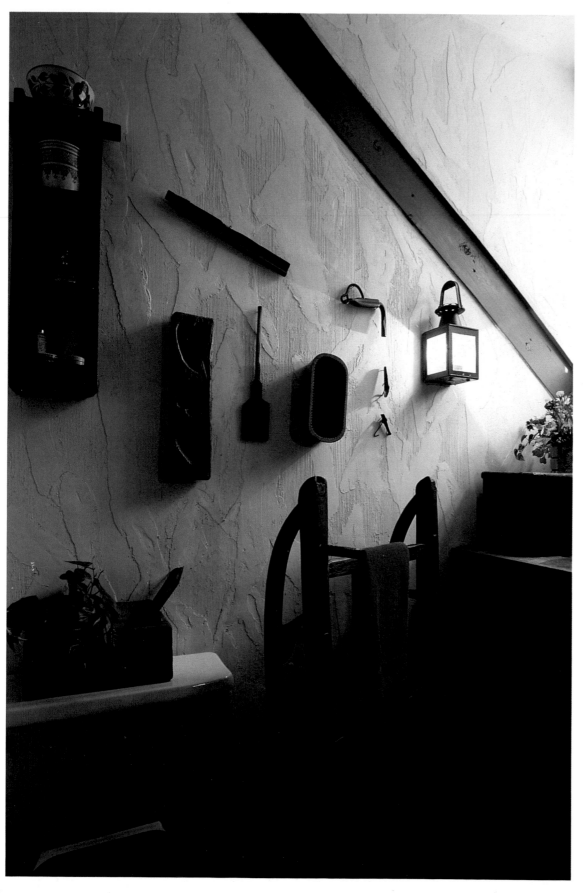

An old wooden ice sleigh, recycled as a towel holder, and other country auction finds add interest to a Lake Joseph cottage.

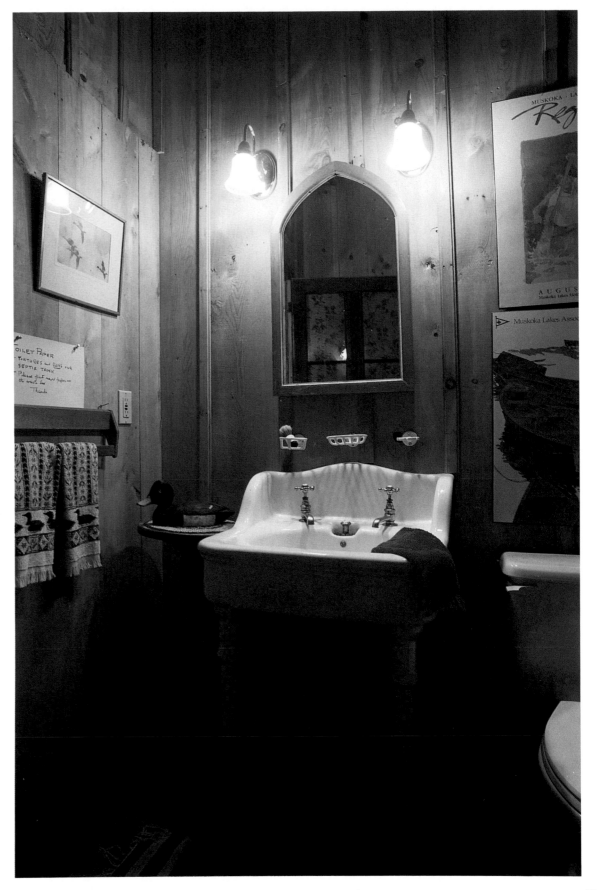

Tacked on the walls of many cottage bathrooms is a gentle reminder about the ever-so-fragile septic system.

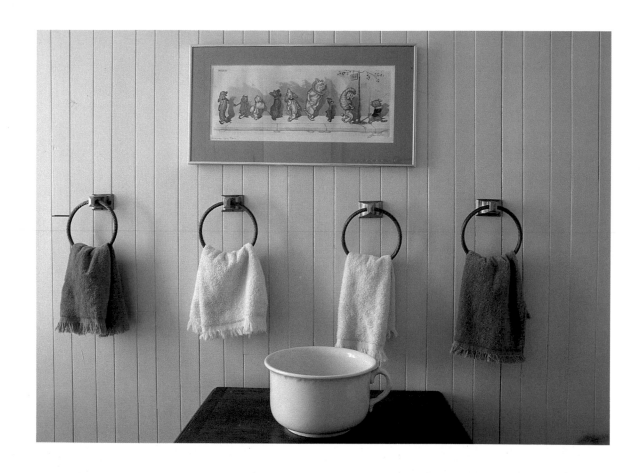

A bathroom vignette in a boathouse on Lake Joseph.

Elegant porcelain basins and marble vanities reflect the Victorian formality of cottaging at Roche's Point on Lake Simcoe.

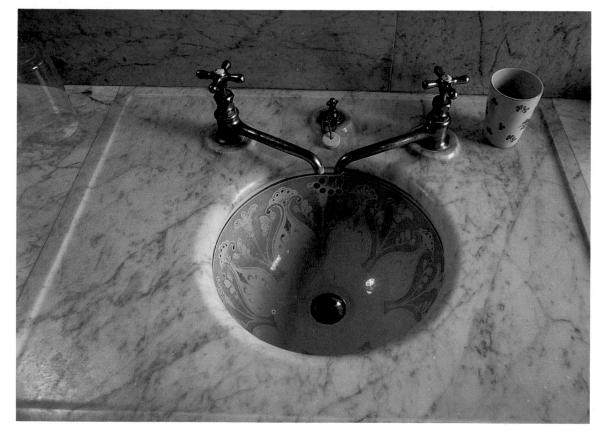

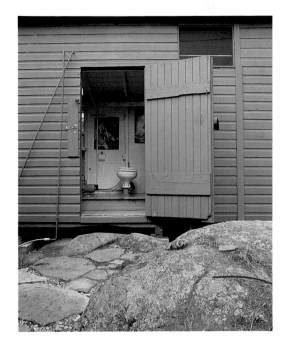

The bathhouse, with a shower, sink, toilet and washing machine, was converted from a wood and coal storage shed built 75 years ago at Wee Island on Stoney Lake.

Waiting at the outhouse.

A ground-floor powder room tucked beneath the stairs in a vintage Lake Rosseau cottage.

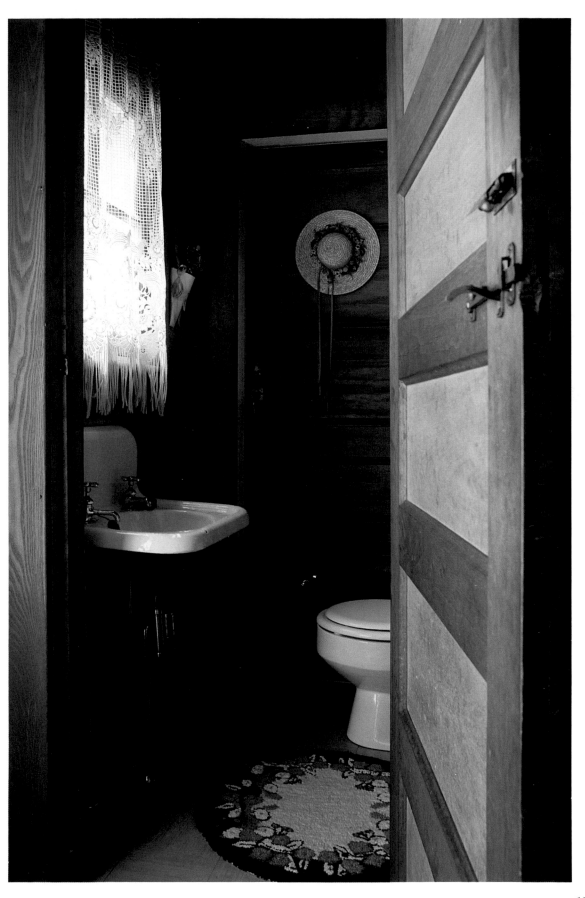

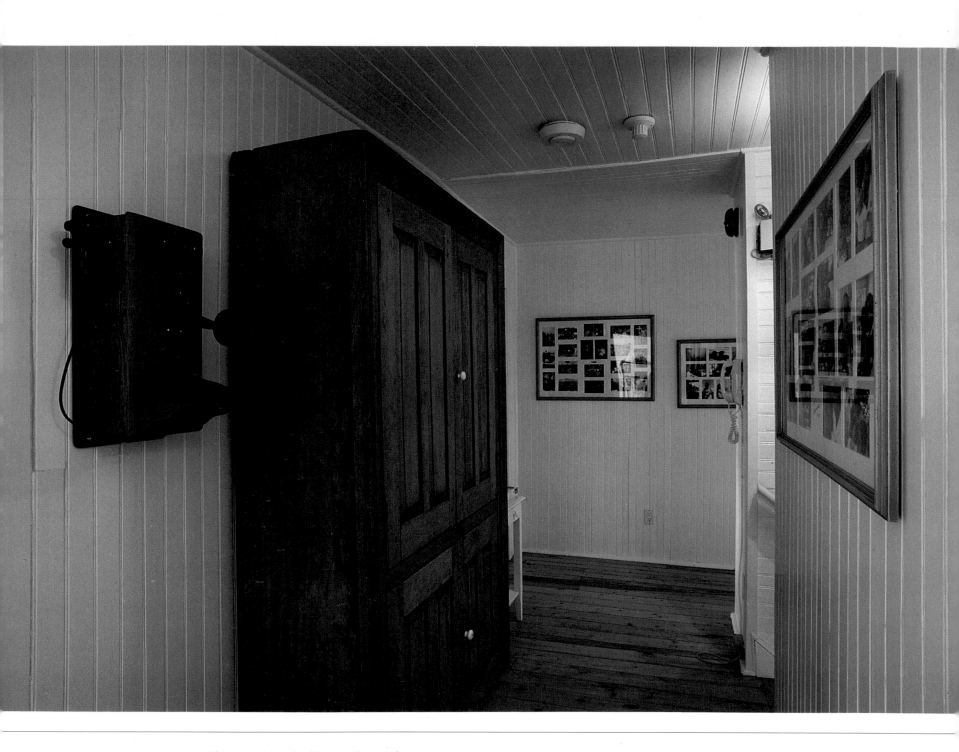

The upstairs hallways in early cottages
were often large enough to be playrooms
for children on rainy days. With several
large bedrooms as well, there was little
consideration for the economy of space.
In this airy Muskoka cottage there's
plenty of wall area for family photos.

GRAND HALLWAYS

"Whenever I think of rainy days at the cottage," recalled one old-timer who grew up in a summer mansion on Lake Rosseau, "I remember the upstairs back hallway. I think we called it the servants' hallway, but we children turned it into a raceway on rainy days. We had more fun racing along the hardwood floors and up and down the back staircase. I think my feet still have slivers from those days."

Back in the days when cottages were built on a

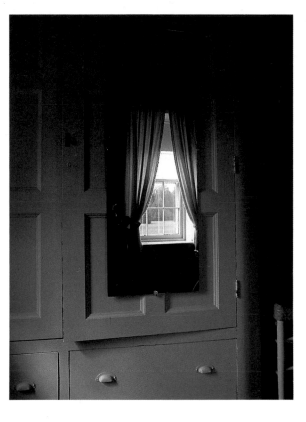

grand scale and the stairs leading to the second floor were as wide as a king-size mattress, there was often a morning room off the upstairs hall where tea was served to the early risers. And usually, tucked at the end of a corridor near the back staircase, there was a walk-in closet lined with tin. It was here, at the end of summer, that all the freshly laundered bedding would be stacked in neat piles, safe from the mice and squirrels and protected from the winter dampness.

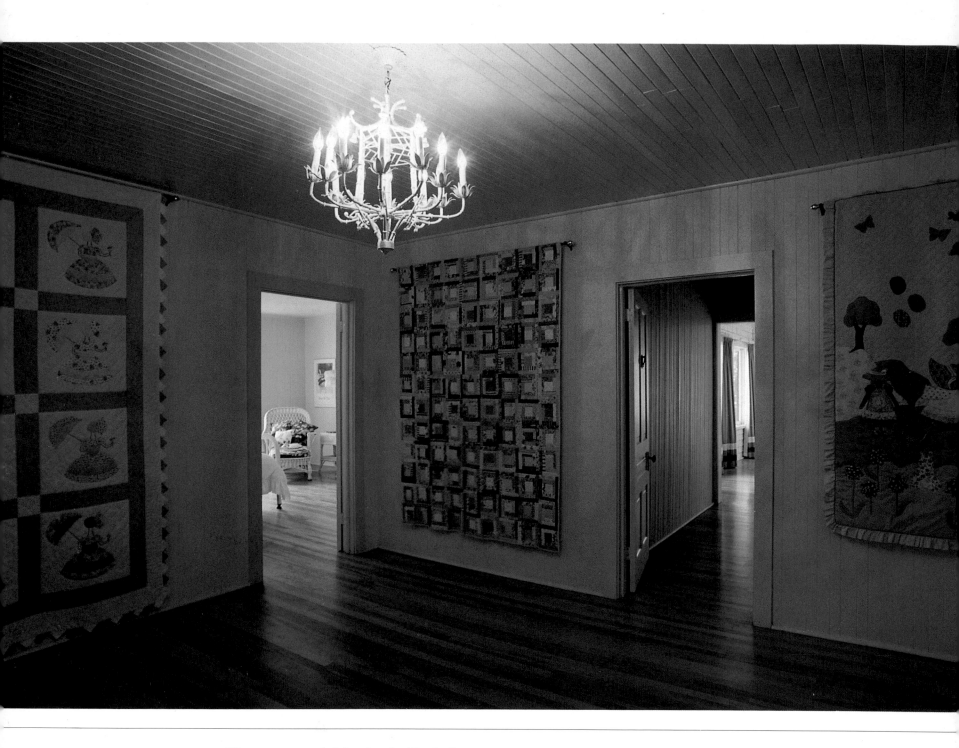

The owners of this classic Muskoka
cottage prefer to keep their two-months-
a-year summer house as uncomplicated as
possible. "When we moved here, we threw
out 80 years of accumulated house gifts,"
claims the owner, "It taught me
to resist clutter."

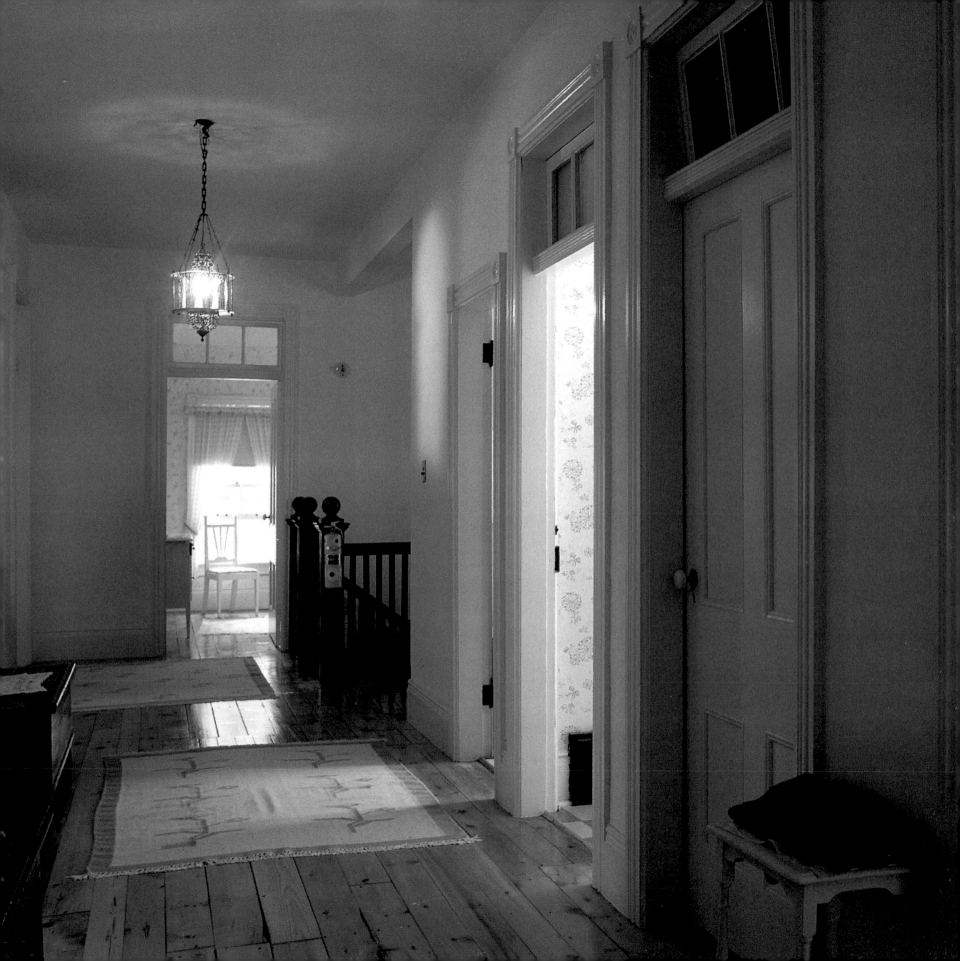

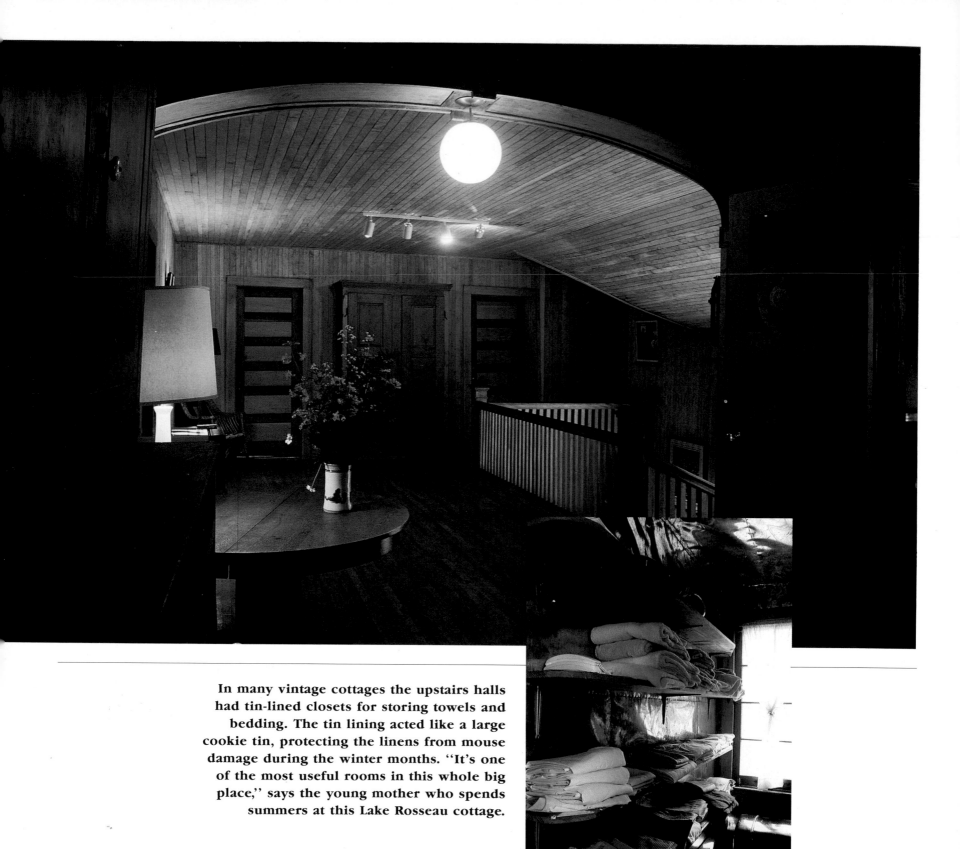

In many vintage cottages the upstairs halls had tin-lined closets for storing towels and bedding. The tin lining acted like a large cookie tin, protecting the linens from mouse damage during the winter months. "It's one of the most useful rooms in this whole big place," says the young mother who spends summers at this Lake Rosseau cottage.

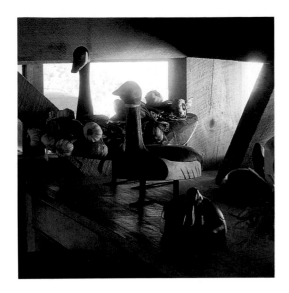

A gaggle of geese decorate a ledge in the front hall of a Muskoka cottage.

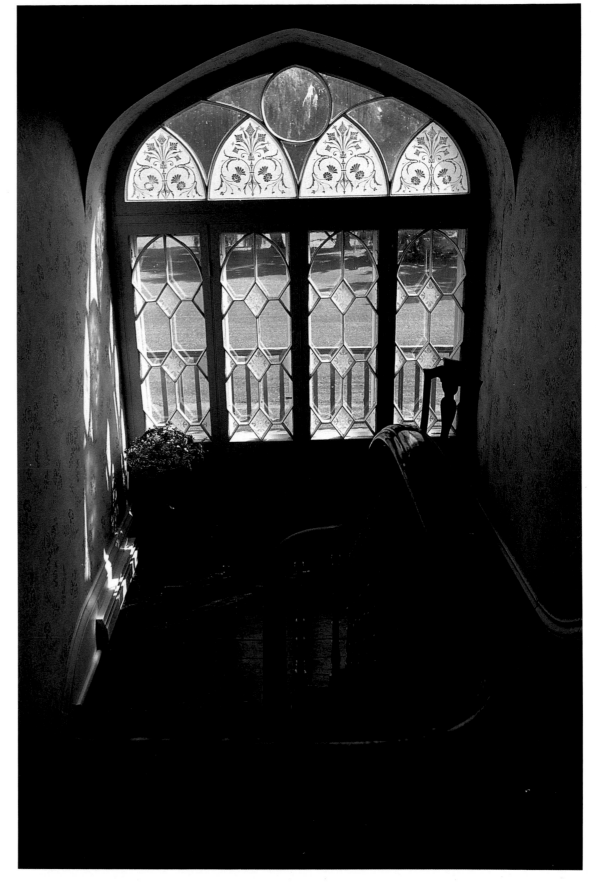

At Roche's Point the stairway landing is flooded with light from a lovely window of etched and leaded glass.

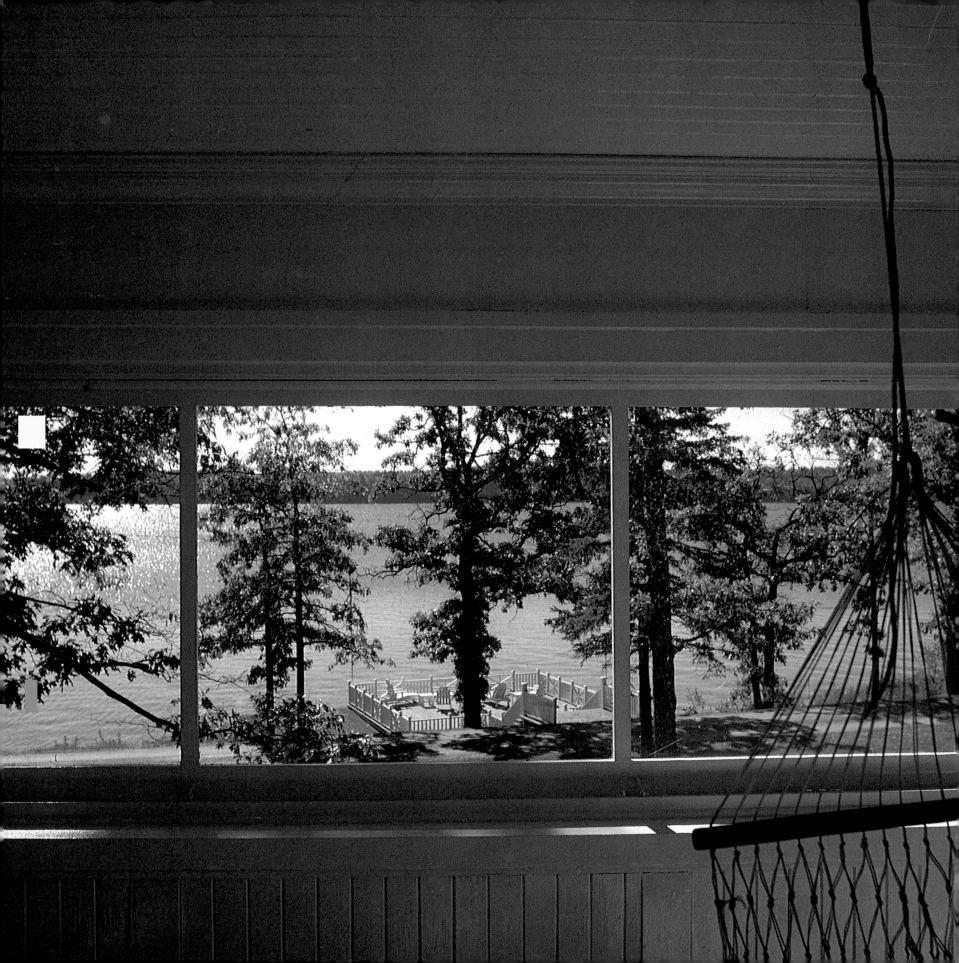

A ROOM WITH A VIEW

About the most valued of all cottage assets is a heart-stopping view. Settled in our quiet getaways we treasure the wraparound vistas of rock, water and woods, finding solace in the gently changing states of nature. The two words most mentioned when cottagers talk about their views are *private* and *unchanging*. For those who summer in gracious estates along the south shore of Lake Simcoe, the view is of tall cedar hedges and formal gardens, some of them laid out by Frederick Law Olmsted, the designer of Central Park in New York. The scene beyond the

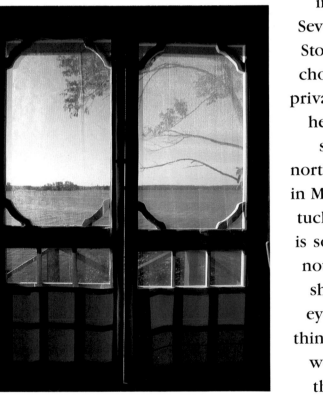

bedroom window is lush, green and romantic.

In contrast, a Georgian Bay islander looks out on the austere landscape of wind-swept rock and twisted pines immortalized in paintings by the Group of Seven. One cottager on Stoney Lake claims she chose the place for the private view of great blue herons feeding on the shore. And up at the north end of Lake Joseph in Muskoka, a boathouse tucked in a lonely cove is so private that there's nothing but untouched shoreline as far as the eye can see. The more things change, the more we treasure the things that remain the same.

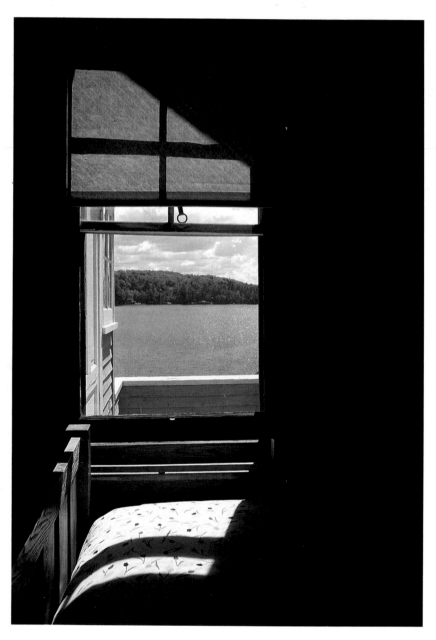

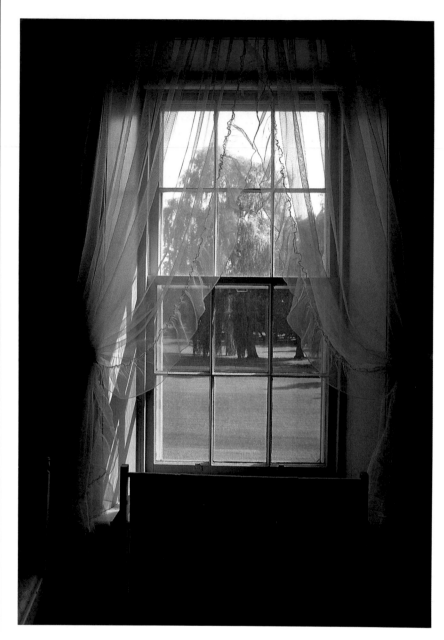

From the boathouse bedroom a heart-melting view of Lake Joseph.

Lush greenery beyond the bedroom at Roche's Point on Lake Simcoe.

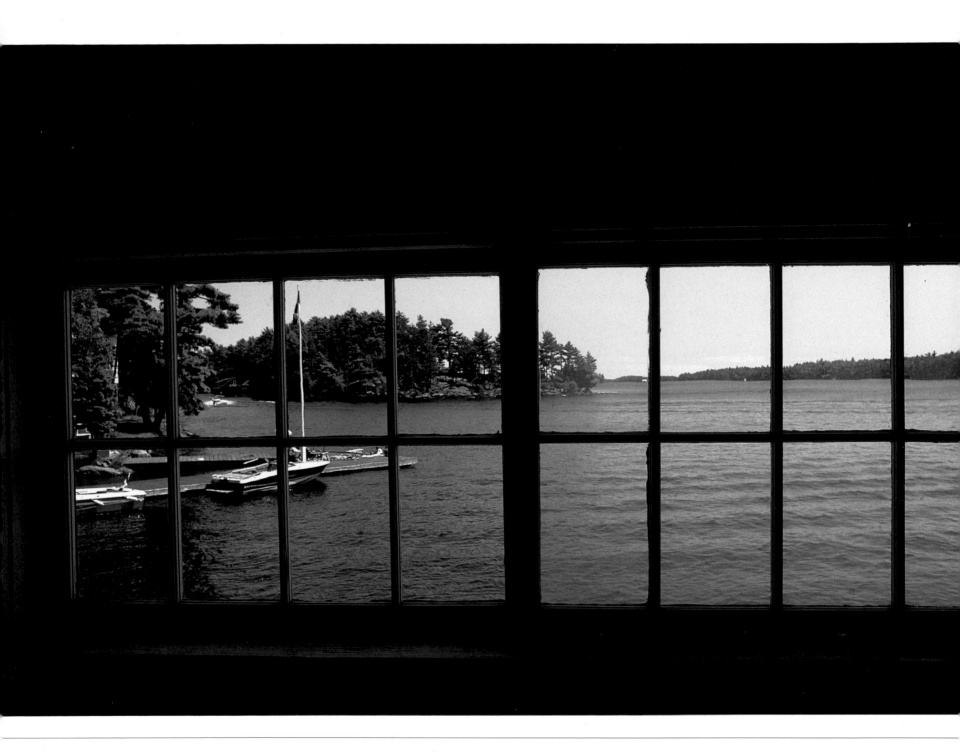

**A boathouse view of waterfront activity
at Beaumaris on Lake Muskoka.**

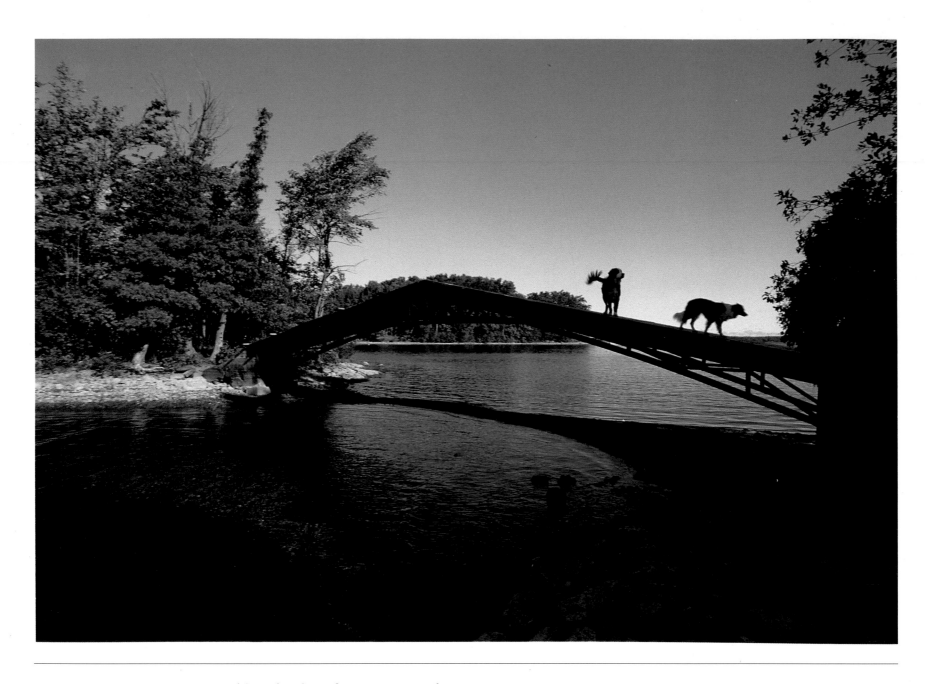

**Watching the dogs from a cottage in
the Rideau Lakes.**

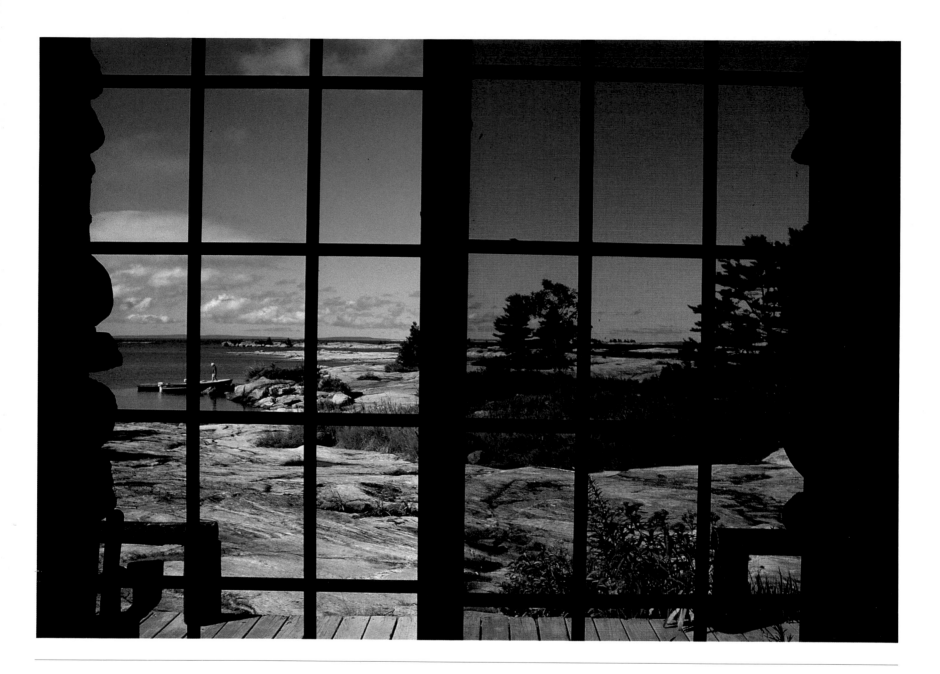

The rocky front yard of a cottage at Go Home Bay. "This place means so much to me that when I was getting married I told my husband if he didn't love Georgian Bay the whole thing was off," says the owner, who spent her childhood here.

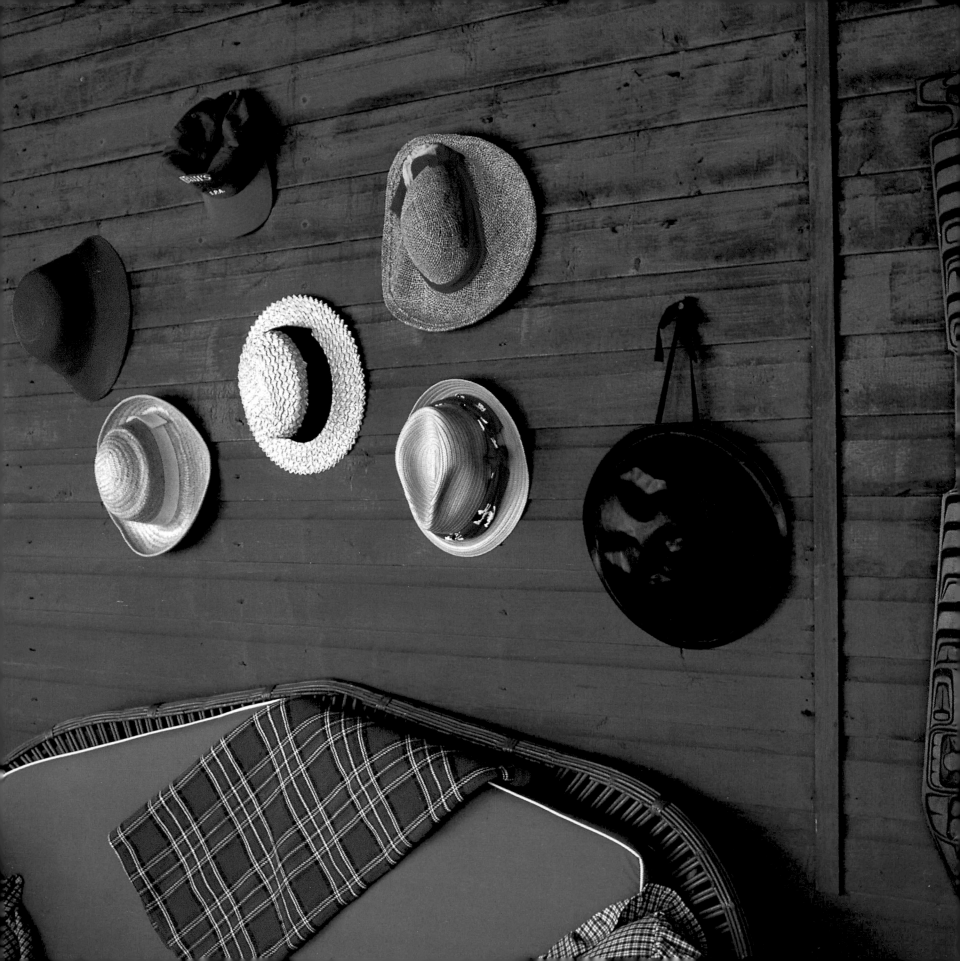

WALLWORKS

*A Latin motto used to be carved above the doorways of English country cottages.
It read, Parva Sed Apta — "small but just right."*

A cottage is a place that wraps around us in a cozy fashion, a cocoon that insulates us from our urban cares. And in this comfortable setting we store treasures that remind us of other summers — gifts from friends, photos of childhood, relics from the past. One cottager who bought a vintage Muskoka cottage claimed that she threw out years of odds and ends when she moved in. "I resolved afterwards," she said, "to never take a house gift to a cottage that can't be eaten, drunk or worn."

But the temptation to crowd our cottage walls with things that revive memories is mighty powerful. Among the favourites are family photos, black and white with curling corners thumbtacked to the wooden wall; regatta ribbons that go back to grandfather's day; old paddles, snowshoes, canoes and carpenter's tools; maps (both old and new); collections of everything from straw hats to kitchen gadgets; and amateur paintings of the cottage done by house guests who might return.

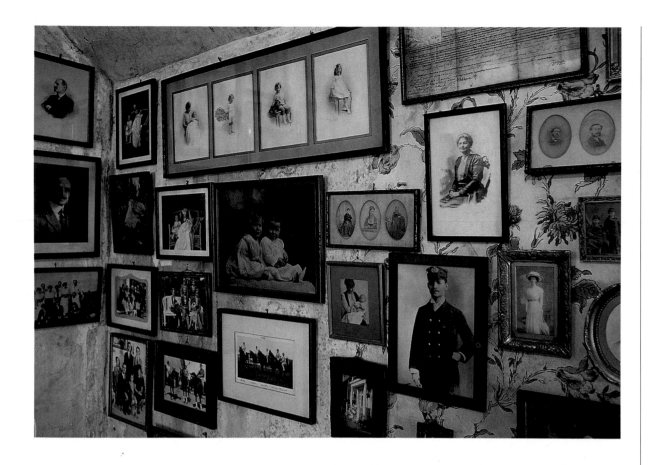

Ancestors peer out from yellowed photographs on the wall of this Roche's Point cottage. The same family has summered here since 1923, preserving the grand old cottage the way it always was. Peeling wallpaper dates back to 1929. "My father chose all the wallpaper," claims the owner, who keeps framed pieces of the old paper as reference, "so when it absolutely has to be replaced, I try to find something close to his original choice."

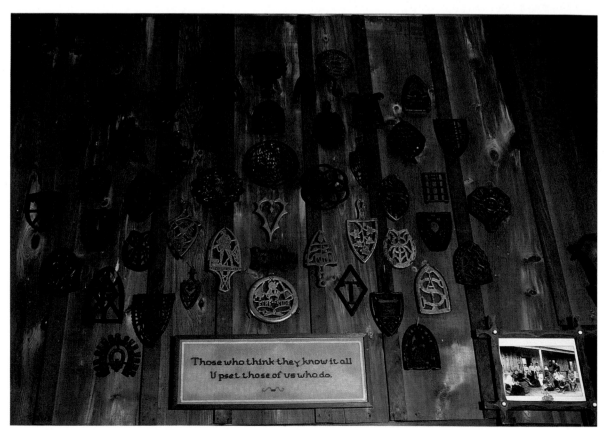

A collection of trivets covers the board-and-batten walls of a vintage Muskoka cottage kitchen. "Many of these were in the cottage when we bought it," says the owner, "but then we began to collect kitchen gadgets and trivets, and they just kept spreading across the walls."

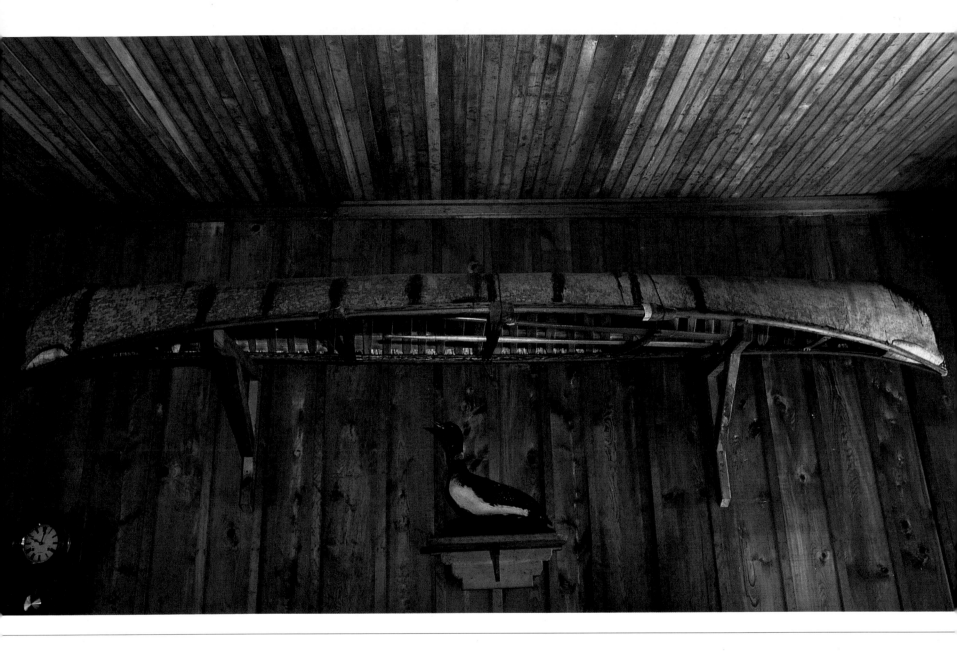

The birchbark canoe belonged to the original owner and has become almost a symbol of this Lake Rosseau island cottage. "I used to canoe around this island every evening with my children," explains the cottage patriarch, "and we always stopped to talk to the elderly lady who lived here. She greatly appreciated canoes and enjoyed our nightly chats. To my surprise, when she died, she left us first refusal rights to buy the island. We bought it and we've been here ever since."

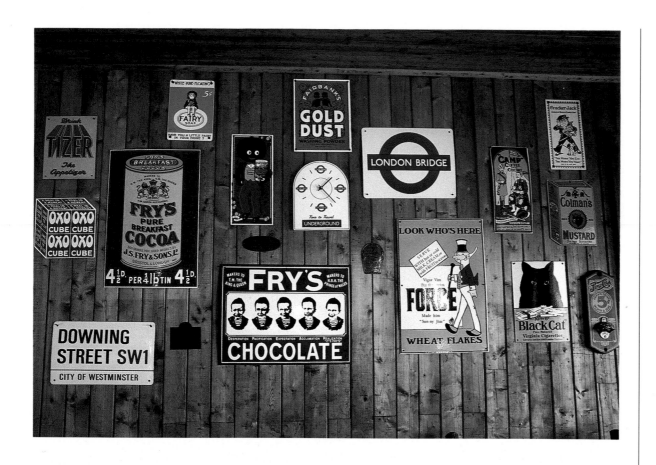

Vintage tin advertising signs brighten a boathouse wall on Lake Rosseau.

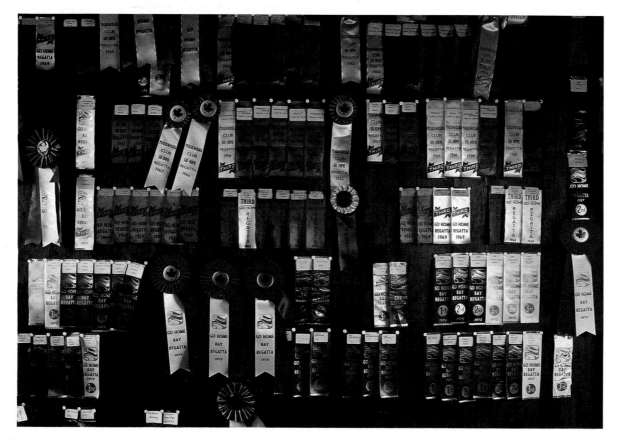

Regatta ribbons suggest family boating prowess and add colour to the weathered wooden walls at Go Home Bay.

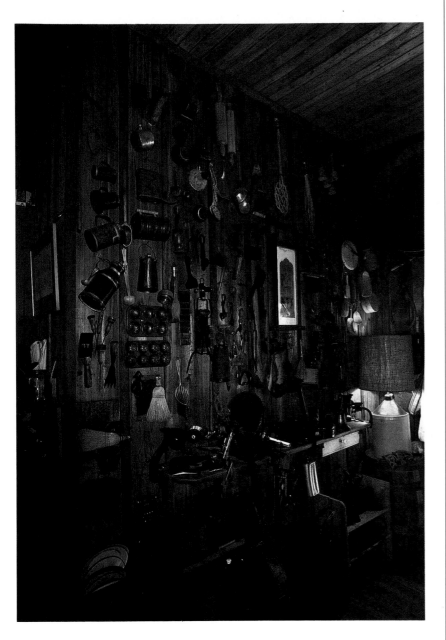

Some of these vintage kitchen tools are still in use at this Lake Rosseau cottage.

Fishing is one of many summer pursuits at Go Home Bay.

At this Stoney Lake cottage, the tiny guest
bedroom and canoe house are combined.
A door in the bedroom wall opens so that
canoes and rowboats can be pulled in
for winter storage.

GUEST CABINS AND BUNKIES

In the early years, getting to the cottage was a bittersweet experience involving lengthy treks on trains and steamships, and tedious layovers on railway sidings. Consequently, once there, families usually settled for the entire summer. Later, when highways and back roads were carved into the area, cottagers began arriving by car. Even though the trip was still long and arduous, it

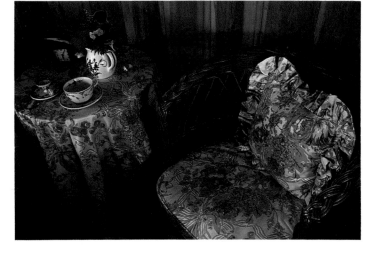

could be done on a weekend. Soon a new category of cottager was born — the weekend guest.

At many cottages, the guest cabin had humble origins. Often it had been the icehouse, laundry room or, in one Muskoka cottage, the workroom for the boat chauffeur. In Georgian Bay, where island cottages tend to be one-storey rock-hugging structures, shingled sleeping cabins were built as need arose. Today the cottage may encompass a string of cabins scattered across the island. The term *bunkie*, an abbreviation of *bunkhouse*, originally meant a workman's house, but in cottage vernacular, it's often the sleeping cabin used by the children. "One of my fondest childhood memories was moving into the bunkie with my brother for the summer," recalled an elderly cottager. "I can remember the feeling of freedom, of having our very own four walls, far removed — at least 30 feet! — from the eyes and ears of our parents."

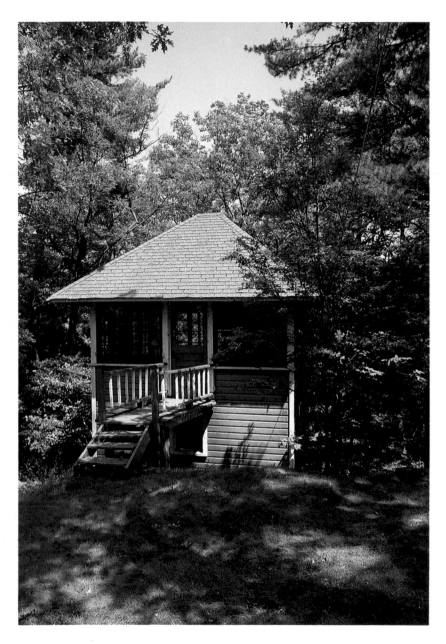

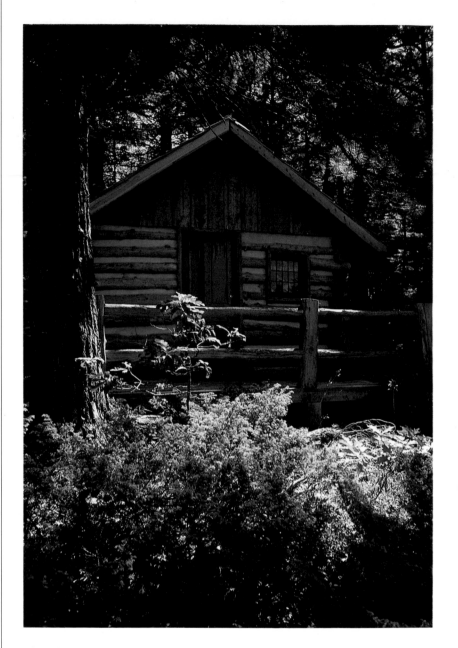

A tiny bunkie tucked in the woods behind a 1000 Island cottage has been a favourite place to sleep for generations.

This log cabin was built by hand using hemlocks from the Lake Joseph property and windows from an old Muskoka hotel. The children now use it as a rainy day playhouse.

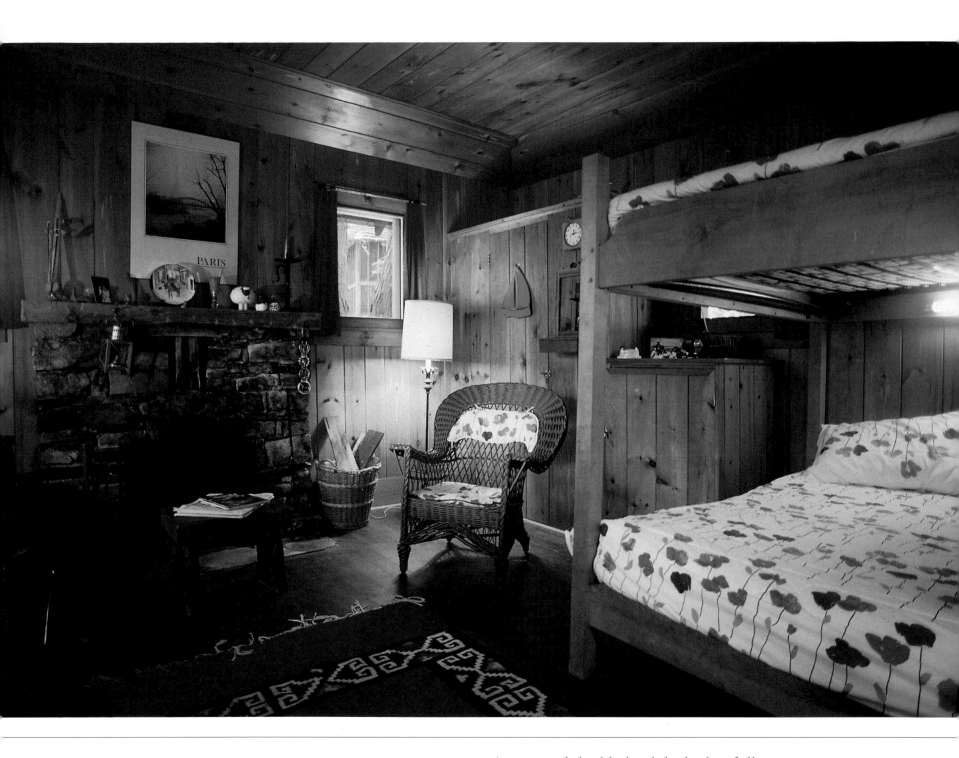

An unusual double bunk bed takes full
advantage of the small space in a Lake
Rosseau sleeping cabin. Like the other
guest cabins in this island compound,
it has a fireplace as well.

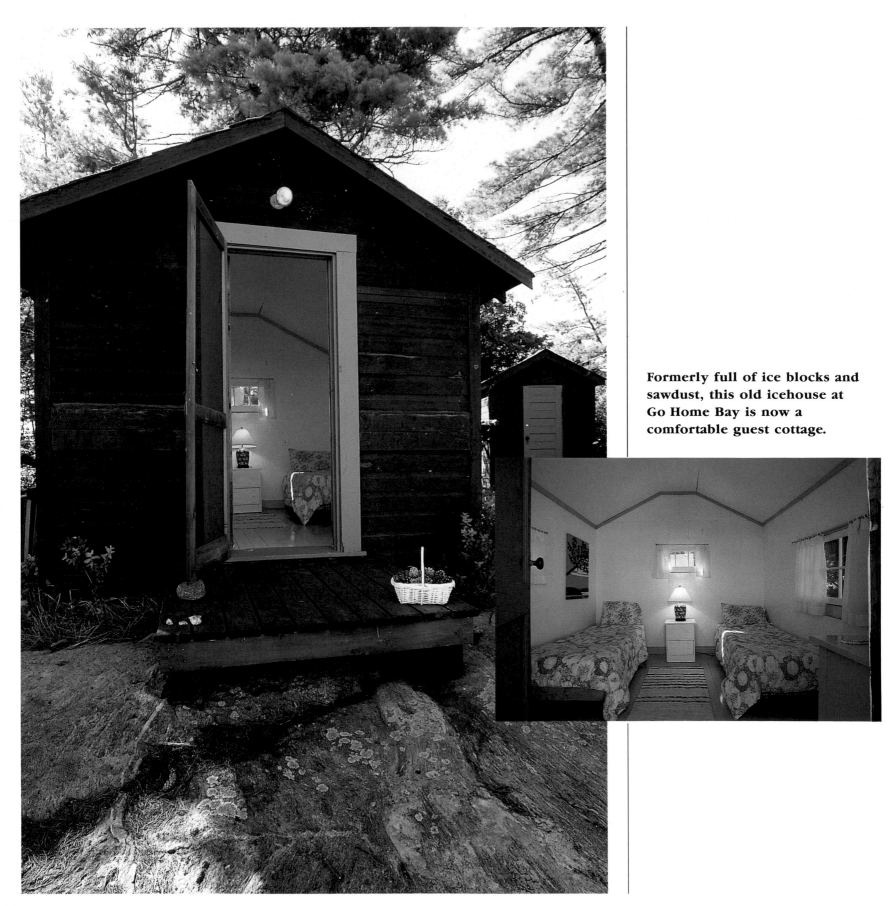

Formerly full of ice blocks and sawdust, this old icehouse at Go Home Bay is now a comfortable guest cottage.

Sleeping bunkies, Muskoka style.

SNORE INN

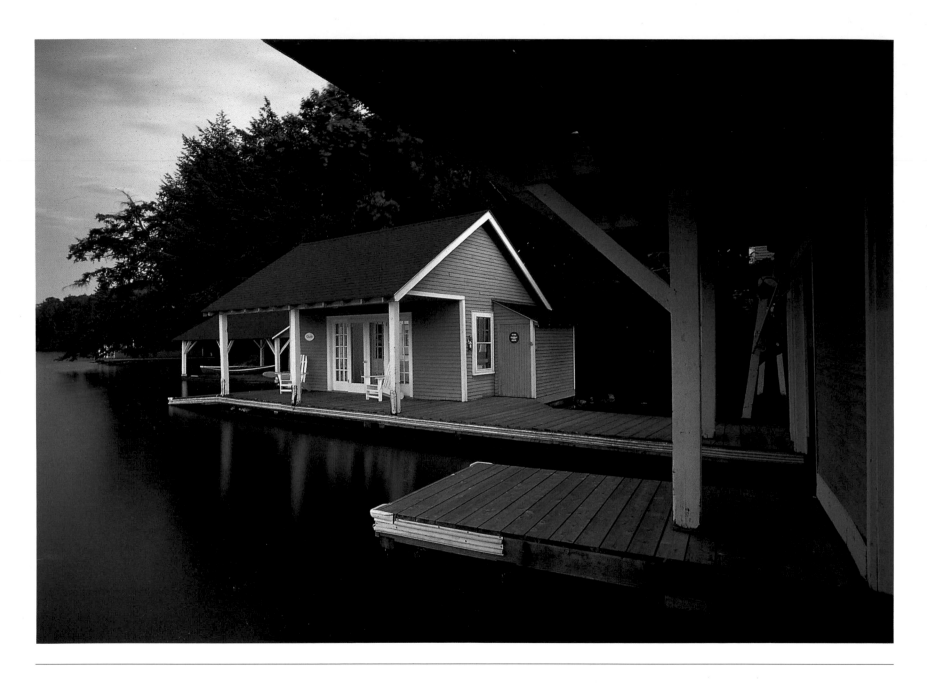

A waterfront guest cottage on Lake Joseph.

At right:
**Guests at this Pointe au Baril cabin
enjoy the breezy pleasure of a
panoramic view of Georgian Bay.**

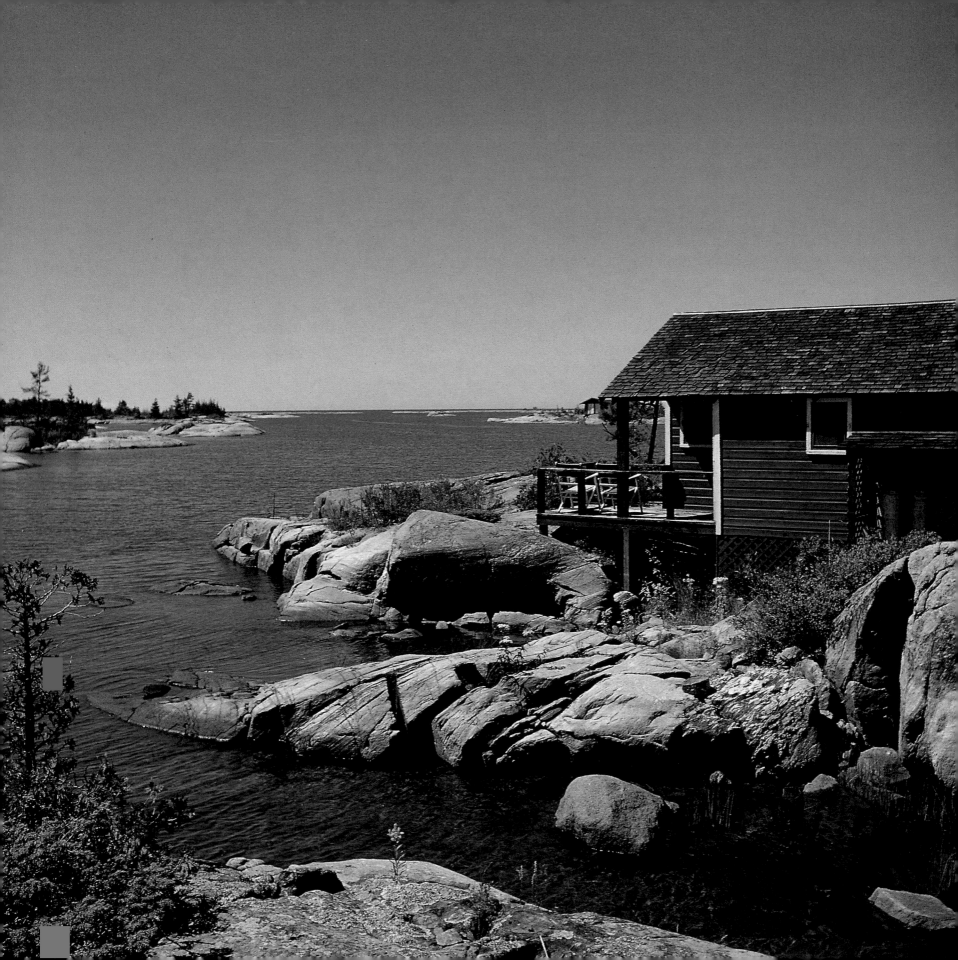

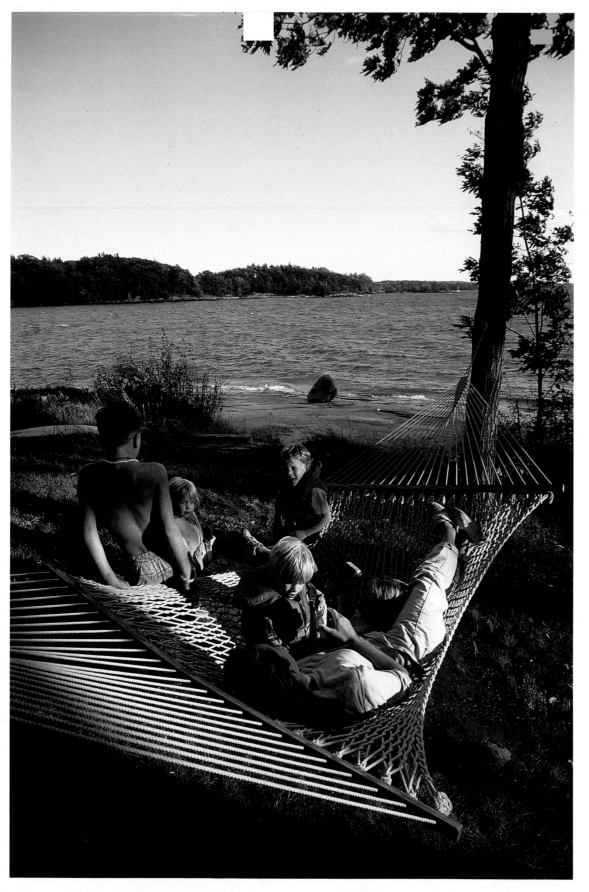

HAMMOCKS

Originally intended as shipboard beds, hammocks now represent the essence of summer relaxation. Whether strung across the corner of a porch or between two birch trees on a cottage lawn, there's no better place to spend an afternoon listening to birdsong and the rustle of leaves in the summer breeze.

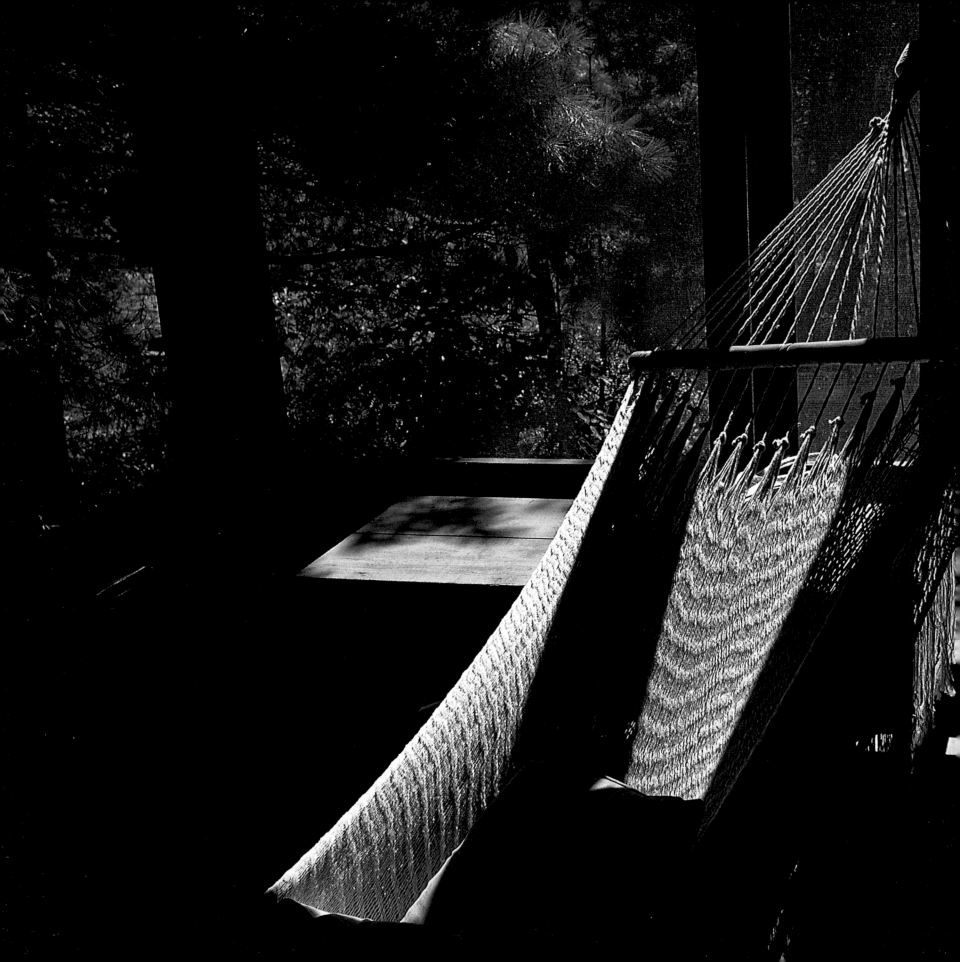

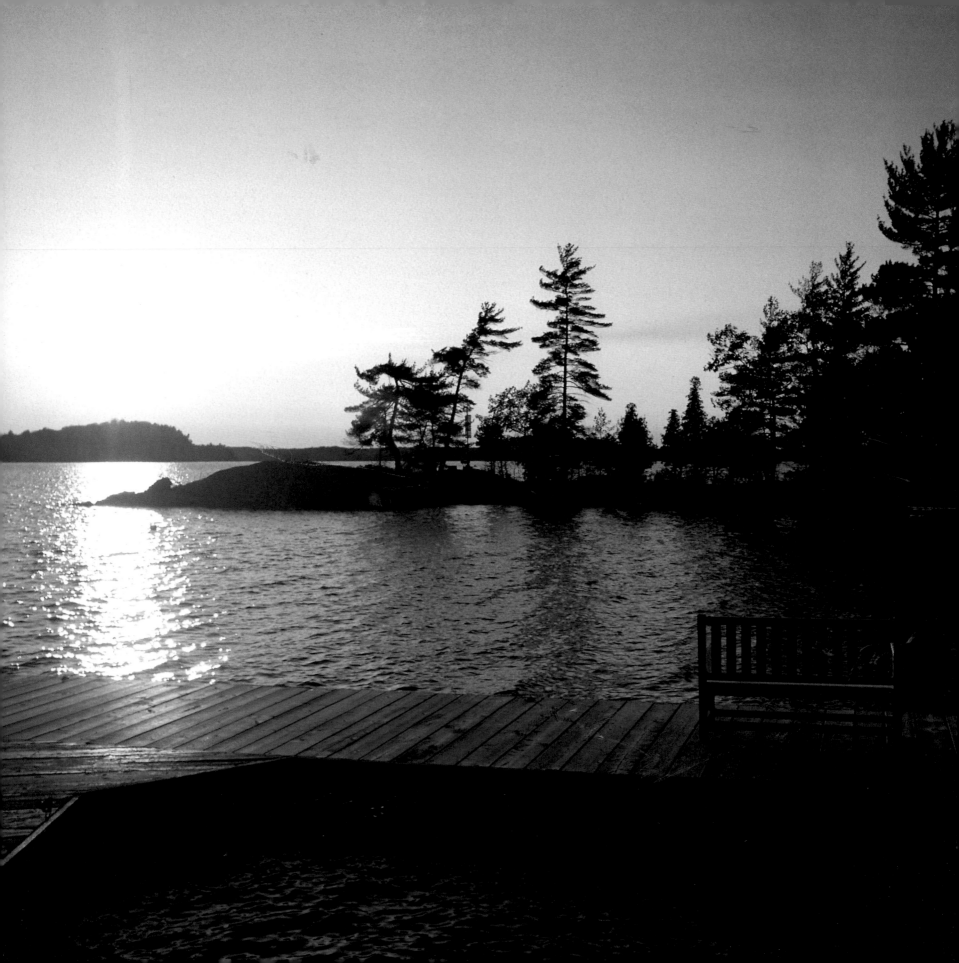

JUST FOR TWO

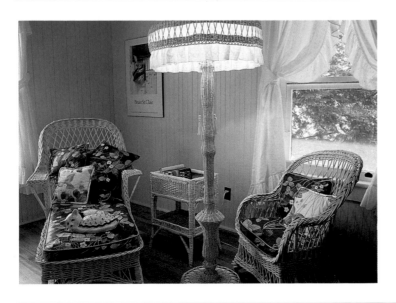 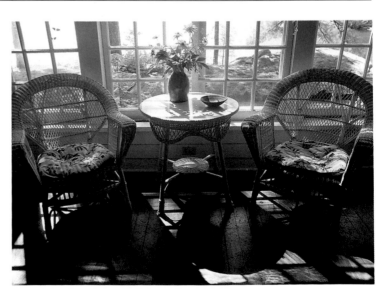

BURSTING WITH BLOOM

One of the first signs of summer in cottage country is the arrival of annual plants at local nurseries. Flat after flat of petunias, geraniums, impatiens and begonias are trucked in to roadside nurseries, creating fields of colour in the still-brown land. Then, on the long Victoria Day weekend in May, cottagers begin perusing the selections, dreaming of glorious successes on their summer porches.

For island dwellers this annual flurry of planting means lugging bags of soil and peat moss, flats of flowers, and clay containers from car to boat to dock to garden. At one 7-acre island in Lake Rosseau, 10,000 annuals are barged in every spring. All the pathways are lined with begonias, window boxes brim with petunias and ivy, stone statues are surrounded by clumps of geraniums, and an old cedar-strip canoe is filled with earth and planted with bright pink impatiens. Along the shore-line known as Millionaires' Row at Beaumaris, on Lake Muskoka, the more opulent the boathouse, the more dazzling the window-box display. Reaching their peak of perfection about midsummer, these fanciful boxes brimming with colourful blooms are a tourist attraction all on their own.

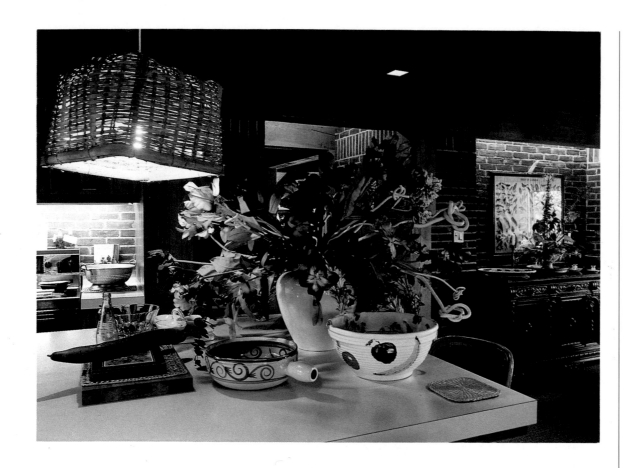

Silk flowers colourfully arranged in a Muskoka kitchen. "I like to make rooms happy," says the owner, who is a professional florist. "I use all manner of flora in a variety of ways."

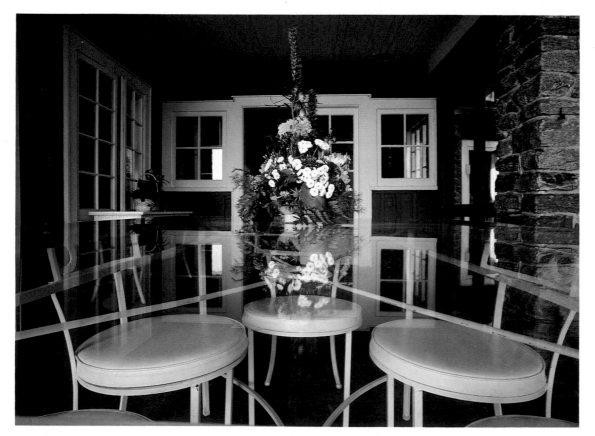

Reflected in the glass tabletop is a bouquet of wildflowers picked from the property of this Lake Joseph cottage. Behind the screen-porch table are doors leading to the dining room.

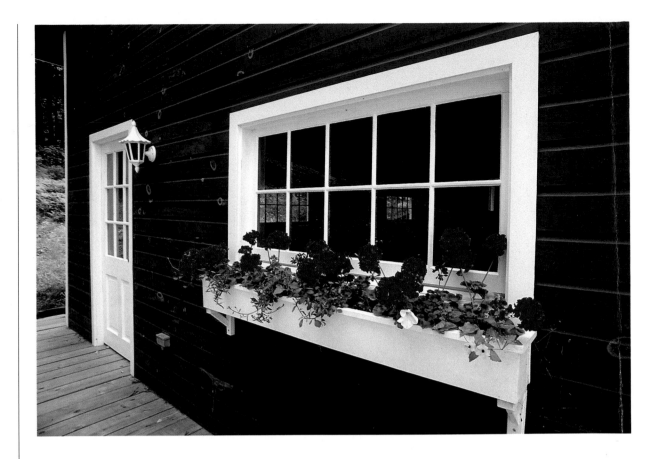

In Muskoka, a boathouse without window boxes is like a day without sunshine. At this new post-and-beam boathouse, the dark green stain and white trim are reminiscent of old cottage style.

The subtle shades of summer. Dappled sunlight and white impatiens against the blue-grey exterior of a Lake Joseph cottage. The board-and-batten addition blends seamlessly with the old stone-pillared cottage.

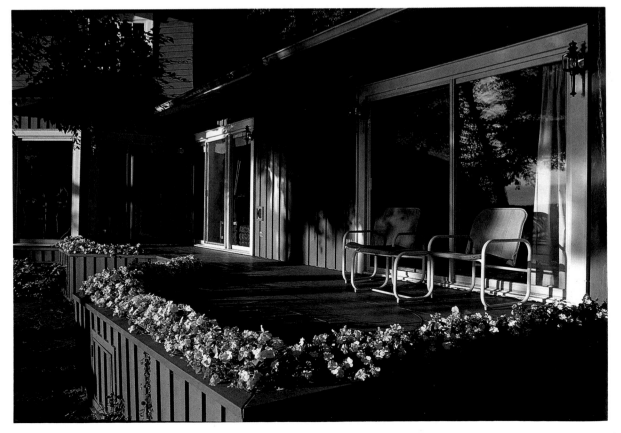

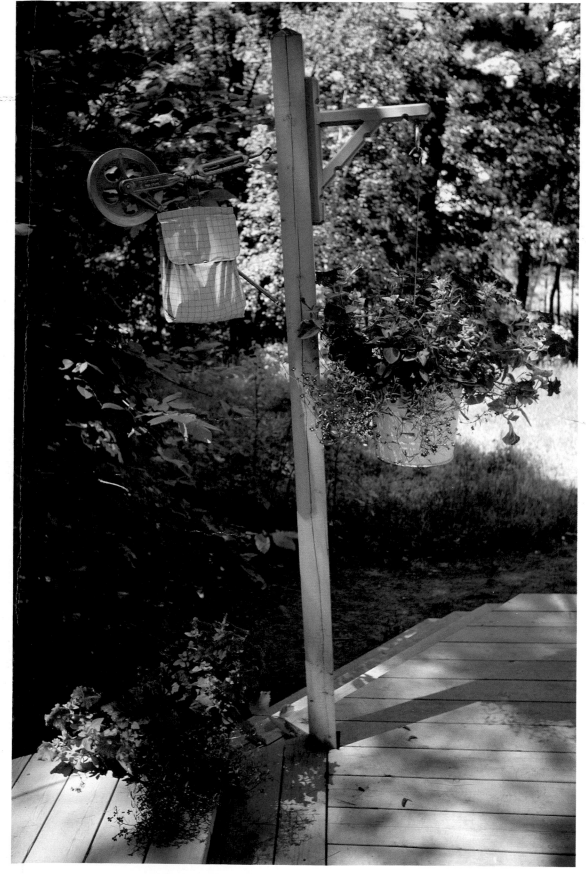

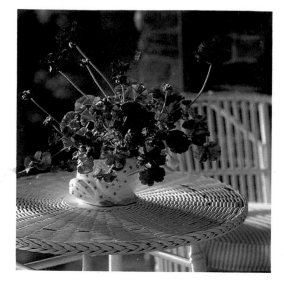

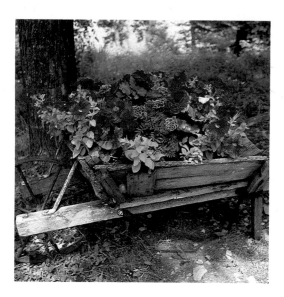

Creative containers.

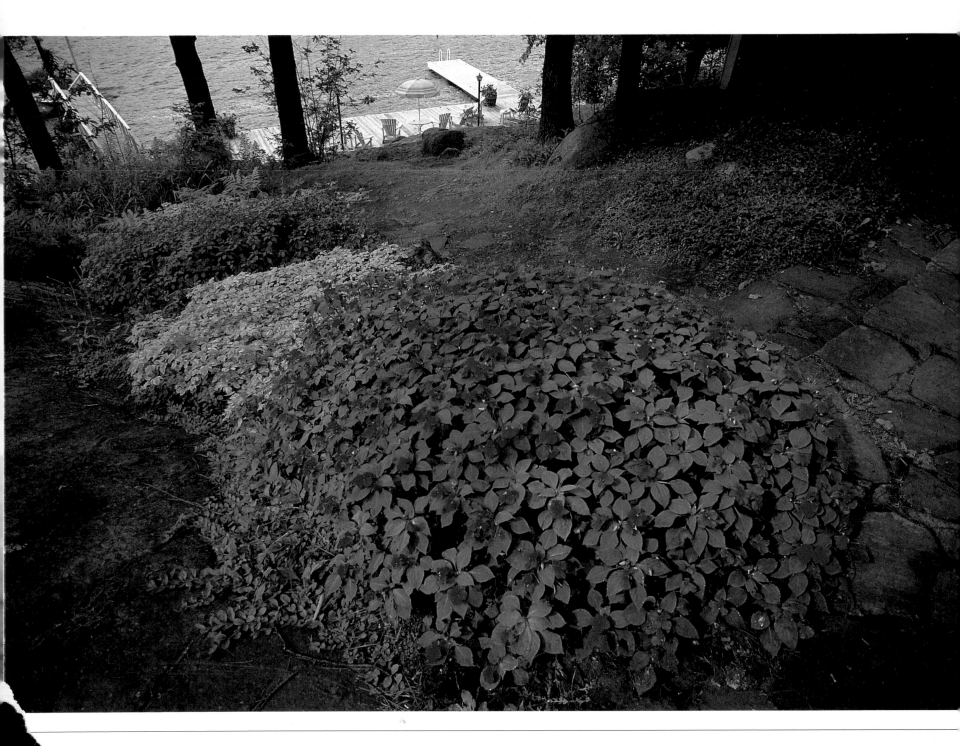

Masses of impatiens spill down the
hillside to the cottage dock at Milford Bay
in Muskoka.

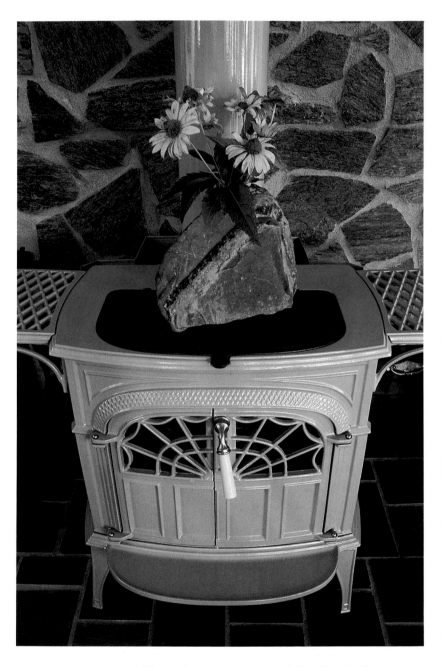

Stove-top arrangement in the sitting room at Stoney Lake.

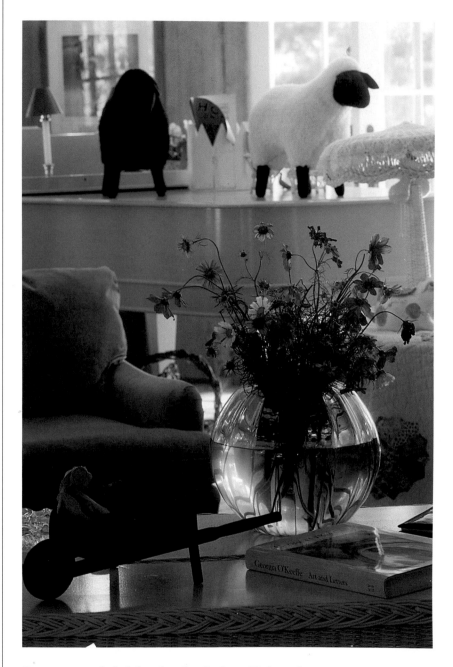

Cosmos and daisies in the balmy light of a Muskoka living room.

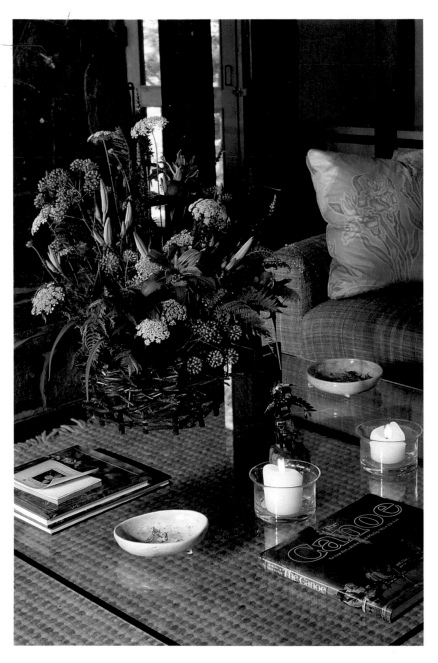

Wildflowers provide ever-changing bouquets on a Muskoka coffee table.

Heirloom wicker bursting with fuschia on a summer veranda.

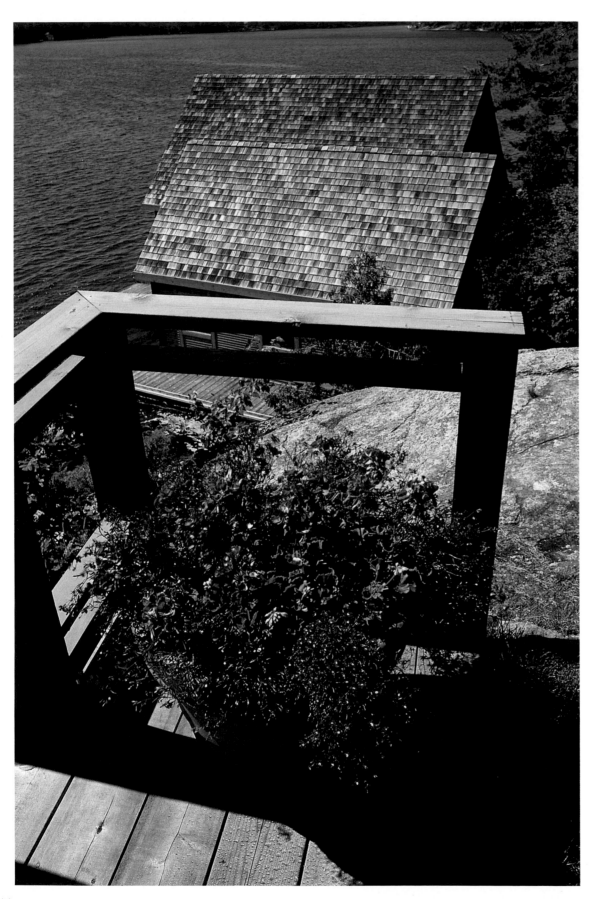

At cottages, the ritual of planting annuals every spring pays glorious dividends all summer long.

HERE WE ARE

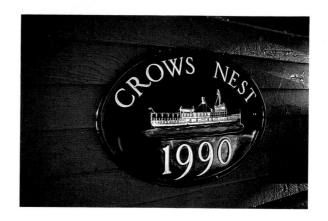

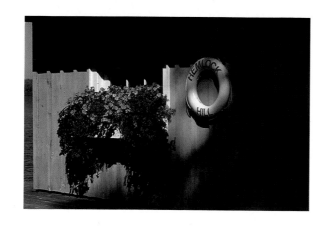

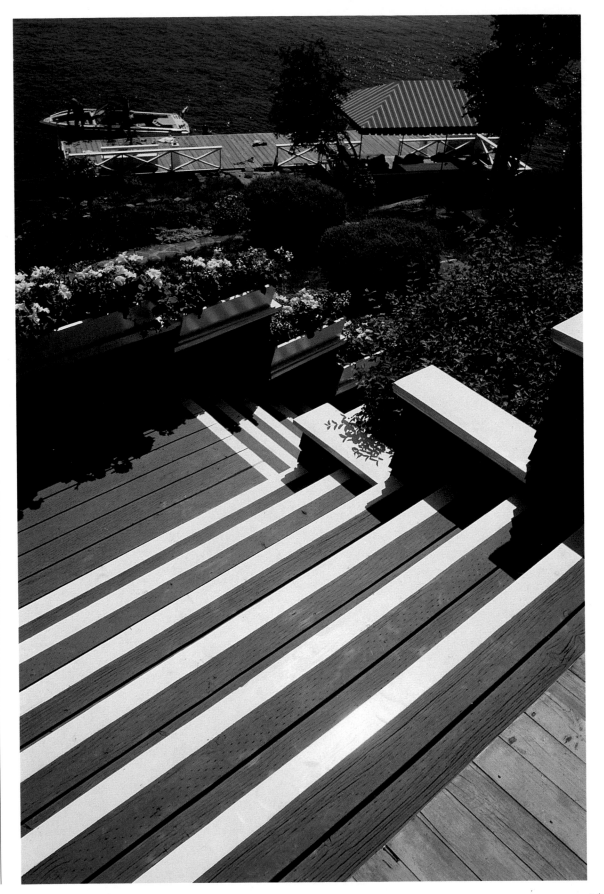

This colourful stairway edged with flowers leads down to the dock at Beaumaris in Lake Muskoka.

THE COTTAGE GARDEN

To own a bit of ground, to scratch it with a hoe, to plant seeds and watch the renewal of life
— this is the uncommonest delight of the race, the most satisfactory thing a man can do."
Charles Dudley Warner 1870 from *My Summer in a Garden*

In the Precambrian rock that forms the basis of most Ontario cottage gardens, the thin layer of soil presents special challenges. Most of the early settlers who tried to farm the land gave up and moved west around the turn of the century. But cottagers persist. Despite the weather — gusty winds that blow in off the lake to batter our little plots, and the late frosts that nip growth in the

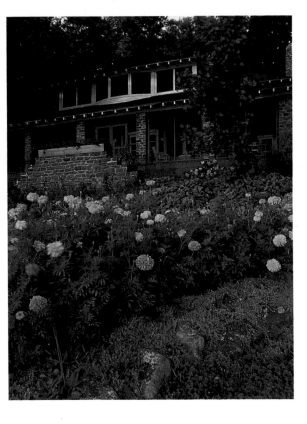

bud — we strive for perfection. And for the weekend gardener there's the added problem of not being there to tend and water during the week. It's not at all easy having a successful cottage garden. But we persevere, because on a soft July night, when the border plants blaze beneath the lamplight and the sweet perfume of white nicotiana fills the air, it all seems worthwhile.

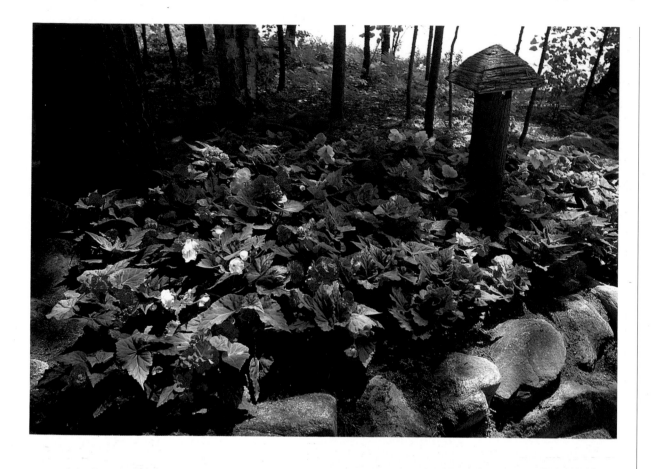

A few of the 10,000 annuals planted every spring at this seven-acre Lake Rosseau island. Cedar-post lamplights illuminate the pathways at night.

Sprouting from the Precambrian rock at Go Home Bay in Georgian Bay are flora and fauna (of sorts).

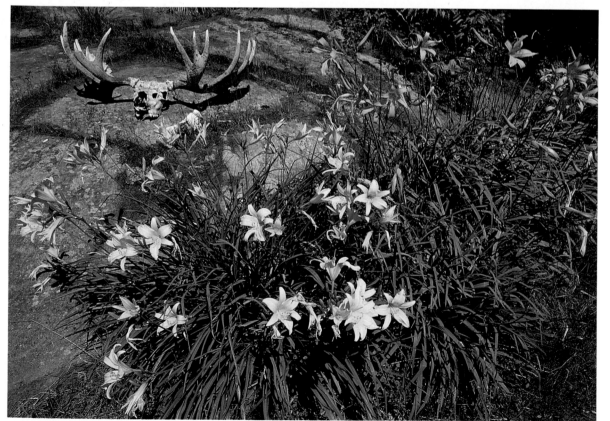

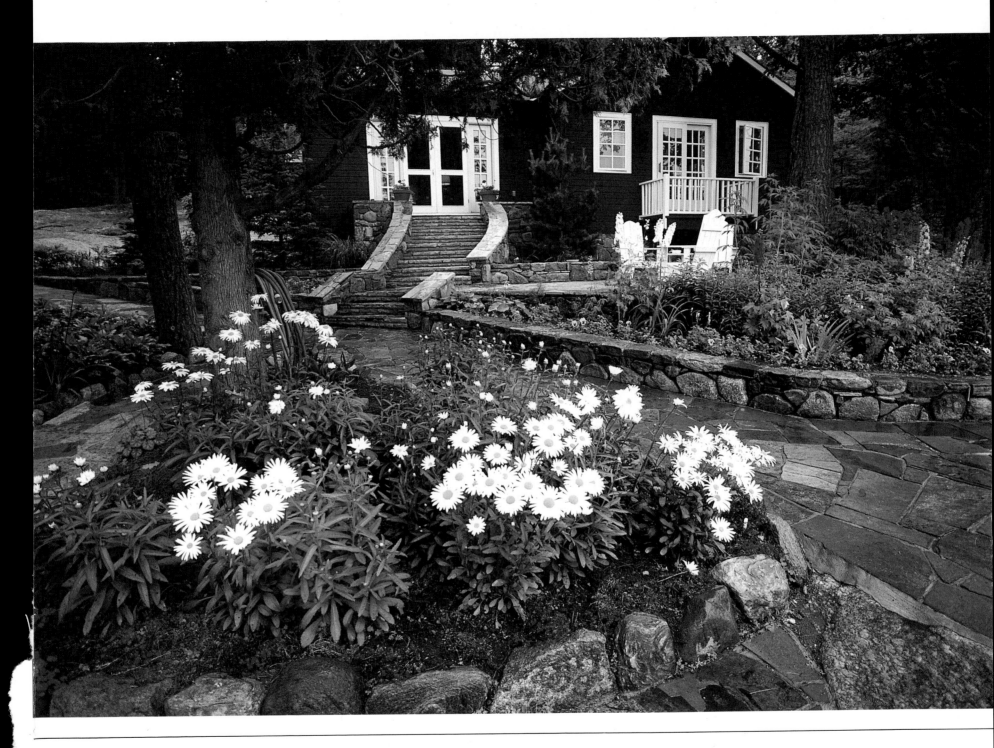

"It's a lazy afternoon and I know a place that's quiet 'cept for daisies running riot . . ." (from a song in *The Golden Apple*)

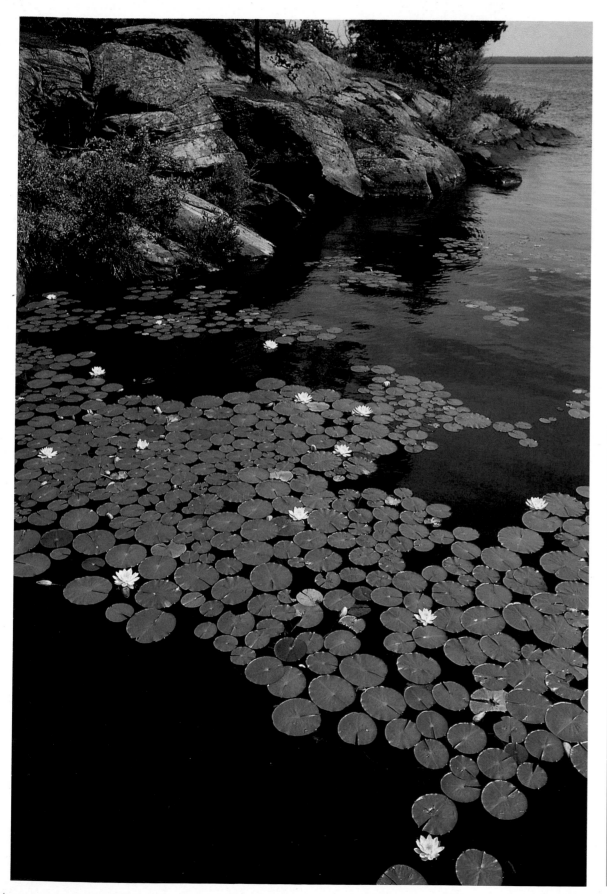

A sheltered cove where water lilies
grow, off Cinderwood,
Lake Muskoka.

154

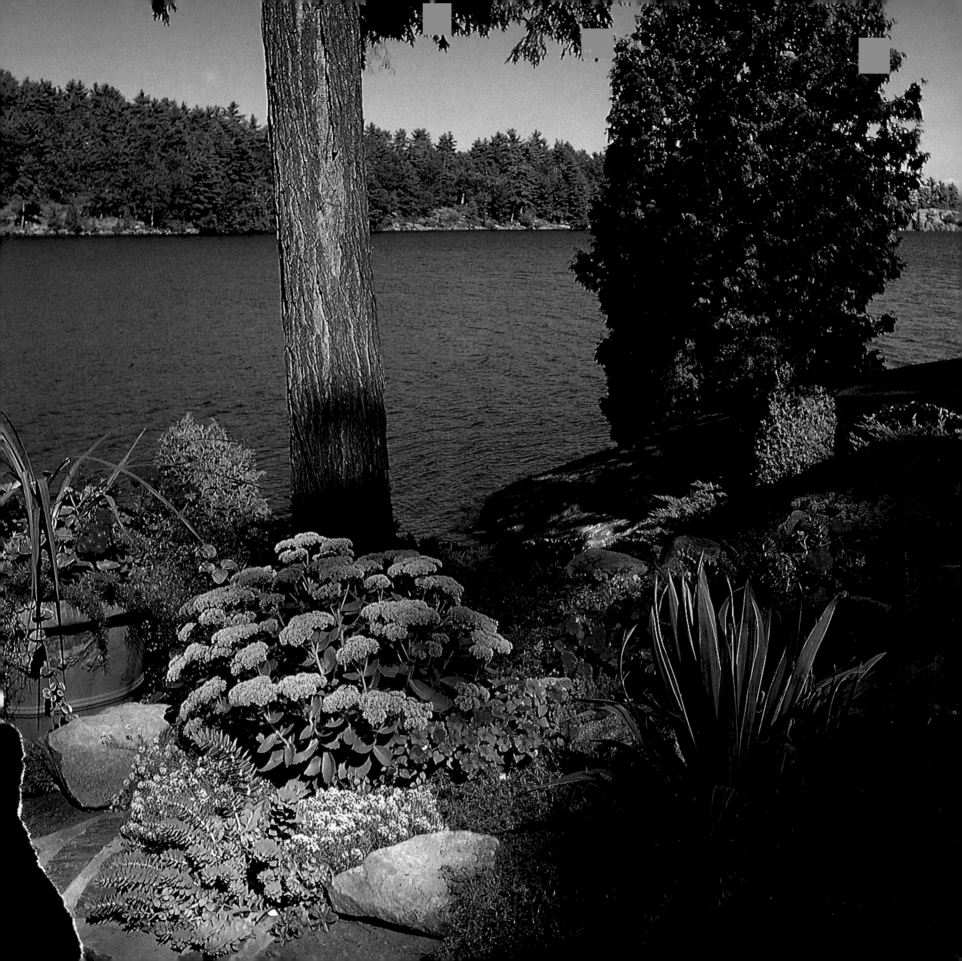

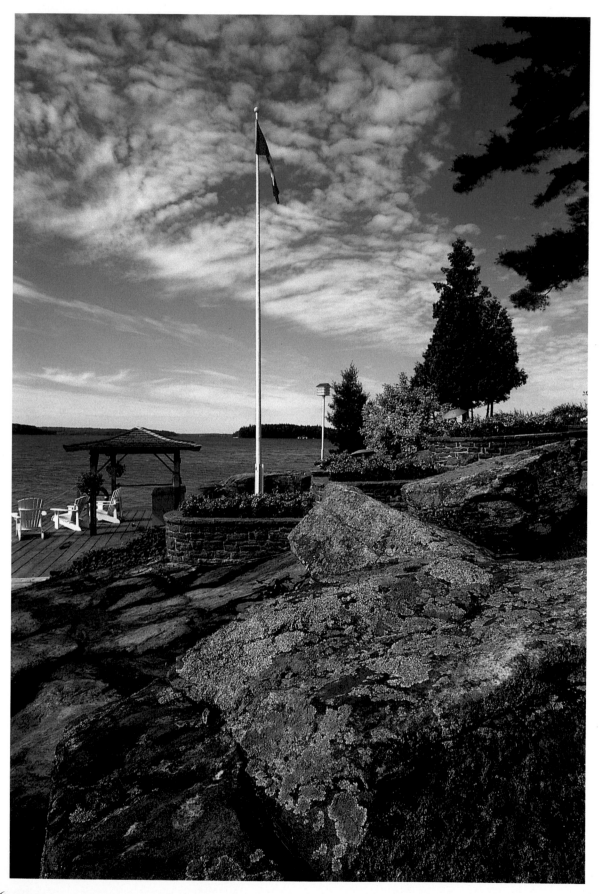

Geraniums march down the shore at Lake Muskoka.

Begonias on the beach at
Woodmere on Lake Rosseau.

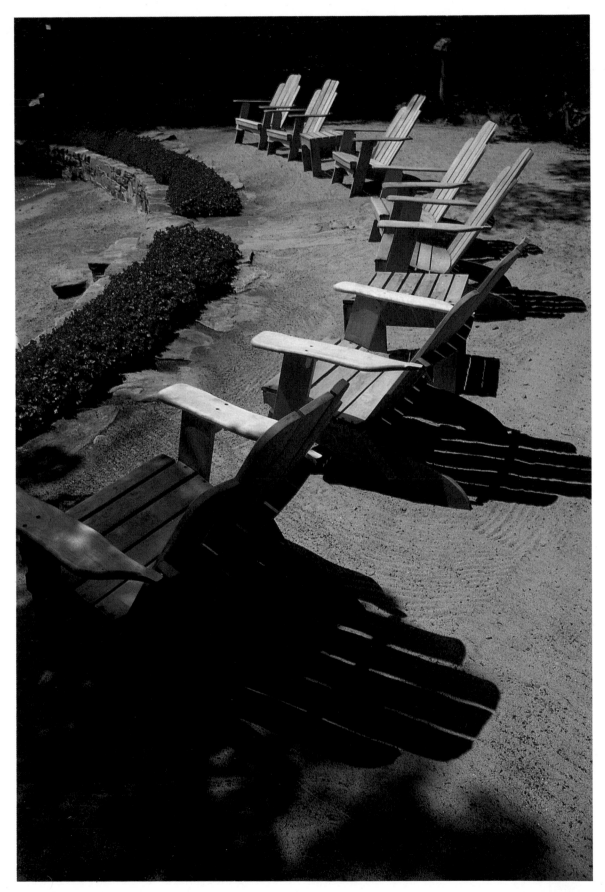

A rustic stairway curves down the hill to Lake Joseph.

Stoddart

A STODDART / BOSTON MILLS PRESS EDITION